THE ART OF SCIENCE

ARTISTS AND ARTWORKS INSPIRED BY SCIENCE

This book was produced during 2019–2021 under the challenging circumstances of the Covid-19 pandemic. The authors would like to thank all of those who have assisted and supported our research, writing and editing, including friends, partners, colleagues, librarians and experts, as well as Isabel Wilkinson and the team at Welbeck. Finally, we are grateful to all the artists, past and present, whose work is featured here and who continue to inspire us.

Published in 2021 by Welbeck
An imprint of Welbeck Non-fiction Limited, part of
Welbeck Publishing Group
20 Mortimer Street
London W1T 3JW

Design: Katie Baxendale and Darren Jordan
Editorial: Isabel Wilkinson
Picture research: Steve Behan
Production: Marion Storz

A CIP catalogue for this book is available from the British Library.

ISBN 978-1-78739-456-8
Printed in Dubai

10 9 8 7 6 5 4 3 2 1

THE ART OF SCIENCE

ARTISTS AND ARTWORKS INSPIRED BY SCIENCE

HEATHER BARNETT • RICHARD J BRIGHT • SHEENA CALVERT • NATHAN COHEN • ADRIAN HOLME

WELBECK

CONTENTS

INTRODUCTION

Today, we tend to think of "art" and "science" as very different realms that rarely connect. However, it was not always so. The development and separation of these realms, and their further subdivision into their myriad specializations, disciplines and subdisciplines, took place over centuries. This evolving separation perhaps explains why that archetypal artist–scientist Leonardo da Vinci (1452–1519) was able to work across, what appears to our eyes, an astonishingly broad swathe of human enquiry. In Leonardo's day that separation had not yet been made. In spite of the subsequent disciplinary, educational and cultural distinction of art and science, there have been certain disciplines, such as anatomy, that have continued to connect these two realms, and also many artists who have made science and technology their subject. Now, in the twenty-first century, transdisciplinary reconnections of art and science are providing fertile ground for the making of interesting, relevant and challenging art, while also highlighting the potential of art to provide that cautionary, critical and reflective space in which urgent questions about the practice, ethics and direction of science and technology may be raised and considered.

The Art of Science explores these relationships between science and art through the work of 40 artists, or groups of artists, spanning 10 centuries from the Song Dynasty in China (c. tenth century) and the Renaissance in Europe (c. fifteenth century) to the present day. The artistic practices presented share common bonds of human curiosity, craft and conceptualization, in trying to understand ourselves and our place in the world, conceiving both the arts and sciences as open and systematic inquiries into the deep structure of human experience. Through diverse means – including painting, sculpture, photography, installation, new media, computation, performance and participation – the creative endeavour offers insights and expressions across scales: from molecular mechanisms, through subjective experience, to the vast intangibles of the universe, all brought to a human scale and to human sensibility through art.

Throughout history there have been many points of convergence, where the questions probed in scientific endeavour reverberate in the activity of artists: whether the advent of electricity, new paradigms in the laws of physics, or the implications of biotechnological futures. *The Art of Science* does not attempt to give a definitive chronological history of the interrelations between art and science, but the various subjects of enquiry are grouped around five broad themes. The location of artists is intended to guide an exploration of their work from a particular perspective, although in many cases there are obvious synergies with ideas explored in other sections.

Alchemy & Cosmos explores the work of artists concerned with perception and interaction with light, the relationship between macrocosmic and microcosmic space, and experiencing science and technology through the lens of art. The artists in this section invite us to view the world and our relationship to it in a different way, to visualize and imagine new worlds.

Being Human considers the ways in which artists place the human body at the centre of their work, and interrogate, extend and explore the internal and external limits of the body, as well as the body as a site of consciousness. In doing so they point our attention towards the body as an "interface" between scientific, corporeal (bodily), and sensual forms of knowledge.

Ecology & Environment spans four centuries of artistic practice that closely observes the environment and engages directly with its inherent ecologies. Through diverse methods of representation, intervention and transformation these artists challenge our perceptions of, and relationships with, the natural world.

Machines & Systems covers a spectrum of investigation and experimentation by artists concerning the mechanics and ordering of space, form and media. The artists in this section invent and employ a range of systems, devices and mechanisms to question underlying principles and challenge our relationship with technology.

Nature & Beyond explores the ways in which artists have understood, investigated and represented nature over the past millennium. The section considers the changing perceptions of our relationship to the natural world over time, culminating in works that challenge the concept of nature itself.

In the dynamic and co-evolving fields of artistic and scientific research, there are many other artists whose work would merit inclusion in this book. The task of selection was not easy. We could not hope to be comprehensive, but we do aim to offer an introduction to important themes, ideas, artists and works. The inevitable omissions and deficiencies may be remedied in further writings, but we hope that the selection reflects the depth of engagement with some fundamental existential questions and a diversity of artistic forms of investigation and expression. *The Art of Science* navigates an improbably vast terrain – of history, geography and artistry – inviting the reader into a glimpse of extraordinary works, in which science, poetics and sensual experience mutually support the quest for greater understanding of what it means to be human, and of our place in the world.

Heather Barnett, Richard Bright, Sheena Calvert, Nathan Cohen and Adrian Holme – 2021

ALCHEMY

&

COSMOS

Alchemy may be defined as the process of taking something ordinary and turning it into something extraordinary, sometimes in a way which cannot be explained.

From the Greek κόσμος, cosmos means the "ordered whole", the universe considered as a system with an order and pattern. Our sense of the cosmos, of the ordered whole, puts us on the trail of the patterns and principles our brains impose upon the events we experience.

This section covers a broad spectrum of investigation and experimentation by artists concerned with perception and its interaction with light, the relationship between macrocosm and the microcosm, and the experience of science and technology through the lens of art.

Our view of the realities outside us is structured in relation to existing perceptual experience and pre-established criteria of interpretation. If we look at their processes, art and science share many common grounds – observation, speculation, experimentation, visualization and the presentation of experience in particular modes – and the visual more often than not plays a central role.

The artists in this section invite us to view the world and our relationship to it in a different way, to be transformed and to visualize new worlds. Berenice Abbott's photographs reveal to us otherwise invisible scientific phenomena while Yves Klein's monochromatic paintings are intended to make visible the absolute.

The dynamics of the rising ferment of eighteenth-century science are revealed in the work of Joseph Wright of Derby, along with our tapping of the forces that animate nature, while the material nature of our world, experienced through the lens of science and technology in the twentieth and twenty-first centuries, is explored by the artist duo Semiconductor.

Explorations of the transforming experience of light, grounded in science and the study of optics, can be found in the works of Georges Seurat and Susan Derges, in which the viewer is a crucial component.

And the interrelationships of the macrocosm and the microcosm are explored in Robert Fludd's seventeenth-century visual descriptions of the occult relationship between man and the universe and in Katie Paterson's contemporary contemplations on deep space and cosmic archaeology.

ROBERT FLUDD

Dr Robert Fludd (1574–1637) was a physician, alchemist,[1] follower of Rosicrucianism,[2] and writer who attempted to synthesize the philosophy and knowledge of his day. He has been described as "the most prominent Renaissance Christian Neoplatonist of his time, and the greatest summarizer and synthesizer of that tradition of his age."[3]

Fludd was born in Kent, England, and studied at Oxford University, gaining degrees in humanities and medicine. He travelled widely in Europe following his graduation. In 1609 he was admitted as a Fellow of the College of Physicians of London, and practised medicine in London, where he also had an alchemical laboratory dedicated to experiments on wheat. A scholar and writer, Fludd was in correspondence with leading British and continental European scientific figures of the day.

Today, Fludd is best known for the illustrations he created for his major work *Utriusque Cosmi Maioris scilicet et Minoris Metaphysica, Physica Atque Technica Historia* (*Technical, physical and metaphysical history of the Macrocosm and Microcosm*, 1617–1621), which included striking images engraved to the very highest standards by his publisher Johann Theodor de Bry of Oppenheim. We would not call Robert Fludd an "artist" in the contemporary sense: today, we might use the term "illustrator". But the importance of these powerful images, from a time when "art" and "science" were not yet conceptually divided, lies in their communication of complex ideas, of visual arguments, in the form of pictures – something common in the late alchemical tradition. Fludd wrote

two works in defence[4] of the shadowy Rosicrucian movement (see also Yves Klein, page 28) the "invisible" followers of which synthesized Judaeo-Christian, Neoplatonic and alchemical philosophies. In this way, Rosicrucianism provided a bridge from the magical and animist world of the European Renaissance to the world of modern experimental science[5] – the world of Galileo and Descartes.

Fludd's illustrations show his cosmology of occult links between the lesser world (microcosm) of the human, and the larger world (macrocosm) of the entire cosmos. Although Fludd's alchemical cosmology fell out of favour with the emergence of modern experimental, mathematical and mechanical science, his startling images, such as his series depicting an alchemical version of the biblical Genesis (pages 12–13) provide a testament to the enduring power of imagery to communicate complex ideas. Referring to his ill-tempered dispute with the astronomer Kepler, Fludd said of their differing approaches: "What he [Kepler] has expressed in many words and long discussion, I have compressed into a few words and explained by means of hieroglyphic and exceedingly significant figures."[6]

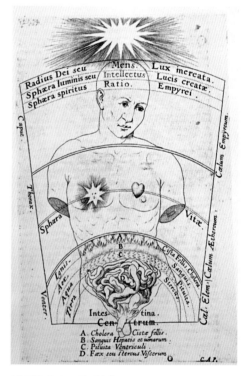

ABOVE: Robert Fludd, from *Utriusque Cosmi Maioris scilicet et Minoris Metaphysica, Physica Atque Technica Historia* (*Technical, physical and metaphysical history of the Macrocosm and Microcosm*), Volume 1, page 109, 1617–21. Engravings by Johann Theodor de Bry, showing the relationship between the larger cosmos (Macrocosm) and the human body (Microcosm).

History of the Macrocosm and Microcosm

This dramatic title page to Fludd's major work – a far cry from later scientific illustration – shows graphically the relationship between Microcosm and Macrocosm. The human Microcosm is mapped onto the zodiac, the four inner circles representing the four humours, with Saturn-governed melancholy at the very centre. The outer circle contains the Ptolemaic Macrocosm, which influences the human at every level. To the upper right, the deity of time, Chronos-Saturn (a link to the Saturnian melancholy of the centre), pulls a rope that drives the motion of the entire cosmos, and provides an image of time at once linear and circular.

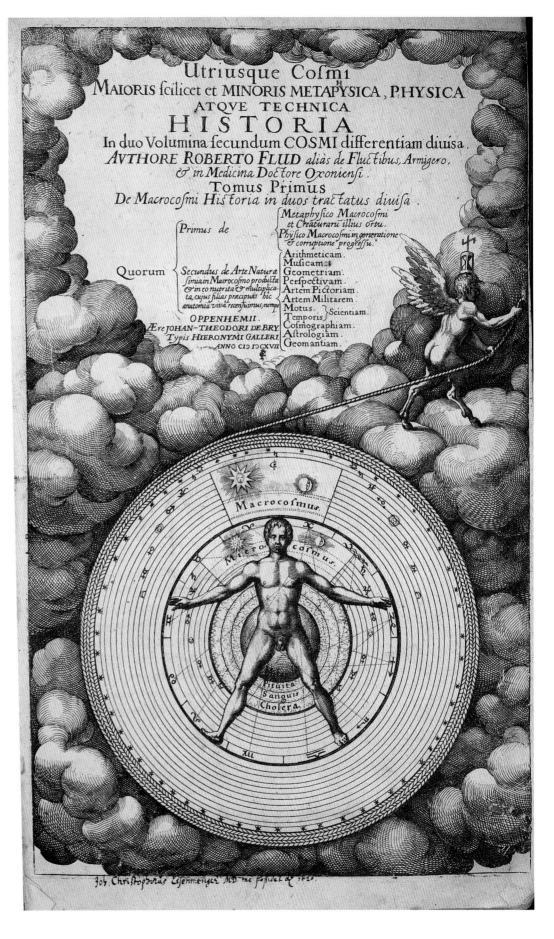

RIGHT: Robert Fludd, from *Utriusque Cosmi...*, Volume 1, title page, 1617–21.

Et sic in infinitum

Et sic in infinitum

CAPUT V.
De tenebris & privatione.

AUGUSTINUS contra Manichæos asserit, privationem nihil aliud esse, quàm tenebras, quæ definiuntur lucis absentia. Sed si rectè consideretur tenebrarum significatio, illam latius quàm privationis vocabulum se extendere percipiemus. Nam, teste Moyse, tenebræ super faciem abyssi fuerunt, priusquam lux seu forma crearetur; privatio verò nominari non potest, nisi respectu cujusdam positionis, hoc est, ubi est alicujus formæ præcedentis absentia. Quare, u. cum Augustino consentiam, omnis privatio est tenebra, hoc est, formæ lucidæ

CAPUT IX.
Quod universa cœlorum, tam spiritualis, quàm corporalium substantia, sit aut elementum, aut ex elementis compositum.

POST hujus igitur divini opificii complementum, omnis cujuslibet ejus regionis substantiæ portio, aut elementum aut elementatum esse comperta est; quarum, quæ elementum vocatur est prima, minima, & simplicissima pars, ex qua cujuslibet cœli elementatum immediatè constituitur. Et quia cujuslibet cœli substantia propter majorem vel minorem lucis præsentiam crassior, impurior, & imperfectior habetur, igitur elementi simplicitas vel absolutè intelligitur, tantummodò elementorum cœli spiritualis, vel respectivè consideratur: Nam si ad ea cœli inferioris comparentur,

E 3 simplicia

C A P U T III.

De tribus prioribus creationis diebus.

DIFFICILIS videtur cognitio difpofitionis dierum ante Solis creationem factæ, cùm inter ipfos quoque Patres Theologos differentia haud exigua de dierum illorum natura oriatur, Nam *Bafilius, Damafcenu,* & alii *Græci* volunt, quod lux illa facta primo die caufaverit diem per emiffionem luminis, noctem verò per retractionem illus voluntate divina factam. Sed *Doctores*

G *Latini*

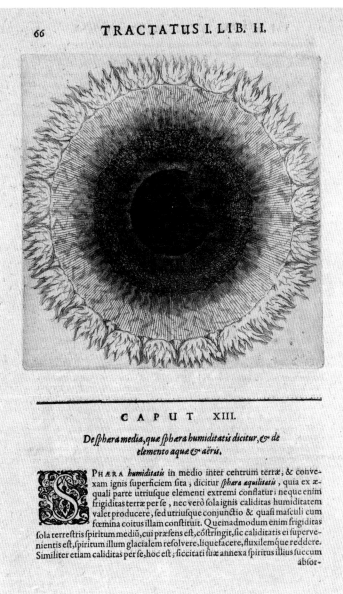

C A P U T XIII.

De fphæra media, quæ fphæra humiditatis dicitur, & de elemento aquæ & aëris.

PHÆRA *humiditatis* in medio inter centrum terræ, & convexam ignis fuperficiem fita, dicitur *fphæra æqualitatis*, quia ex æquali parte utriufque elementi extremi conflatur: neque enim frigiditas terræ per fe, nec verò fola ignis caliditas humiditatem valet producere, fed utriufque conjunctio & quafi mafculi cum fœmina coitus illam conftituit. Quemadmodum enim frigiditas fola terreftris fpiritum mediü, cui præfens eft, côftringit, fic caliditatis ei fupervenientis eft, fpiritum illum glacialem refolvere, liquefacere, fluxilemque reddere. Similiter etiam caliditas per fe, hôc eft; ficcitati fuæ annexa fpiritus illius fuccum abfor-

OPPOSITE & ABOVE: Robert Fludd, from *Utriusque Cosmi...* 1617–21. Engravings by Johann Theodor de Bry. Selected pages from Fludd's alchemical depiction of the Creation in the biblical story of Genesis. The first image (left to right), *Et sic in infinitum* (And so on to infinity) shows the primordial darkness at the beginning. In the second image the bright Spirit of Mercury is forming between the upper heavenly waters and the lower dark waters from which matter will emerge[7]. In the third image God sends forth his breath, his divine spirit (the dove) which circles the cosmos three times, creating the first three days. The forth image (above right) depicts a later stage in the formation of air and water.

JOSEPH WRIGHT OF DERBY

Joseph Wright (1734–97) painted the world around him that many of his contemporaries overlooked – the England of the Industrial Revolution, with its iron forges and textile mills, and its people, including workers, industrialists and scientists. But, in tackling these modern secular subjects, Wright utilized earlier languages of visual symbols (iconography) taken from religious and alchemical imagery.

Joseph Wright was born in Derby and, though he spent time in London, Liverpool and Italy, he spent most of his life in Derby. In the Enlightenment of the eighteenth century, this English town was an important centre of Britain's Industrial Revolution – a transformation of the economy and land, powered first by water and wind, and then by coal and steam (and funded in part by proceeds of the transatlantic slave trade). This was an age in which science and technology were harnessed to a burgeoning capitalism

and imperialism. Wright (who styled himself "Wright of Derby" to distinguish himself from another artist of the same name) painted this world of science, technology and industry, along with the associated landscapes and people – such as Richard Arkwright, whom Wright depicted with a model of his power-driven spinning machine as his emblem.

Wright is most famous for his Candlelight works, in the style of Caravaggio, in which he placed the source of light – often two sources – within the picture, hollowing out a space

within the darkness. Works such as *Three Persons Viewing the Gladiator by Candlelight* (1765) (see page 16) are concerned with the working of light and the act of looking and representing. In such works, Wright was influenced by the writings of philosopher John Locke (1632–1704), who had inquired into perception and vision. Locke believed that we learn through the passive reception of impressions, much as the eye itself, a dark chamber, receives light. Wright's paintings abound with dark chambers.

RIGHT: Joseph Wright of Derby, *A Philosopher Giving that Lecture on the Orrery, in which a lamp is put in place of the Sun*, 1766. Oil on canvas. The heads of the onlookers, illuminated by the "Sun" at the centre of the model solar system, appear like phases of a planet – implying perhaps that gravitation also functions in the social sphere.

OPPOSITE: Joseph Wright of Derby, *The Alchymist, In Search of the Philosopher's Stone, Discovers Phosphorus, and prays for the successful Conclusion of his operation, as was the custom of the Ancient Chymical Astrologers*, 1771/1795. Oil on canvas. The praying alchemist discovers not the philosopher's stone, but the light of phosphorous – a scientific revelation, yet still alchemically linked to the sulphurous candlelight and the mercurial light of the Moon.

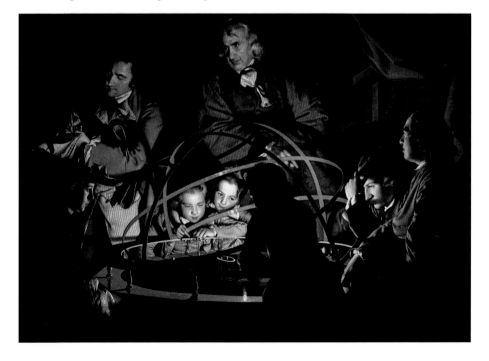

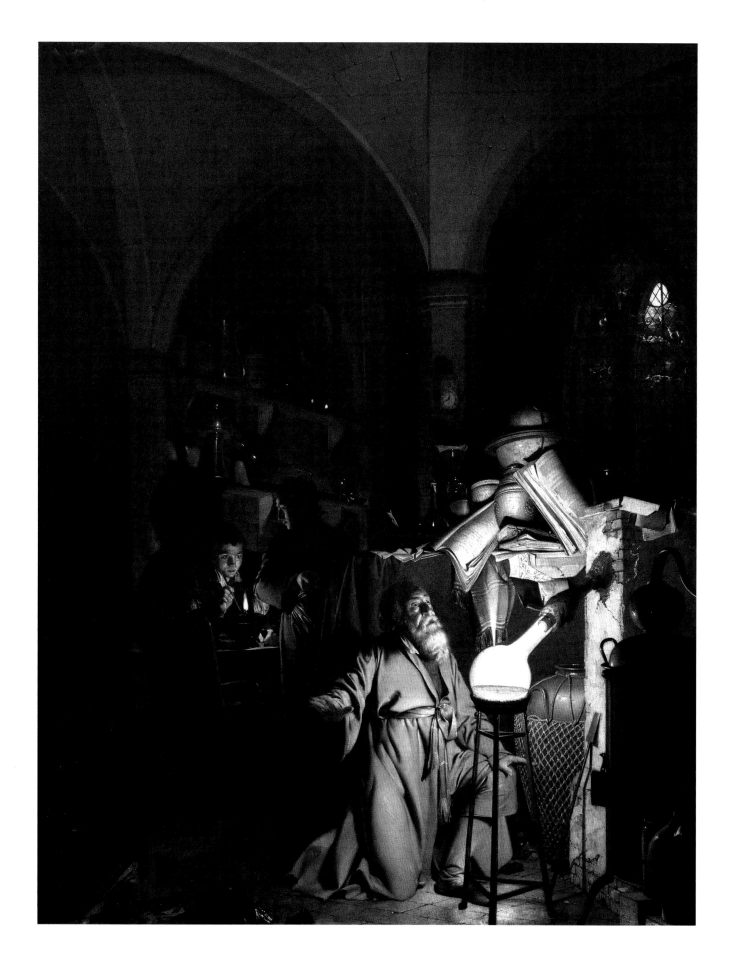

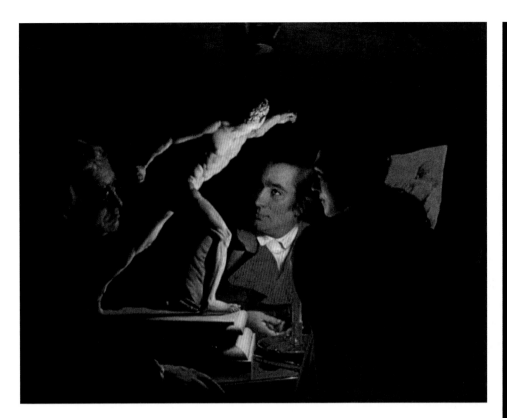

An Experiment on a Bird in the Air Pump and *A Philosopher Giving that Lecture on the Orrery...* (both pictured) explicitly show scientific experiments or demonstrations. But one, *The Alchymist...*, depicts the (by then discredited) practice of alchemy yet results in genuine scientific revelation – in the form of the light of phosphorous. We can find further alchemical symbolism in Wright's frequent inclusion of two lights in his paintings – a yellow light representing the Sun and sulphur, and the full Moon, representing mercury.[1] In alchemical practice, the Sun and Moon, and sulphur and mercury, interacted in the quest for the supposed "philosopher's stone".

In other works, Christian iconography is evident – the white bird standing in for the Holy Spirit in *An Experiment on a Bird in the Air Pump*, or the glowing iron in the series of paintings of blacksmiths' forges, recasting a nativity scene, in which people gather around an iron ingot as though they are around the radiant light of the Christ child. Within such secular settings Wright was able, through painting, to explore latent spiritual and emotional aspects of the modern world of industry, technology and science.

An Experiment on a Bird in the Air Pump

One of Wright's most noted Candlelight works, *An Experiment on a Bird in the Air Pump* (1768) (right) dramatically depicts a scientific experiment, the evacuation of air from a glass vessel containing a helpless white bird (reminding us of the white dove of the Holy Spirit). The varied reactions of people around the table range from horror, to curiosity, to detachment. Only the "scientist" (demonstrator) in the centre looks directly to us, as if asking: "What do you think?"

ABOVE: Joseph Wright of Derby, *Three Persons Viewing the Gladiator by Candlelight*, 1765. Oil on canvas. A painting about looking and representing: the sculpture of the gladiator (representation of a man) looks most real. We see Wright himself in profile, and his drawing of the sculpture – a representation of a representation, all contained within another representation, the painting itself.

RIGHT: Joseph Wright of Derby, *An Experiment on a Bird in the Air Pump*, 1768. Oil on canvas.

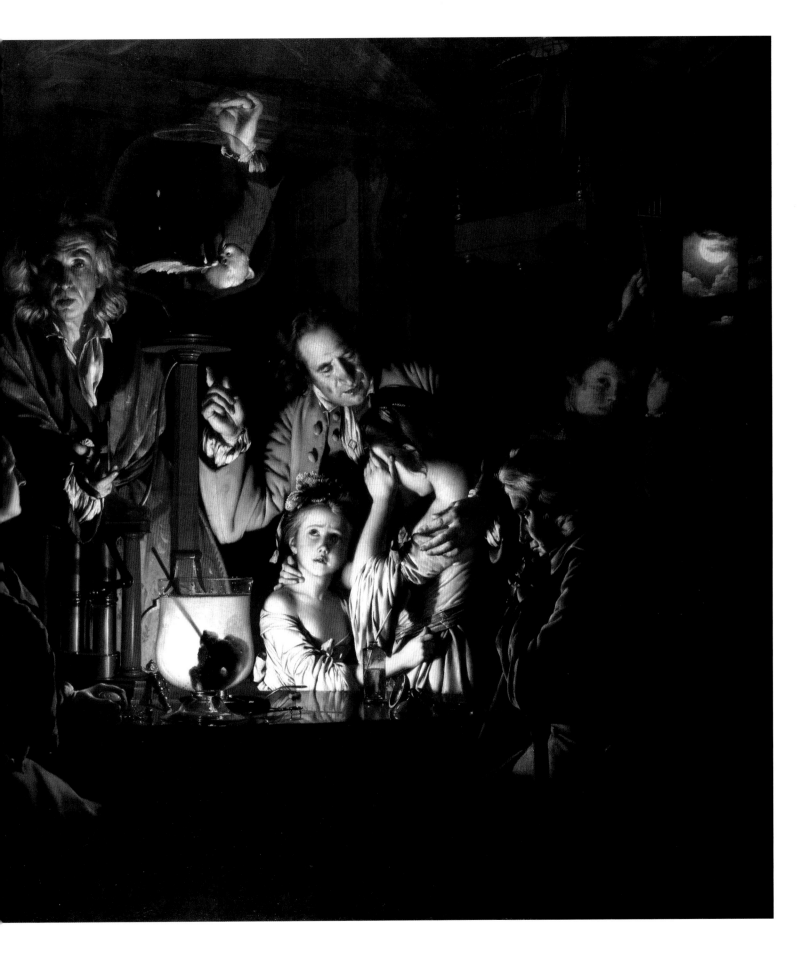

GEORGES SEURAT

"Art is Harmony. Harmony is the analogy of the contrary and of similar elements of tone, of colour and of line." So wrote Georges Seurat in a letter to the writer Maurice Beaubourg in 1890. Georges Seurat (1859–91) was a French neo-impressionist painter of figures and landscapes, whose later work was highly influenced by scientific colour theories. During 1881–3, Seurat concentrated on drawing, especially in Conté crayon on Michallet paper.

The use of the surface texture of laid paper to capture the essence of the drawing media would have been part of his academic training, but in *Embroidery; The Artist's Mother*, the work is drawn entirely without line, instead using tonal passages of black. Scarce atmospheric light, subtly evoked by lessening pressure on the crayon, illuminates the interior where the woman sews. The quality of the black grains in these Conté drawings, where the varying density of the grains determines the gradations of tone, can be equated to the dots of Seurat's later pointillist paintings.

From 1883 Seurat began to analyze colours into their components (divisionism) and lay them on the canvas side by side in small brushstrokes (pointillism). He applied to his paintings the contemporary scientific theories of colour and the physics of colour, as described in the experiments on light conducted by James Clerk Maxwell and Hermann von Helmholtz, and the colour theories of American physicist Ogden Nicholas Rood and French chemist Michel Eugène Chevreul.[1]

Seurat's purpose in applying these colour theories was to fuse colour and light, pigments and spectral colours harmoniously in a picture while retaining their luminosity. Instead of mixing his colours on the palette, he let the viewer's eye do the mixing. He broke up the colours into their prismatic components and applied the resulting pure colours in small dots that, when seen from a distance, would produce the intended colour on the viewer's retina.

Seurat painted *Le Bec du Hoc, Grandcamp* (1885) while holidaying on the Normandy coast in the summer. He made a study of this motif on the spot, but refined and developed the image in the studio. As the realm of colour became an orderly and balanced arrangement of contrasts, the picture was seen to be governed by a rigorous law of harmony. The systematic pointillist technique acquired a special meaning. Seurat was not now an open-air painter in the impressionist sense, he was a studio painter. He still worked from sketches made out of doors, but the final painting took form in the studio.

RIGHT: Georges Seurat, *Embroidery; The Artist's Mother*, 1882–3. Conté crayon on Michallet paper.

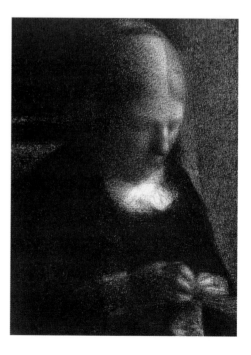

A Sunday Afternoon on the Island of La Grande Jatte (1884–86) was the first major manifestation of the pointillist technique. The painting shows members of each of the social classes participating in various park activities, who are rendered in an unrealistic and almost minimalist style. Every detail is carefully planned. The work required sketches on panel, 25 drawings and 3 preliminary studies. Seurat's inclusion of an innovative painted frame makes the experience of the painting even more intense by adding more colours, tones and textures to the composition.

At the Salon des Indépendants in 1888, Seurat continued to demonstrate the versatility of his technique by exhibiting *La Parade du Cirque*. This was Seurat's first foray into nocturnal painting, and he attempted to render artificial light effects at night using the pointillist method. This is one of Seurat's most important paintings, with its innovative formality and symmetry. The spatial position of the subjects is established through lighting, with those in the foreground unlit – painted in dark blue – while those behind the gas lights are brilliantly lit.

BELOW: Georges Seurat, *Le Bec du Hoc, Grandcamp*, 1885. Oil on canvas.

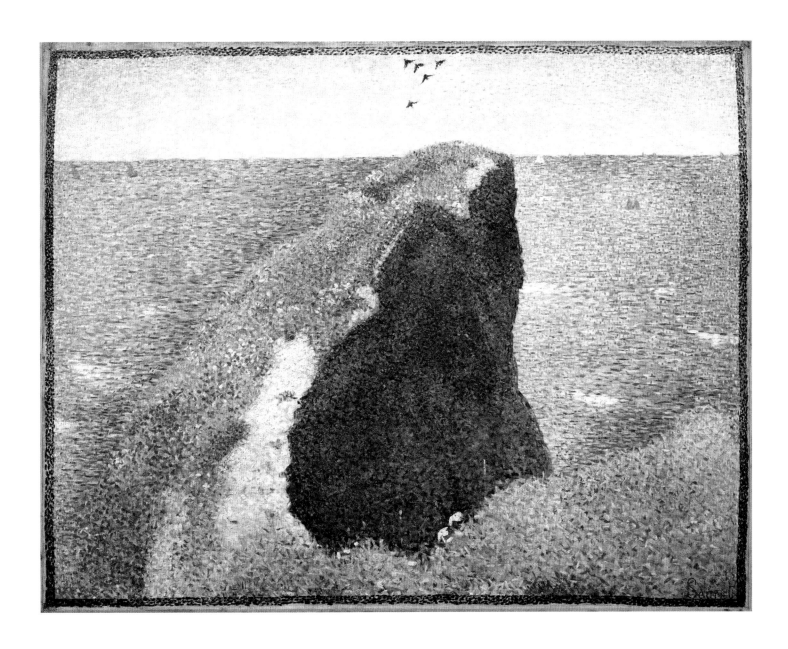

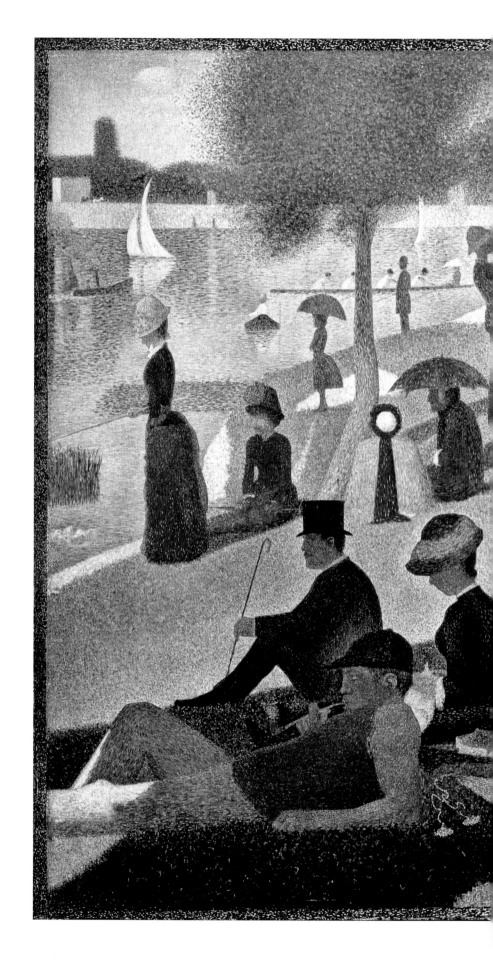

RIGHT: Georges Seurat, *A Sunday Afternoon on the Island of La Grande Jatte*, 1884–86. Oil on canvas.

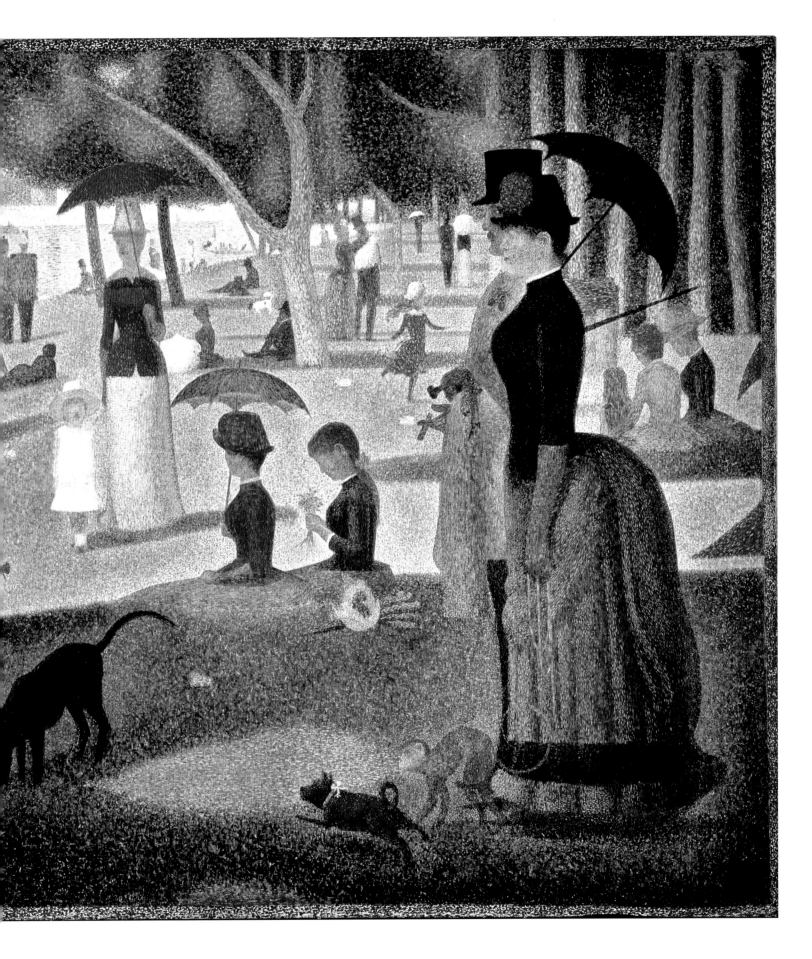

BERENICE ABBOTT

A twentieth-century American photographer, Berenice Abbott is best known for documenting the transformation of the 1930s New York cityscape and for her contribution to the visualization of scientific phenomena.

Berenice Abbott (1898–1991) was born in Ohio, USA, and studied sculpture in New York before travelling to Europe in the early 1920s. There, she was inspired by the street photography of Eugène Atget and met the surrealist Man Ray, soon joining him in his studio as photographic assistant. These early influences, of documentary photography and creative darkroom manipulation, became key characteristics throughout her career as her work developed along both scientific and artistic avenues.

In the early 1930s, Abbott began an extensive documentation of a *Changing New York*,[1] the title of her travelling exhibition and book. Shot mostly on large-format cameras, she captured the growth of skyscrapers, the pace of development and the economic push and pull of the time. Her keen eye and attention to detail resulted in a collection of over 300 images which still, today, provide a valuable archive of urban expansion. Abbott saw photography as a particularly astute visual medium to capture the rapid change she observed, which combined logic, realism and imagination in one. As part of the group of "objectivist" photographers, inspired by the writings of mathematician philosopher Alfred North Whitehead,[2] Abbott believed that photography could render the appearance of things in absolute terms, "that the constant gaze of the camera would inexorably disclose the underlying pattern of the world".[3]

Alongside her documentary and portrait photography she enjoyed experimenting,

in camera (with macro photography and rapid sequence shooting of moving objects), and in the darkroom (playing with light and chemistry).[4] Her interest in science manifested in her becoming photo editor for *Science Illustrated* and creating photographs for a number of physics textbooks. She was committed to education and understood the requirement to excite the viewer while also communicating a clear visual coherence. Her joy of experimental and collaborative working came to fruition in 1958 when she was hired by MIT to create a body of work making visible the underlying mechanisms of physical science. Over a two-year period, she translated the unseen properties of motion, waves and forces into dynamic black-and-white images. Simultaneously beautiful and full of information, the photographs perfectly intersect the methods of science and art – taken with extreme precision and technical expertise but with a deeply held understanding of aesthetic values. Published in the high school standard textbook *Physics*, her work influenced an entire generation of scientists-to-be.

Collectively, her work can be seen as a time capsule depicting the prevailing concerns of the mid twentieth century and its preoccupations with progress and knowledge. Her stunning images, observing the details of change and revealing otherwise invisible phenomena, continue to be widely reproduced for publication and exhibited internationally.[5]

ABOVE: Berenice Abbott in Paris in 1927.

OPPOSITE: Berenice Abbott, *City Arabesque from Roof of 60 Wall Street Tower*, 1938. Gelatin silver print.

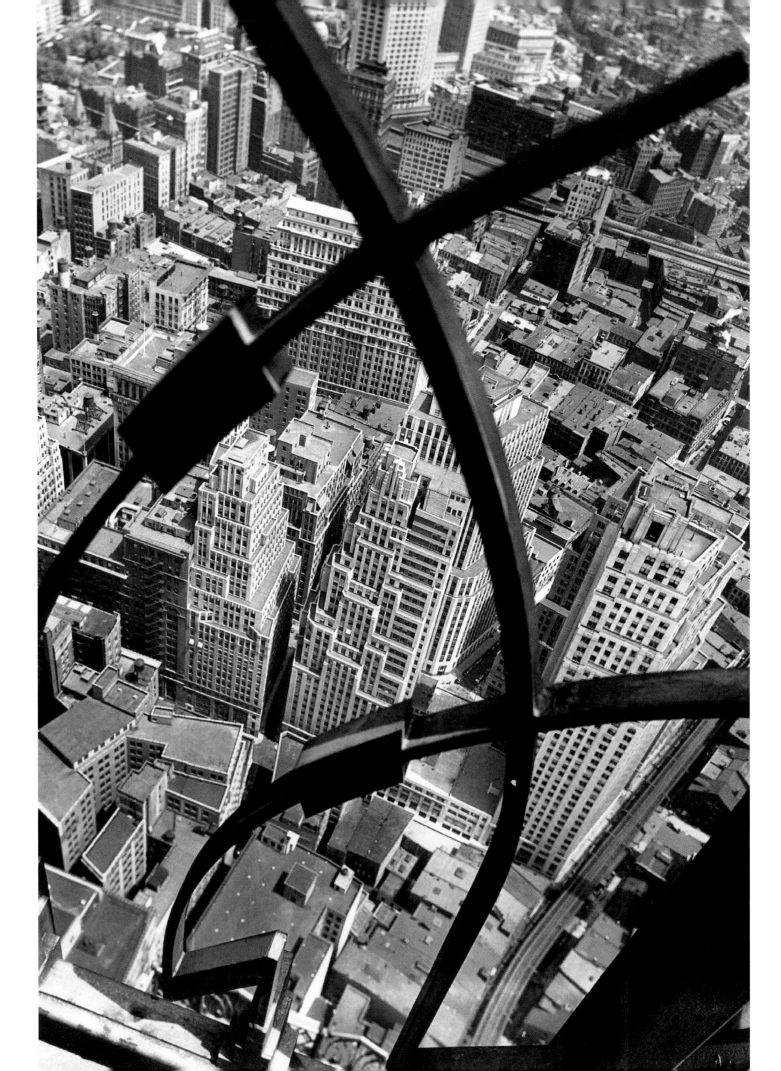

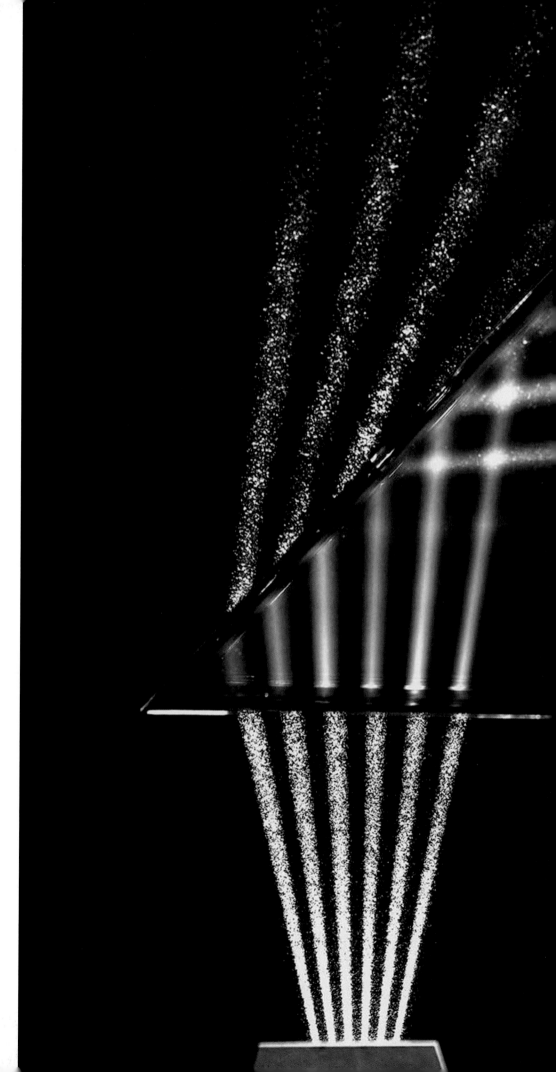

RIGHT: Berenice Abbott,
*Beams of Light Through
Glass,* 1960. Gelatin
silver print.

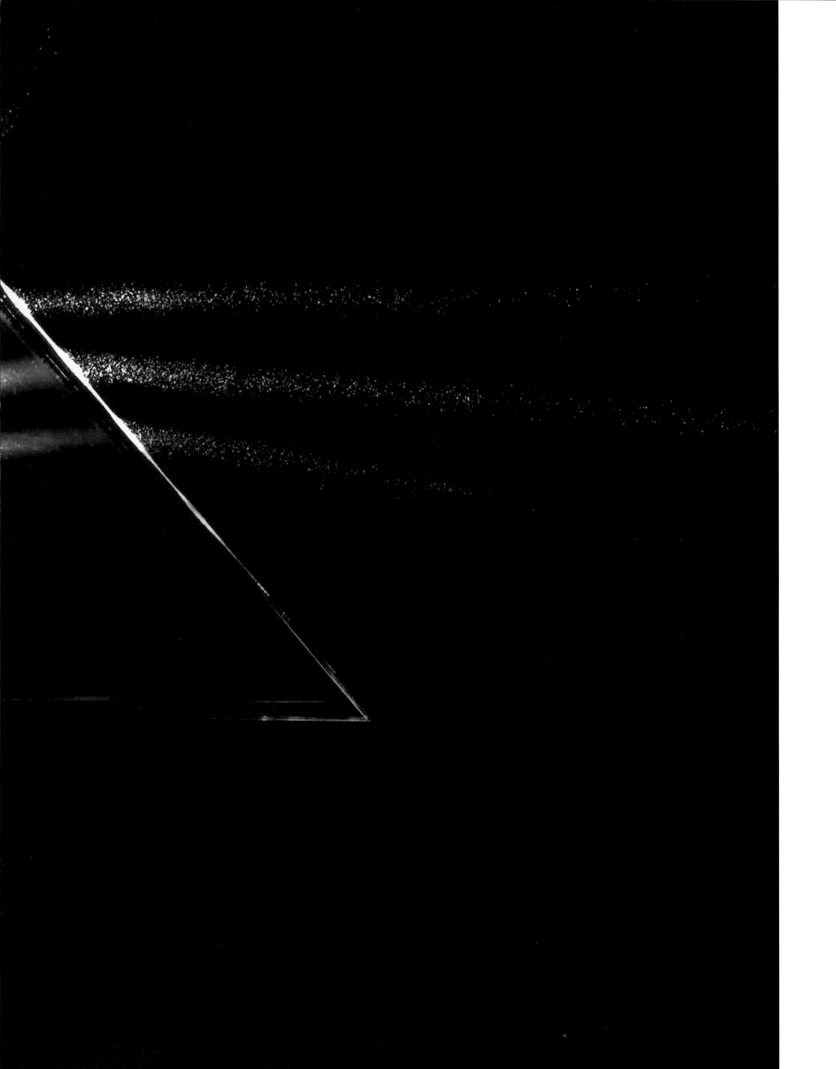

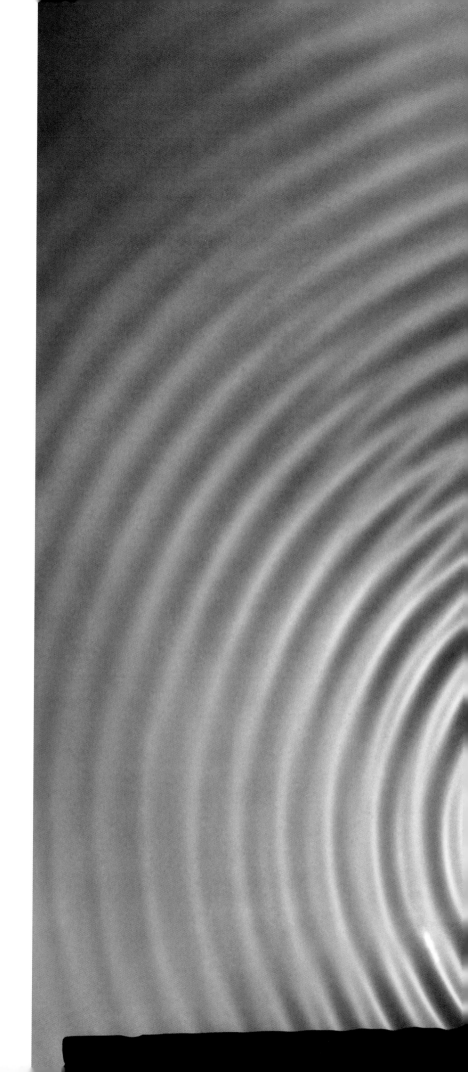

RIGHT: Berenice Abbott,
Interference Pattern,
1958–61. Gelatin
silver print.

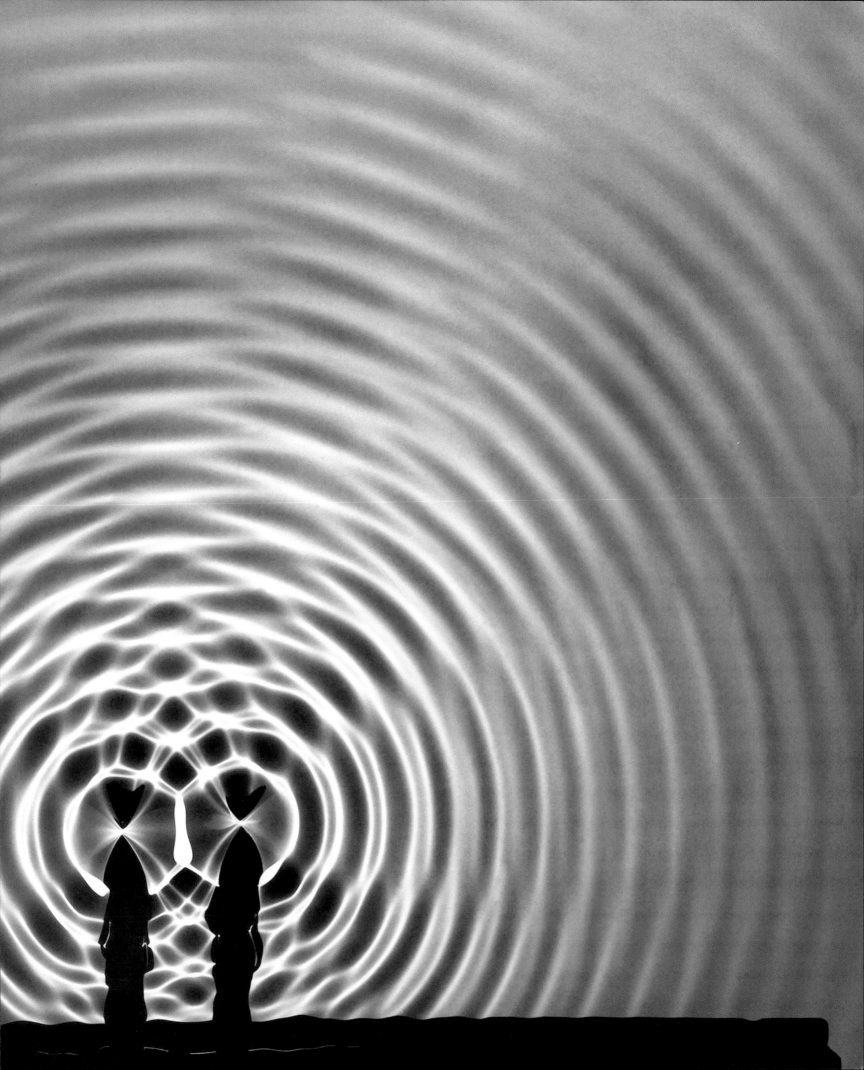

YVES KLEIN

Yves Klein (1928–62) was a modernist artist: a painter, sculptor and performer who produced a large body of work within his short career.[1] His influences transcended "East" and "West", drawing upon Japanese culture, judo and Zen as well as Rosicrucianism, with its roots in the Christian alchemical tradition.[2] In fact, with his concerns for material and spiritual purification, we may interpret Klein as a kind of twentieth-century alchemist.

Between the late 1940s and his early death in 1962, Yves Klein produced some 700 paintings, along with performances, actions and installations. His statement "My paintings are the ashes of my art"[3] indicates the importance of his presence as an artist and performer, as well providing an alchemical reference to fire and transformation of matter. Klein used fire directly in works such as *Wall of Fire* and *Column of Fire* (1961), and in his fire paintings, made by directly burning into paper[4] and tempered dramatically by water provided by an attending fireman.

Yves Klein first came to prominence with his monochrome paintings, becoming known as "Yves le Monochrome"; these early minimalist works were paralleled in sound by his *Monotone-Silence Symphony* (1947), an orchestral piece based upon one note. But he is best known for his use of the colour blue, and the particular form of ultramarine used with a resin binding agent – a combination he named International Klein Blue (IKB) and for which he was granted a patent. Sometimes his IKB paintings incorporated other materials, such as the sponges incorporated in *Untitled Blue Sponge Relief* (1957) (see page 32). In this unearthly and disorienting piece, the saturated blue absorbs the viewer into the work, which somehow seems to dematerialize and rematerialize in front of our eyes, and from which the organic forms of sponges emerge mysteriously, like life forms in an alien ocean.

His *Blue Globe (RP7)* (1957) speaks to a certain universalism – this is not a geopolitical, but a unified globe, prefiguring the views of our blue planet later captured from space. And Klein's influences encompassed the globe. Studying judo in Japan, he assimilated aspects of Zen Buddhism that carry through into his work (such as the concept of the activation of emptiness), combining these with his Rosicrucianism, a form of Christian alchemical tradition in which philosophies of "East" and "West" had already been brought together (see also Robert Fludd, page 10).

Perhaps it is in the *Ex-Voto* (1961) (see page 30–31), donated to a convent and containing a private prayer to Saint Rita, patron saint of lost causes, that we see most clearly Yves Klein's material and spiritual alchemy. The little box, like a reliquary, contains compartments for the trinity of colours Klein is said to have discovered in fire. Gold, said his friend and art critic Pierre Restany, represented the Father, the heavenly Sun, immortality; blue represented the Son of God, Christ, sensibility; and rose represented the Holy Spirit and divine blood.[5]

Klein sought material and spiritual purification in relation to a world of contemporary science and technology. Yet, he did this with his own inimitable and somehow mischievous style. "Great beauty", he wrote, "is only a reality when it contains, intelligently mixed into it, 'genuine bad taste', 'irritating and intentional artificiality', with just a touch of dishonesty."[6]

A leap into the void

In a suburban street, a man launches himself into space. His hair is raised, his arms outstretched, his black besuited body arcs away from the first-floor ledge of the building. Across the road, a cyclist calmly goes on their way, oblivious to the drama. What are we to make of this scene? Is the man flying? Is he falling? Is it trickery? And who is this strange person, this "painter of space"? It is the artist Yves Klein.

OPPOSITE: Yves Klein, *Leap into the Void*, 1960. Photographed by Harry Shunk and János Kender.

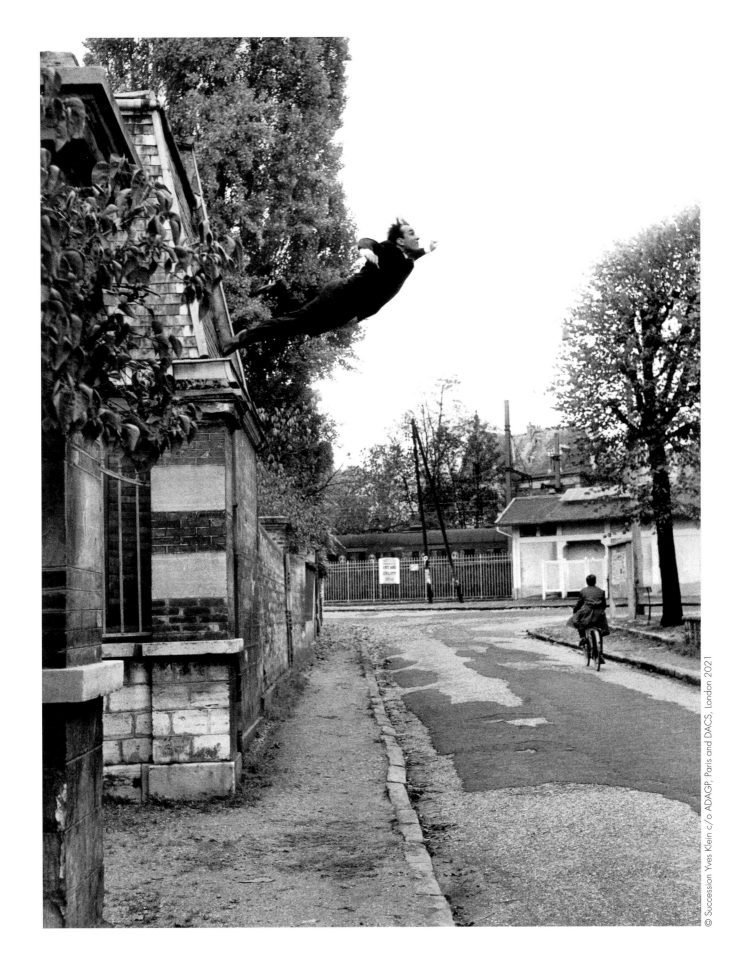

YVES KLEIN

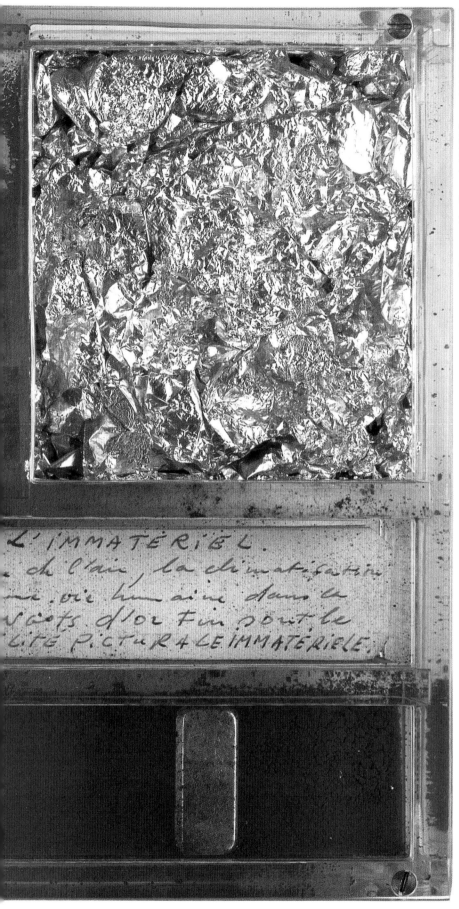

LEFT: Yves Klein, *Ex-Voto dedicated to Saint Rita of Cascia*, 1961. This small, private work, donated to an Italian convent, shows alchemical concerns with material and spiritual purification, using Klein's three characteristic colours/materials of rose pigment, ultramarine pigment and gold leaf, together with a prayer to Saint Rita, patron saint of lost causes.

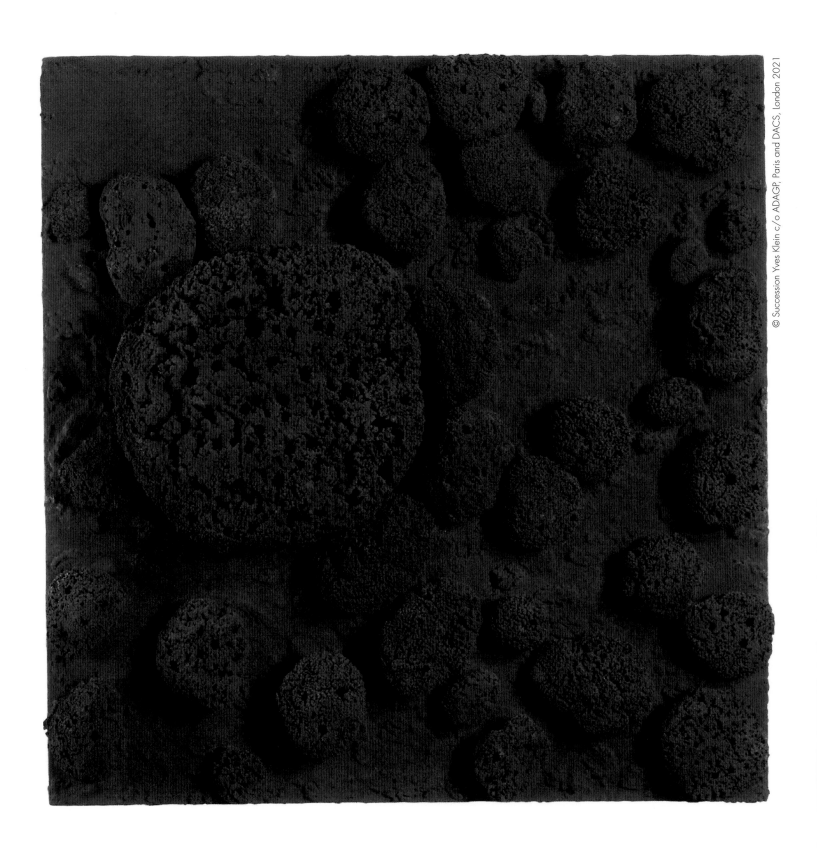

ABOVE: Yves
Klein, *Untitled Blue
Sponge Relief (RE
29)*,1957.

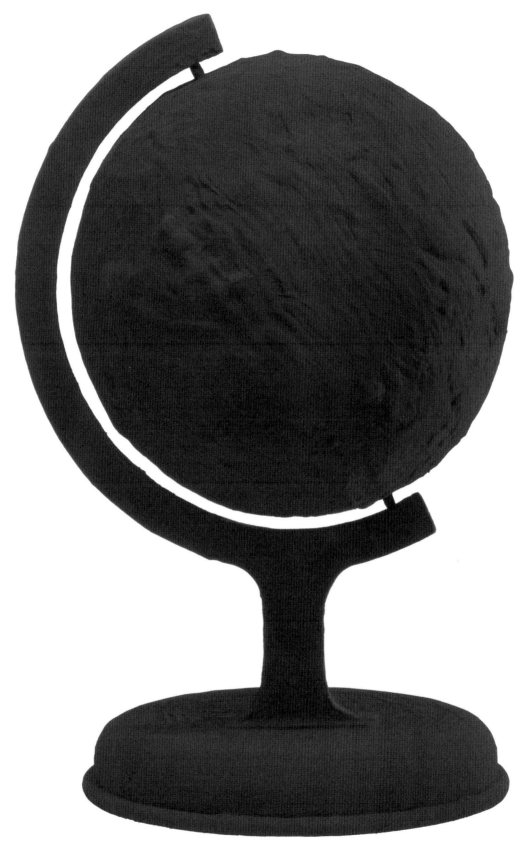

ABOVE: Yves Klein, *Blue Globe (RP 7)*, 1957. Pure pigment and synthetic resin on metal globe.

© Succession Yves Klein c/o ADAGP, Paris and DACS, London 2021

SUSAN DERGES

Susan Derges (born 1955) is an artist who uses camera-less photography, creating photograms[1] in which nature imprints itself directly into patterns and rhythms, growth and form onto the light-sensitive surface of photographic paper. Her work revolves around the creation of visual metaphors that explore the relationship between the self and nature or between the imagined and the "real".

Susan Derges initially trained as a painter, concerned with the creative interface between art and science. A period of living and studying in Japan led Derges to adopt photography as her principal means of expression.[2] Her early work explored such phenomena as powder on vibrating plates, as in her Chladni Figures[3]; bee populations in honeycombs; and vessels of germinating toad's eggs. Subsequent series continued to explore hidden forces and cycles of nature and her most frequently recurring subject, water.

In her 1991 series, The Observer and the Observed, Derges explored the interdependence of viewer and object by creating a setup inspired by the experimental work of scientist Sir Charles Vernon Boys.[4] The series was created by using sound to break a stream of water into individual droplets and photographing this with a strobe light. The droplets act as a lens, capturing an inverted image of Derges's face in each. A distorted image of her face is also positioned behind the water jet.

The act of immersion is an important part of the River Taw series, in which she treats the surface of the river, along its journey from its source to the sea, as a photographic transparency, and where the body is directly referenced in the long, vertical format of the prints. By submerging the photographic paper just beneath the surface of the water,

shining a flashlight from above at night, a brief moment of the turbulence, vortices and flow forms are fixed directly onto the paper. What is being recorded is not the reflection of light on the surface as taken from above, as with that shot with a camera, but the energy of the river, as seen from below. The recorded image looks out through the surface into the world above. The viewer is immersed, on the same plane and scale as the paper, becoming part of the process and flow of the river, a living entity reflecting a human microcosm.

Natural Magic (2001) was an exhibition following Derges's year-long residency at the History of Science Museum at the University of Oxford. In this she created images, such as *Aëris* (2001), that focused on the theme of metamorphosis, echoing the chemical narrative of the distillation process found in early Renaissance experiments, with its concern with alchemy, at a time when imagination and subjectivity were inseparable from scientific enquiry.

In her Moon and Star Field series and Cloud series she created ambiguous, disorientating spaces, visualizing the idea of a threshold on the edge of two interconnected worlds, one internal and imaginative, the other an external world of nature. They confound a sense of orientation, questioning what is above or below and implying a dialogue between the microcosm and the macrocosm. For example,

in *Full Moon Fir* (2003), is one looking at a reflection or is one submerged beneath the surface of water, looking up at the Moon?

All of Susan Derges's works derive not from dispassionate, objective and independent observation, looking on and analyzing from the outside, but from touching nature, working with nature on its own terms and, above all, exploring the human entanglement with nature.

OPPOSITE: Susan Derges, *Observer and Observed No. 16,* 1991. Silver gelatin print.

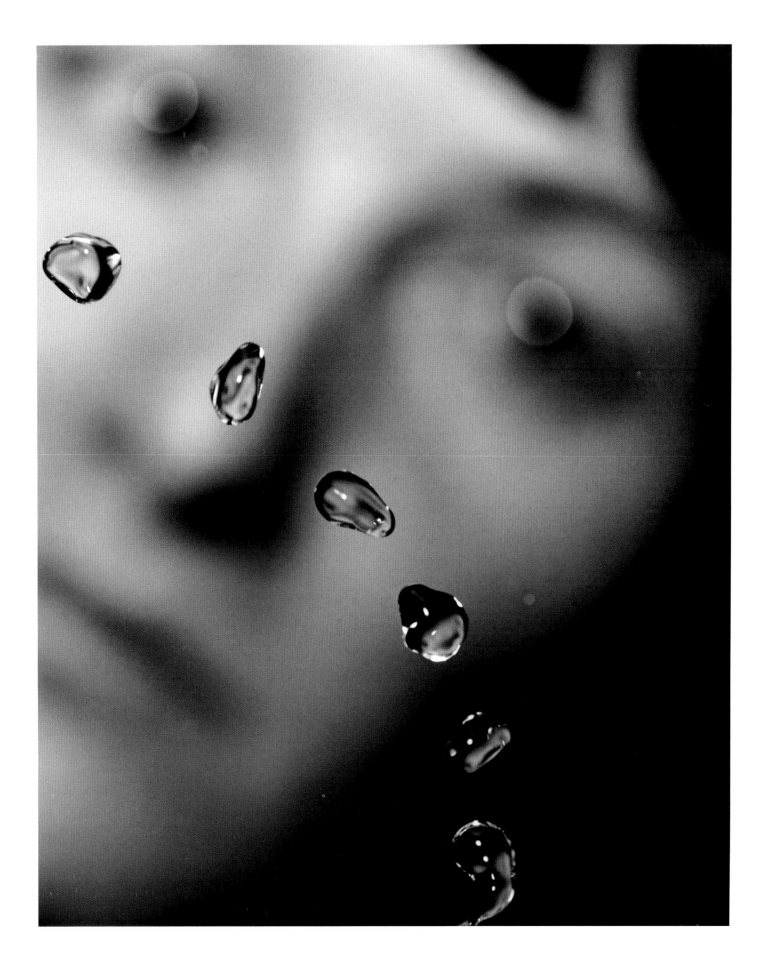

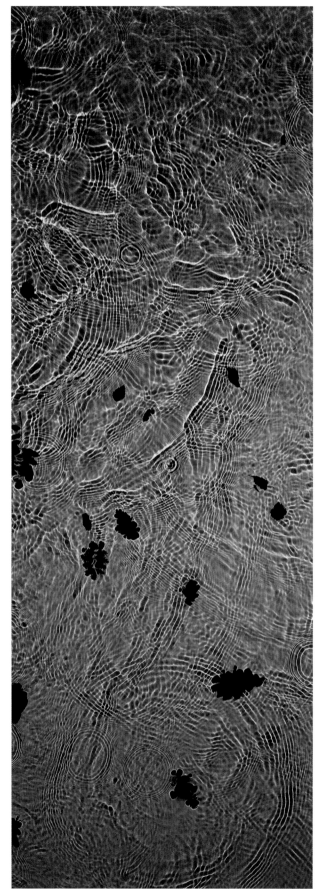

LEFT: Susan Derges,
River Taw, 1997.
Ilfochrome print.

ABOVE: Susan Derges,
Aëris, 2001. Ilfochrome
print.

OPPOSITE: Susan
Derges, *Full Moon Fir*,
2003. Ilfochrome print.

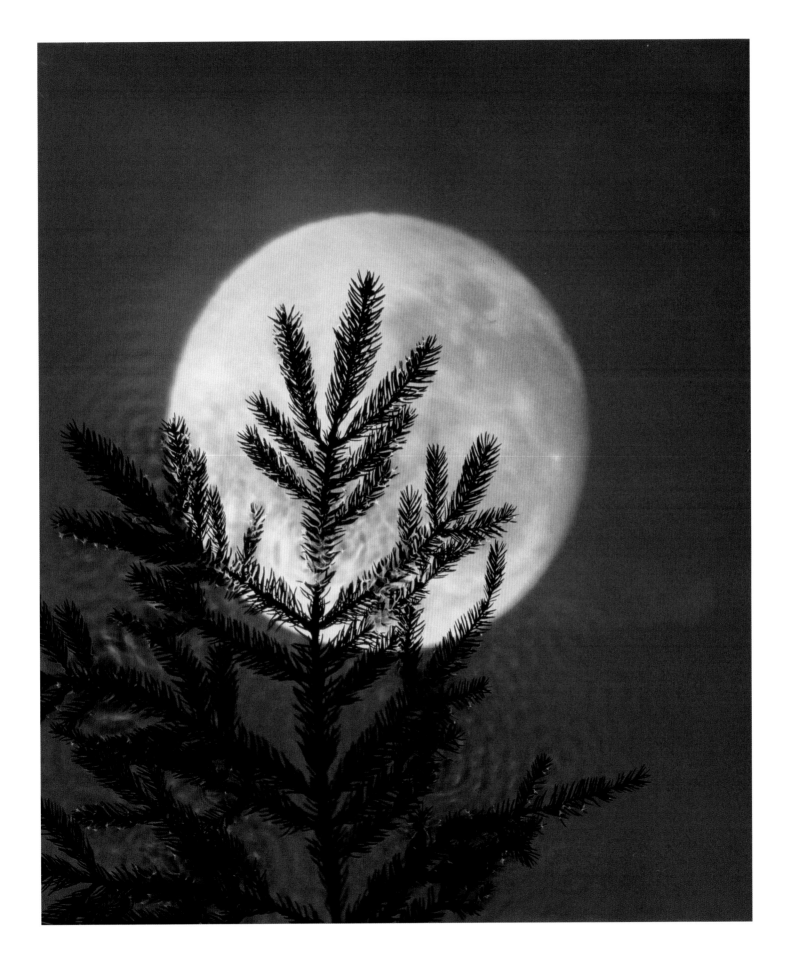

SEMICONDUCTOR

Semiconductor bring intangible data to human experience through sensory translation and physical embodiment, making manifest the world beyond our physical reach.

Semiconductor are British artists Ruth Jarman (born 1973) and Joe Gerhardt (born 1972) who, since 1997, have blended science, technology, philosophy and art to create large-scale installations derived from theoretical and abstract natural phenomena. Working with data sets, models and simulations, they create work that translates, amplifies and materializes the complexities of our world, from the invisible forces at the core of the earth to the immense energies at the edge of our universe.

Their works emerge from periods of intensive research, having collaborated with such notable institutions as the UC Berkeley Space Sciences Laboratory, the Charles Darwin Research Station in the Galápagos and CERN in Geneva. Immersed in the research, they utilize the tools of science to bring the intangible into the fields of human sensory perception. For example, data captured from the STEREO satellite tracking solar wind and coronal mass ejections[1] becomes *Black Rain* (2009), a large-scale projection revealing the artefacts and glitches of the image-capture technology while journeying past planets, stars and comets.

The imagery transports the viewer to outer space, though never quite leaving the interface of the technology. What is depicted is always mediated by the tools of observation. In *365 Days of Data* (2013), a series of carbon drawings represent environmental information collected over a year from instruments installed at the Alice Holt Research Forest.[2] Etched with a plotter, carbon-coated paper is scratched away to reveal the pattern of seasonal change.

Over time the ambition and scale of Semiconductor's works has increased. In *Earthworks* (2016), the processes of land formation are projected onto a vast screen as colourful layers of shifting seismic activity. This immersive installation combines analogue modelling and computer simulation[3] to reveal the shaping of landscapes over time through glacial, earthquake, volcanic and human activity. The data also feeds the synchronized soundtrack, revealing "the intricacies of the dynamics of our planet in motion".[4]

Following a three-month residency at CERN, Semiconductor created *Halo* (2018), a large-scale audiovisual installation that embodies the particle collisions produced within the ATLAS detector at CERN. The structure comprises a human-scale cylindrical form, inviting the viewer inside to physically experience the physics. The walls of the cylinder are made up of 384 strings, struck by hammers to "play" the data, which is simultaneously projected onto the surrounding walls.

Their work celebrates the conceptual and technical ingenuity of science, yet at the same time critiques the very tools of its discoveries. By giving voice to equations and sculpting with raw data, the subjective experience of scientific enquiry is highlighted. Semiconductor are interested in what can be learned through observation and data acquisition, but they are equally concerned with the barriers to knowledge, the language of science and how scientists operate in the space of unknowns. This meta-critique "observes the work of the observers, drawing attention to the ways in which science mediates our experiences of nature".[5]

ABOVE: Semiconductor, *365 Days of Data: water Vapour*, 2013. One of a series of four carbon drawings representing environmental data, made at the Alice Holt Research Forest, UK.

OPPOSITE: Semiconductor, *Halo*, 2018. This large-scale immersive artwork embodies the particle-collision data captured by the ATLAS experiment at CERN, Geneva.

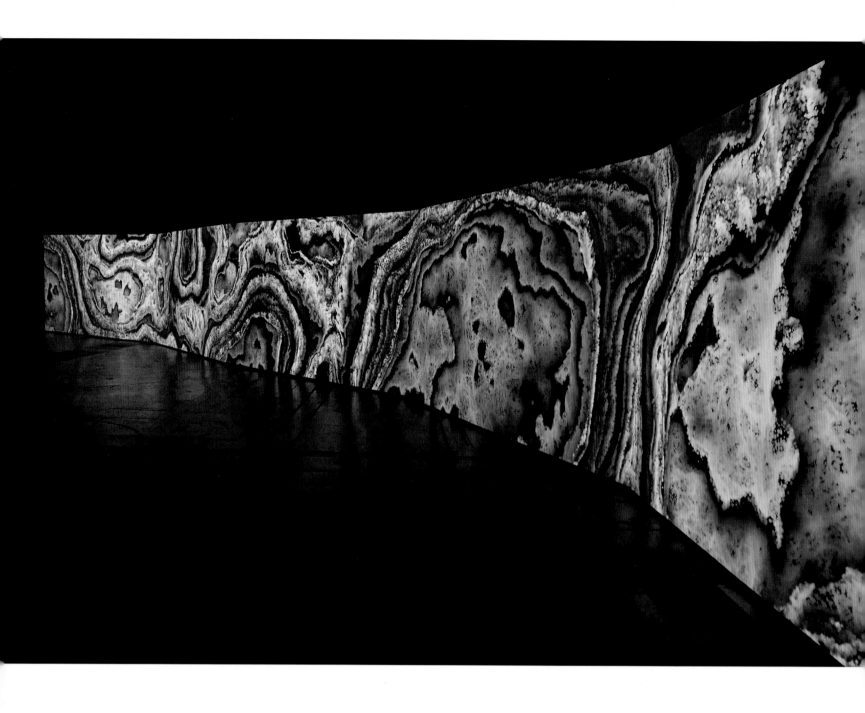

ABOVE: Semiconductor,
Earthworks, 2016. A
five-channel computer-
generated animation
with four-channel
surround sound,
transmitting seismic
data in synchronous
audiovisual simulation.

OPPOSITE: Semiconductor,
Black Rain, 2009.
Installation view at *Earth:
Art of a Changing World*,
Royal Academy, London.

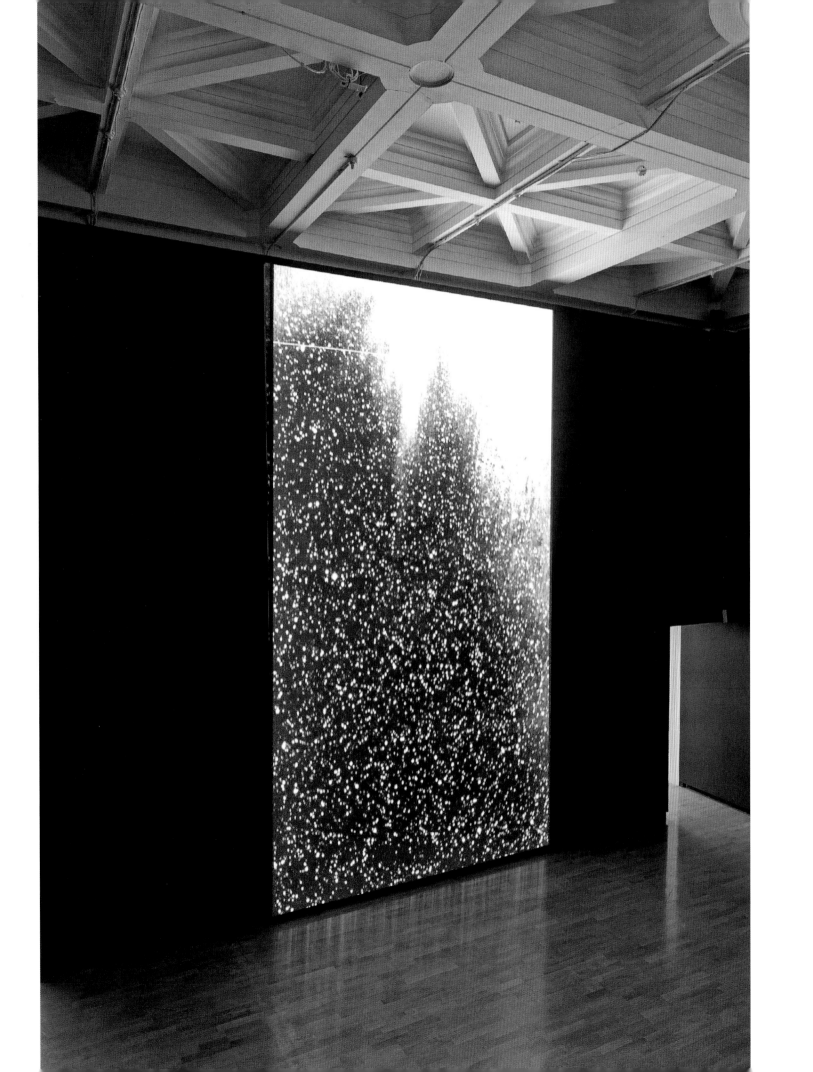

KATIE PATERSON

A contemporary multimedia artist, Katie Paterson's work explores our relationship to the big questions present within cosmology, geology and ecology.

Born in Glasgow in 1981, Paterson studied art in Edinburgh and London and has established an international reputation, with work in landmark exhibitions such as *Light Show* at Hayward Gallery (2013) and a retrospective at Turner Contemporary in Margate, UK (2019).

Her work explores media, scale and subject, drawing remote worlds closer to human experience. Combining the rigour of scientific fields with the poetic and rich visual language of the arts, her diverse practice investigates scales of time and space in myriad ways. Much of Paterson's work is a collective endeavour built on long-term relationships with astronomers, mathematicians and engineers.

In *Light bulb to Simulate Moonlight* (2008), Paterson worked with physicists and engineers to create a lightbulb emitting the spectral colour of moonlight. The full artwork comprises 289 identical bulbs, which collectively provide a lifetime's supply of moonlight (based on an average human life expectancy), a single bulb bathing the walls in a cool glow. In another work, *The Dying Star Letters*, begun in 2011, Paterson has sent a letter of condolence to Professor Richard Ellis at the Cahill Center for Astronomy and Astrophysics in California each time the death of a star is announced. This accumulative gesture translates remotely sensed data relating to events happening well beyond our reach to the personal human act of expressing sympathy.

Back down to Earth, time is manifest in *Fossil Necklace* (2013), a string of 170 spherical beads, each representing a different key event in the evolution of life told through geological time. Another earthbound work, *Future Library*, will only become fully manifest after the artist's own death. Between 2014 and 2114, contemporary writers are invited to contribute new works, one each year, to be printed only after a dedicated forest in Norway has grown sufficiently to resource the job in hand. The work as a whole blends pure concept with tangible materiality – the forest is growing, the writers are writing and a public library is waiting to house the texts.

Paterson has a great sensitivity towards balance: between simplicity and complexity of information; between macro and micro views of our world; between conceptual and material communication; and between that which is remotely and directly sensed. She is above all a great storyteller, translating the grand narratives which lie beyond easy comprehension to a relatable human scale: Beethoven's *Moonlight Sonata* bounced off the moon, playing on a solitary piano; a letter of condolence marking the death of a star; a future library holding literary secrets for an unknown readership. Her works connect these disparate scales with wonder, transforming the vastness of time and distance to something we can hold in our hand. And by holding it near, perhaps we may learn to appreciate and protect it.

OPPOSITE: Katie Paterson, *Light bulb to Simulate Moonlight*, 2008.

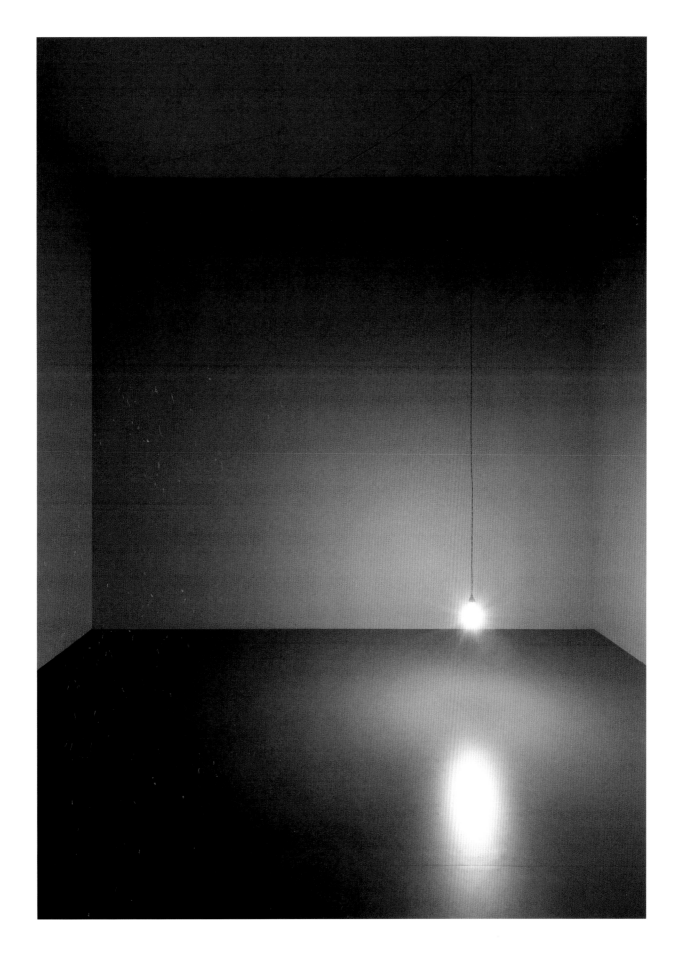

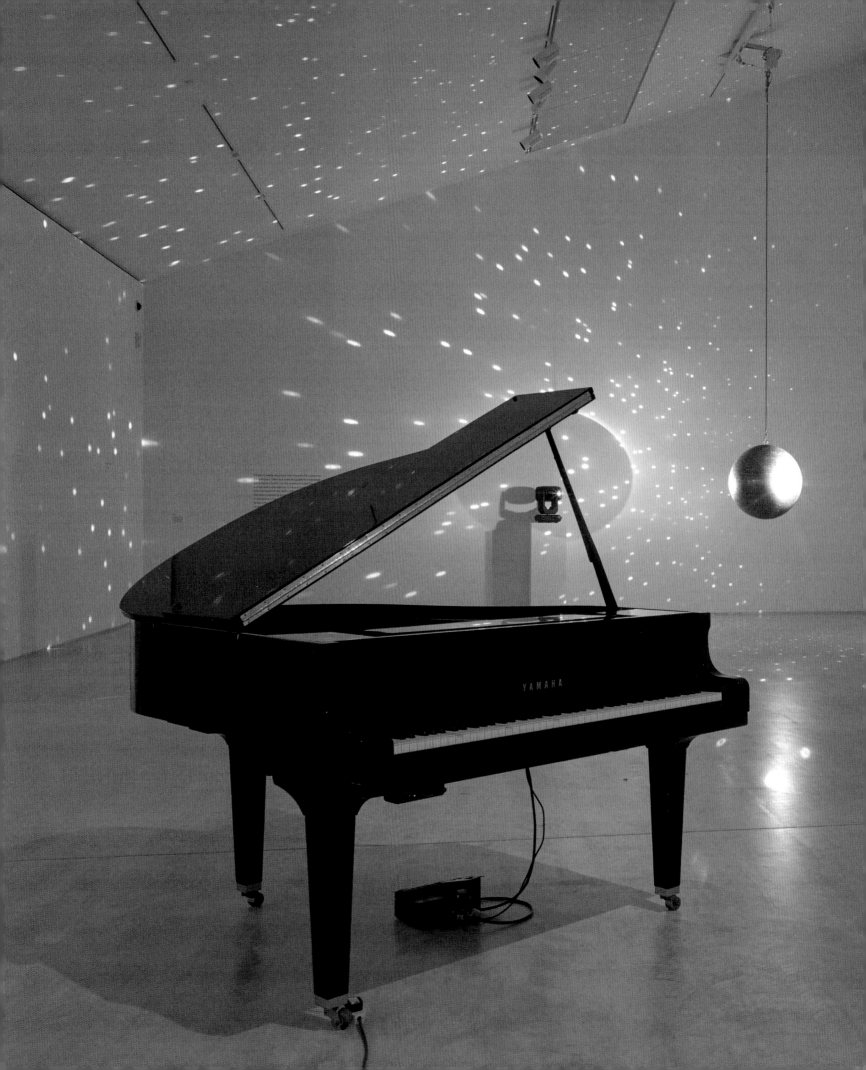

Lunar reflections

In the evocative *Earth-Moon-Earth* (2007), the musical score of Beethoven's Moonlight Sonata was translated into Morse code and transmitted to the Moon as a radio signal. The reflected information was received back on Earth and the score decoded, missing the notes lost in the shadows of the Moon's craters or bounced elsewhere into space. In exhibition, the viewer encounters a grand piano autonomously playing the returned score, with silences representing the lost information. The piece is accompanied by a print of the Morse code visualizing the information sent and the translation reflected back.

LEFT: Katie Paterson, *Earth-Moon-Earth*, 2007.

BEING
HUMAN

This section includes artists who place the human body at the centre of their work when exploring the connections between art and science. The artists presented here use the body (both their own and that of others), to interrogate, extend and explore the internal and external limits of the human form, including neuroscience and consciousness, personal and gender identity, and the relationship between the body and technology. Throughout their investigations, and through diverse media, these artists all point our attention towards the body as an "interface" between scientific, corporeal (bodily), and sensual forms of knowledge.

Leonardo da Vinci is the pre-eminent thinker of the Renaissance and extended our understanding of what it is to be human through his inventions, early automata, and meticulous observations of the human body through anatomical drawings. His influence on contemporary artists working across art and science is unquestioned. Leonardo's early work underpins this section, in which contemporary artists extend his legacy in their own work with the body.

The work of Stelarc asks us to consider the body as a malleable interface between technologies which extend the body, as well as the ways in which the body can be modified. He works across media, including extreme performance art. Stelarc highlights the body as a conscious, pain-experiencing entity; one which can be taken to extremes of endurance. Helen Chadwick uses the aesthetics and materiality of the body to raise socio-political and philosophical issues, such as questioning gender binaries, and the split between mind and body. She examines the binaries which frame our understanding of the body, such as seductive/repulsive, male/female, organic/man-made, and is unafraid to both repulse and seduce in placing the messy realities of the body centre stage. Helen Pynor works where life sciences and art meet, in turn raising philosophical questions about the line between life and death itself, and about where the body begins and ends.

In her work, Susan Aldworth looks primarily at neuroscience and uses a range of media, including installation, drawing, time-based media and printmaking. Through these varied modes of expression she asks us to rethink both the nature of consciousness as well as identity, using her background in philosophy as a way to approach such questions. In Aldworth's work, we are offered another way of viewing the mind/body split, based on her personal experience of undertaking brain scans, leading to a lengthy and highly subjective investigation into the relationship between the human brain and identity.

All of these artists ask us to look again at the human body and to rethink our assumptions about it. By using a range of artistic and scientific techniques – from neuroscience to performance art, prosthetics to photography – they lay bare what it is to be human, both now and, speculatively, in the future.

LEONARDO DA VINCI

Leonardo di ser Piero da Vinci (1452–1519) was born during the Italian Renaissance, a time of social and cultural change, and his observations, art and inventions have contributed to his becoming one of the most celebrated figures of his age.

Leonardo was apprenticed to the studio of Andrea del Verrocchio, where, over a period of years, he learned many techniques that informed his own work as an artist and designer. Florence was a culturally rich environment and the young Leonardo is likely to have met many artists in the course of his work at the Verrocchio studio. This was also a time when the church, aristocracy, merchants and financiers such as the Medici embraced and patronized new ways of thinking in the arts. Alberti's treatises on painting, sculpture and architecture were published in the latter half of the fifteenth century, although written earlier.[1] Leonardo went on to work in Milan, Bologna, Rome and Venice, eventually travelling to live in France, where he died.

At this time, there was a close relationship between mathematics, geometry, engineering, architecture and the arts, which is evidenced in the work of Leonardo over his lifetime as he made his own investigations and provided for the demands of his patrons. Although a limited number of his paintings survive today, these, together with his many drawings, reveal a journey of discovery that shares insights into the way the natural world works and the role of humanity within it.

In different collections of his drawings, we can witness the explorations he undertook, often through a process of analysis of what he was observing, his notes offering more detail of his investigations.[2]

An empirical approach through observation was novel at this time, and Leonardo embarked on detailed and forensic analyses recorded in drawings, the delicacy of which often belies the content, including dissections of the human body, drawings of plants and geological formations, among many other subjects. A desire to comprehend how the mind is structured is evident, while other drawings explore the many parts that compose the human form: the heart, a baby in a womb, blood vessels, musculature, and the different ways they interconnect.

Other drawings investigate what cannot be so easily seen, with images depicting the wave patterns formed by a flock of birds, and how they might be supported by ascending air. The quest for human flight eluded inventors of the day, in part through a lack of understanding of the physics involved. However, with insights gained through his observation of bird flight and other natural phenomena, and his understanding of the principles of engineering, which he applied in other designs that were successfully realized, Leonardo was able to conceive of mechanisms that could be adapted to this purpose.

Leonardo wrote about his observations relating to colour and light and we can see the principles he defined applied in his paintings.[3] He noted that with distance, objects become increasingly blue,[4] which we can see represented in the landscapes of his paintings. His use of subtle renderings of shadow, termed *sfumato*, impart a depth and

illumination to his figures, rendering them more lifelike and enhancing their pictorial presence. This invites the viewer to engage with these figures and to empathize with the intimacy of the scene portrayed.

Perhaps the most iconic of Leonardo's paintings resides now in the Louvre in Paris: *Mona Lisa – Portrait of Lisa Gherardini*. The enigmatic gaze of the sitter looks out at us as we are encouraged to wonder at the lives of both the observed and the observer.

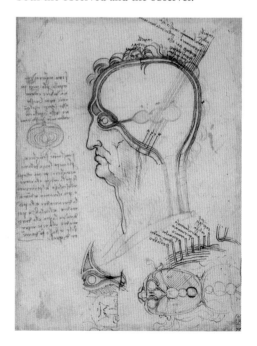

ABOVE: Leonardo da Vinci, *The layers of the scalp, and the cerebral ventricles*, c.1490–92. Red chalk, pen and ink on paper.

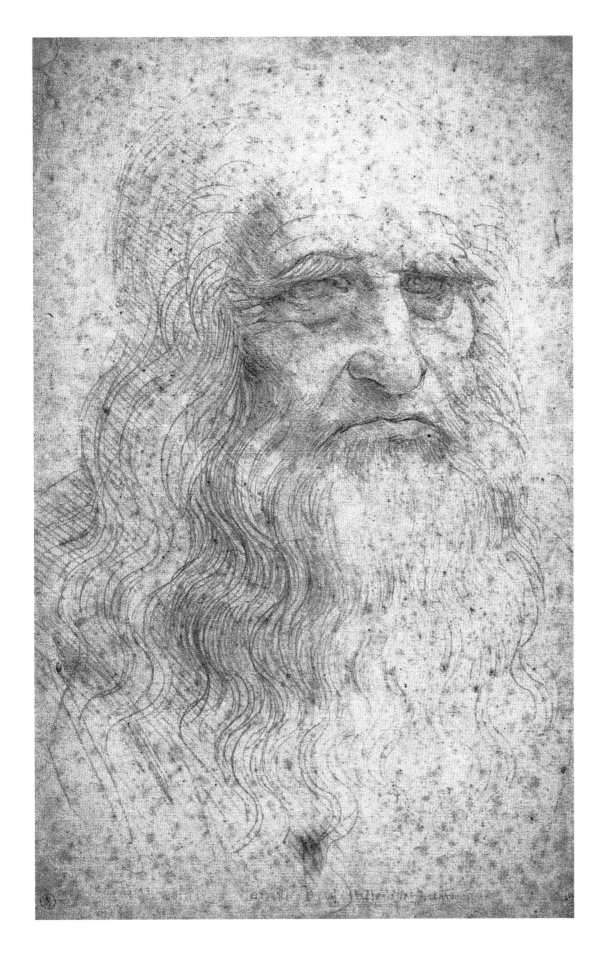

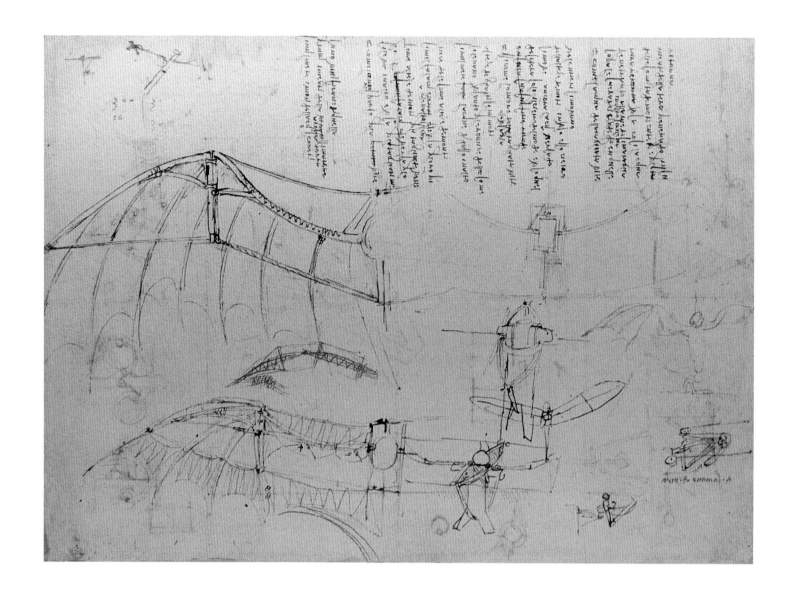

ABOVE: Leonardo
da Vinci, *Design for
a Flying Machine*,
c.1488. Codex
Atlanticus III, red chalk
and ink on paper.

OPPOSITE: Leonardo
da Vinci, *Portrait of
Lisa Gherardini*, , also
known as the *Mona
Lisa*, c.1503–19. Oil
paint on poplar wood.

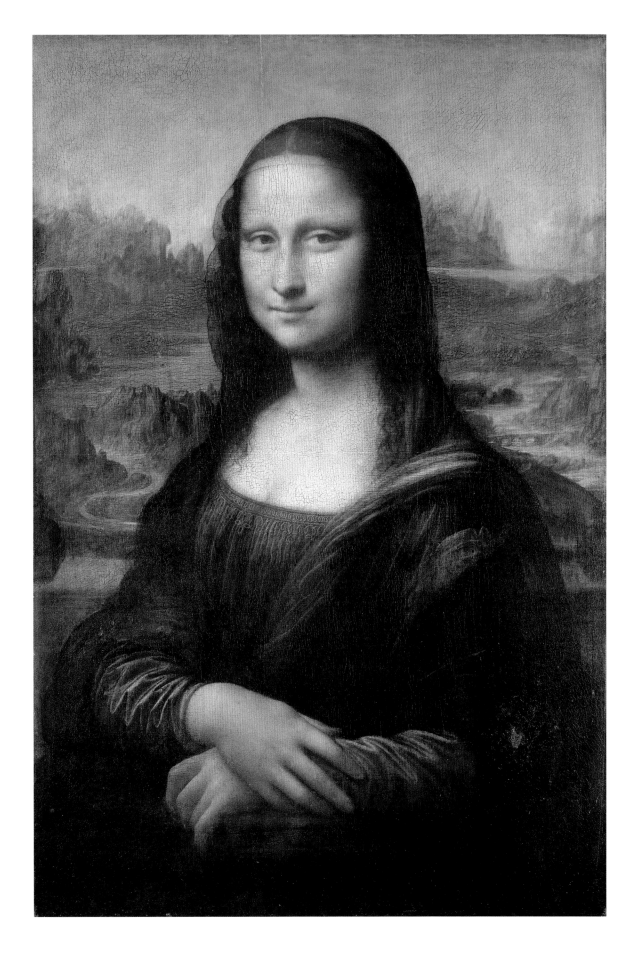

JOHANNES VERMEER

An instant. A moment in time, captured in the paintings of Johannes Vermeer (1632–75), which depict people within a landscape or at home, doing things we might do today: reading a letter, playing an instrument, pouring milk, engaging with each other. Yet these exquisitely wrought images are the product of hours of intense observation and the gradual building of layers of paint upon a canvas.

They are the result of a many-layered process that begins with the carefully constructed composition of the scene to be depicted, the preparation of the painting support and materials with which to paint it, and the act of looking intently and dexterously translating that experience through drawing and painting.

Looking at the completed painting, we are privileged to witness what the artist intended we should see, and in a way that is almost photographic. We are transported across the centuries to that moment in time Vermeer wished to preserve, a representation of all those moments we can still experience and share in our lives today. Yet there is a paradox, for to capture these moments the artist had to spend a good part of his creative life composing and rendering them, a process undertaken over a considerable period of time.

Vermeer was working at a time of advancement in knowledge of the world through travel (maps appear in several Vermeer paintings) and technological invention. This includes inventions with optics. The telescope had already been developed by Galileo Galilei

(1564–1642) and others, revealing previously unseen astronomical details, and now the world of the microscopic could be seen through the work of Robert Hooke (1635–1703), author of *Micrographia* (1665), and the microscopist Anton van Leeuwenhoek (1632–1723).[1]

It has been proposed that one invention likely to have captured the imagination of Vermeer was the camera obscura, a device that focuses the rays of light from a given view through a small hole or lens onto a surface beyond, rendering an image of reduced size that can be closely observed.[2]

Careful viewing of the painting *The Music Lesson* (1662–65) offers insights into how Vermeer constructed the picture's composition. Intriguing clues are also just observable in the mirror's reflection of the painter's location in relation to the scene being observed. He would have sat at an easel to make direct observation, and there is also the suggestion that a boxed optical device might also be depicted.

The evidence for how the paintings were composed is in part derived from what we can observe in them, and although we can

just see small pinholes at the vanishing points in some of Vermeer's paintings, this does not preclude the possibility that optical devices were also used by the artist. The images speak to us over the centuries of the experience of looking and recording what can be seen using paint on canvas. There is a poetry to viewing the light captured by Vermeer in his paintings in the light with which we see them today. They are remarkable testaments to the powers of human observation and are images that can transport us in time, the carefully constructed "instants" that they capture each rewarding contemplation over time for those who view them.

OPPOSITE: Johannes Vermeer, *View of Delft*, c.1660–61. Oil on canvas.

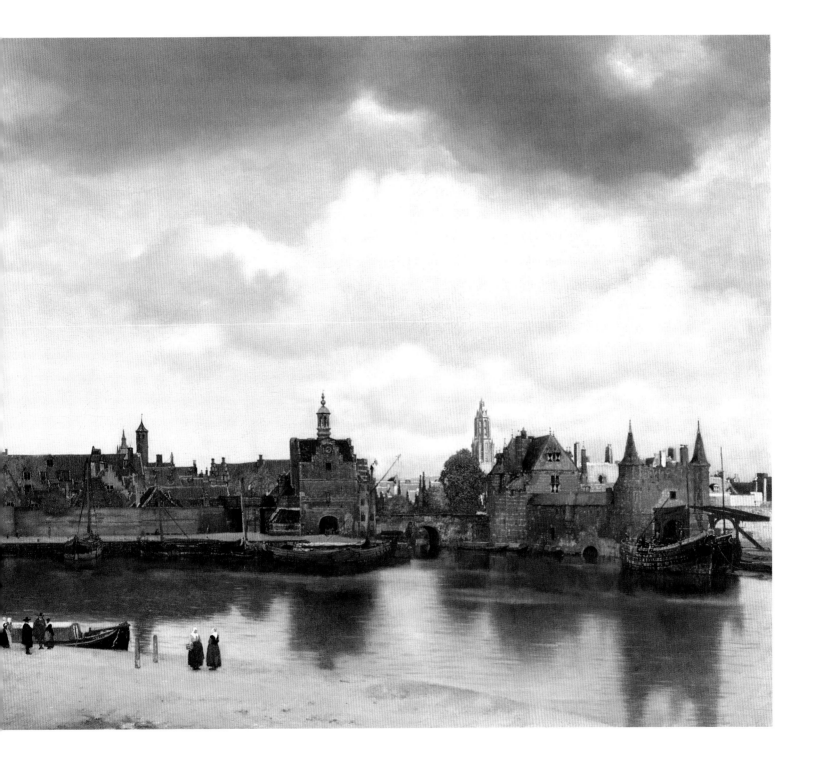

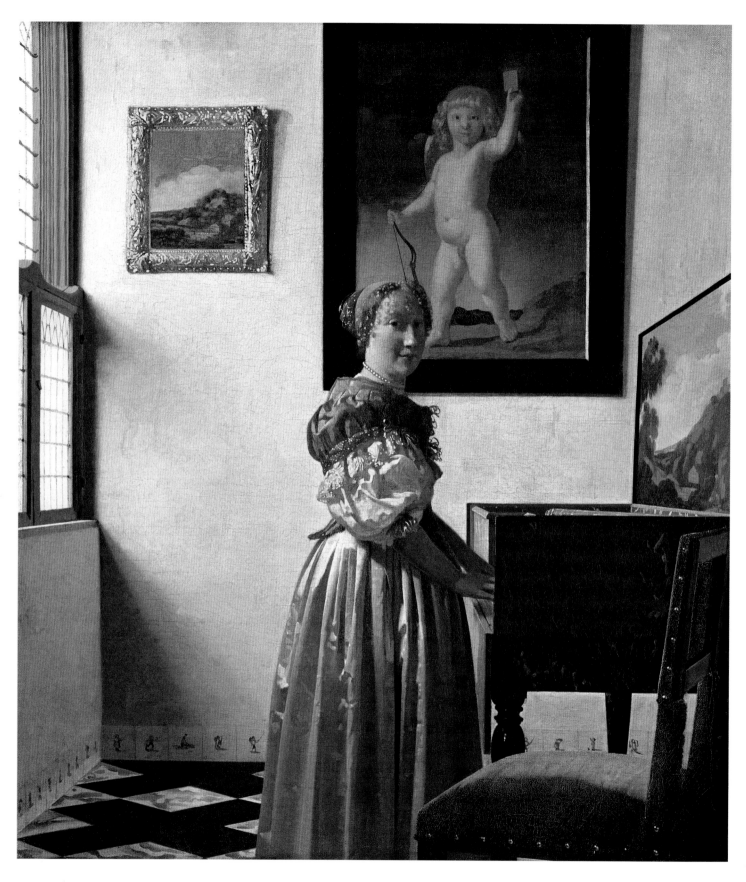

ABOVE: Johannes Vermeer, *A Young Woman Standing at a Virginal*, c.1670–72. Oil on canvas.

OPPOSITE: Johannes Vermeer, *The Art of Painting*, 1666–68. Oil on canvas.

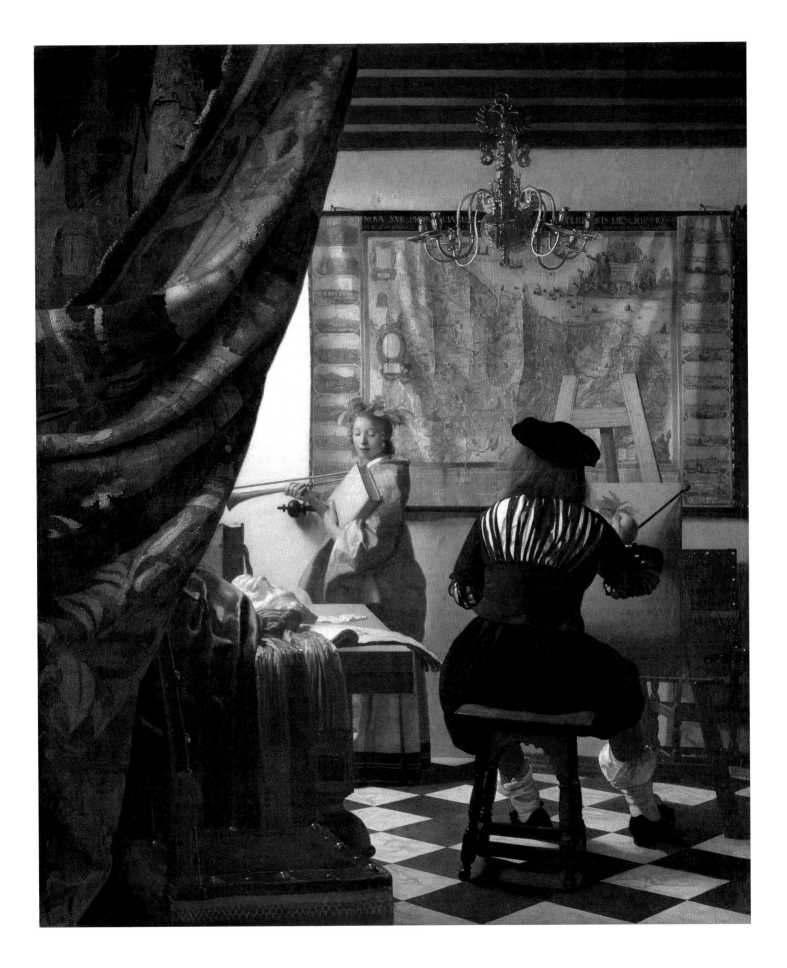

JOHANNES VERMEER

RIGHT: Johann Zahn, *Oculus Artificialis*, designs of portable camera obscura, 1685–86.

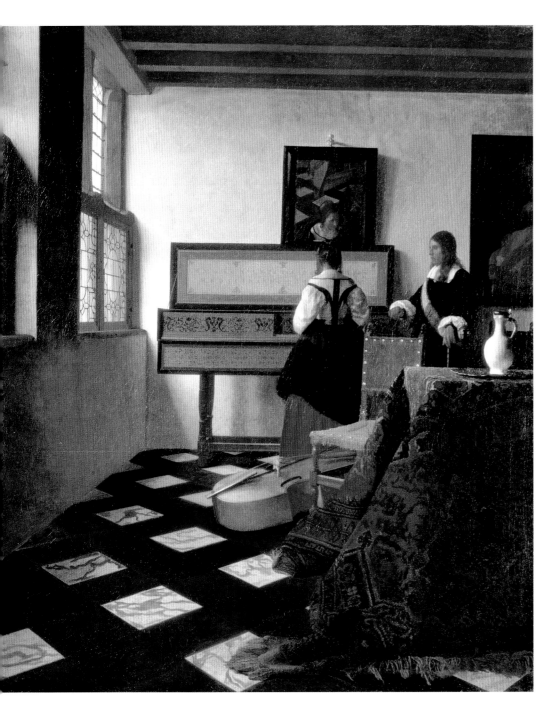

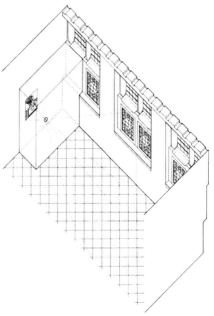

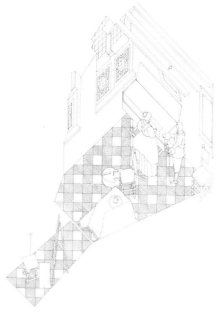

ABOVE LEFT: Johannes
Vermeer, *The Music
Lesson*, c.1662–65.
Oil on canvas.

ABOVE: Projection of
space within Vermeer's
The Music Lesson,
including the part visible
in the mirror.

STELARC

Stelarc is a performance artist whose work explores the relationships between the human body, technology and science. In doing so, his own body becomes an interface.

Born in Cyprus (1946) but raised in Australia, Stelarc creates work to explore the question of what the body can "be", rather than what it is. Using various technologies and processes, he places his own body under stress and adds to its capabilities through robotic extensions and implants. In doing so, Stelarc extends our understanding of the human body, pointing out its vulnerability and its malleability but also its increasing obsolescence. He shares themes and concerns with the artist Doreen Garner, who also uses the body as a site of critical inquiry.[1] Part of his method is undertaking extreme performance art, in which he uses his own body as the medium.[2] Through such physical difficulty, he often pushes his body to the limit, collapsing the relationship between the mind and the body and thus closing the usual distinction between the two. For instance, starting in the 1970s and 1980s, he undertook a series of performance pieces consisting of suspending his body from hooks. Of this work, Stelarc has said: "The suspensions were a body sculpture installed in a space of other objects. The stretched skin is a kind of gravitational landscape … suspended and in stress the anonymous body realises its obsolescence."[3]

Stelarc describes his work as visually probing and acoustically extending the body, intimately reconfiguring it, using available technologies. Since this earlier performance-based work, he has continued to explore the limits of the "natural" body by augmenting it in various mechanical and biological ways, including implanting various kinds of sensors and adding robotic extensions, extra arms and ears – as in the work *An Extra Ear: Ear on Arm* (2011).[4] The cell-grown prosthesis has been growing on Stelarc's own arm since 2006, and includes a microphone and proposed Internet connection in a long-term performance, which involves hacking his own body. In *Third Hand*, completed in 1980 and used in performances between 1980 and 1998, a prosthetic arm is constructed from various materials, including stainless steel, aluminium and acrylic. It allows 11 degrees of rotation, and can be manipulated via four switches, which allow it to be programmed.

Re-wired/Re-mixed: Event for Dismembered Body (2015) is a performance that involved disrupting the stable identity of the body through time and space. For five to six hours a day, under noise-cancelling headphones and a video headset, Stelarc allowed his body to be wired and surveilled in such a way that both his sight and his hearing were overtaken. People in remote locations (New York/London), provided the "eyes" and "ears". In addition, the eight-degrees-of-freedom exoskeleton meant that anyone with an Internet connection and the relevant interface could control Stelarc's arm, remotely. These involuntary movements of his arm rendered his normal control over his own body obsolete. In the gallery, a touchscreen interface allowed viewers to experience what Stelarc himself was seeing and hearing as the performance took place. The piece electronically dismembered the body, and in doing so pointed out the lack of stable identity and control we have over our bodies in the present time.

These extensions of the body create different examples of human-machine hybrid interfaces, causing us to rethink our bodies as solely biological entities. In a time when technologies now enable the usual limits of both body and mind to be routinely transgressed and augmented, Stelarc's work takes a critical position on where the body ends and technology starts. In doing so, he is constantly pushing us to question our relationship with both, and at the same time questioning what it is to be human.

OPPOSITE: Stelarc, *Ear on Arm*, 2006–present.

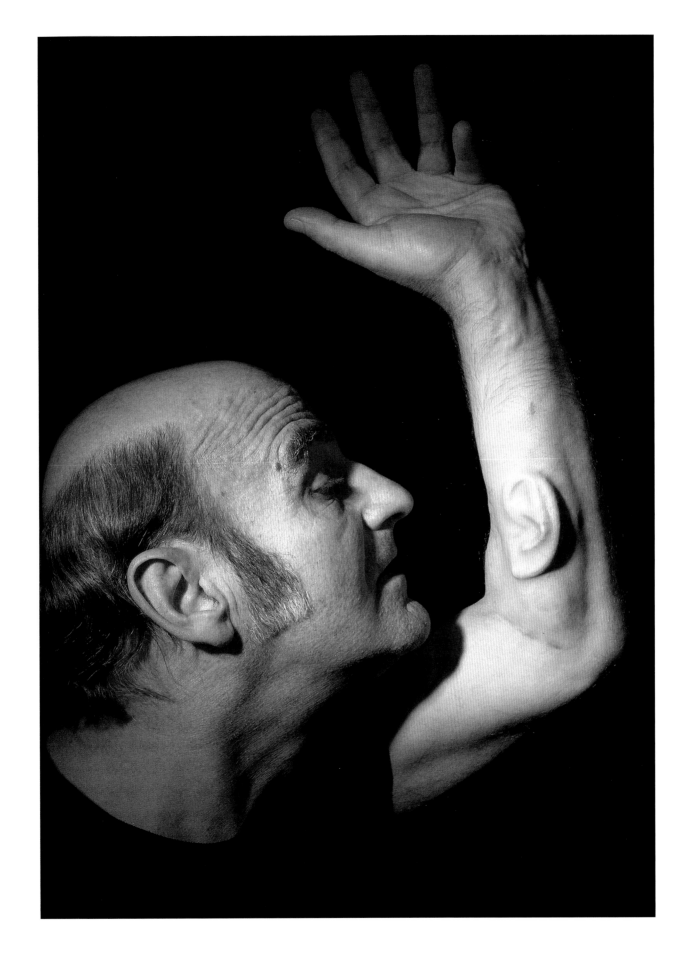

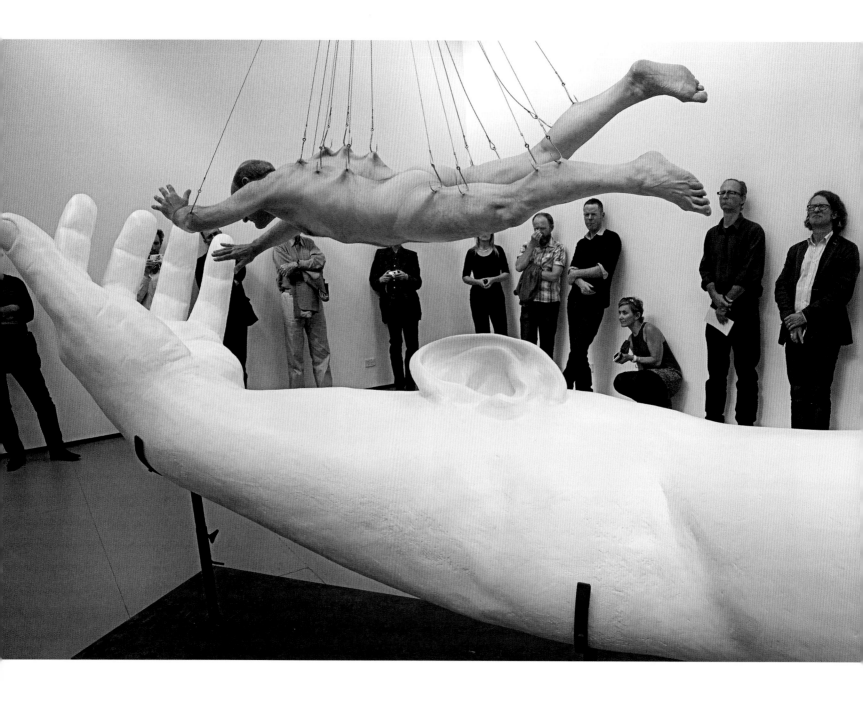

ABOVE: Stelarc, *Ear on Arm Suspension*, 2012. Performance undertaken in Armadale, Australia.

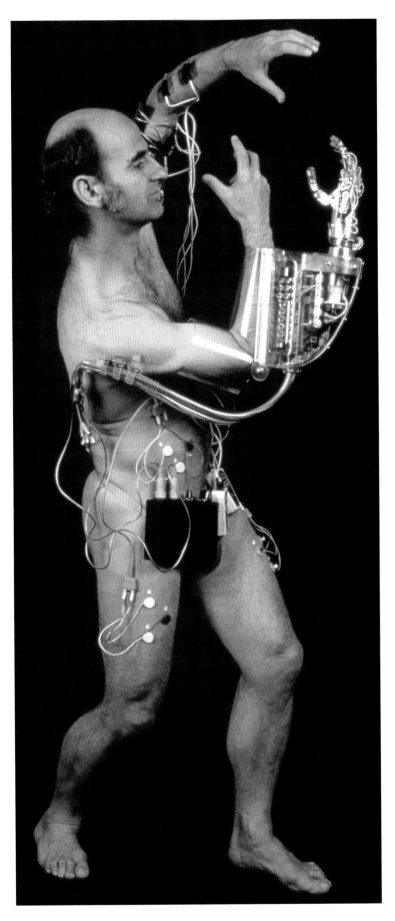

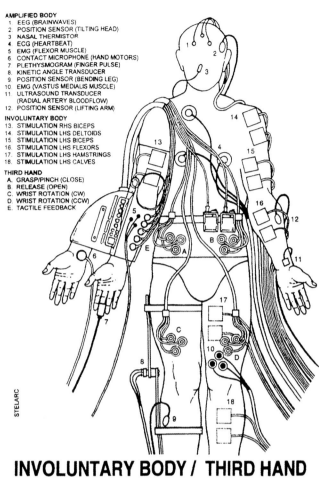

STELARC

AMPLIFIED BODY
1. EEG (BRAINWAVES)
2. POSITION SENSOR (TILTING HEAD)
3. NASAL THERMISTOR
4. ECG (HEARTBEAT)
5. EMG (FLEXOR MUSCLE)
6. CONTACT MICROPHONE (HAND MOTORS)
7. PLETHYSMOGRAM (FINGER PULSE)
8. KINETIC ANGLE TRANSDUCER
9. POSITION SENSOR (BENDING LEG)
10. EMG (VASTUS MEDIALIS MUSCLE)
11. ULTRASOUND TRANSDUCER
 (RADIAL ARTERY BLOODFLOW)
12. POSITION SENSOR (LIFTING ARM)

INVOLUNTARY BODY
13. STIMULATION RHS BICEPS
14. STIMULATION LHS DELTOIDS
15. STIMULATION LHS BICEPS
16. STIMULATION LHS FLEXORS
17. STIMULATION LHS HAMSTRINGS
18. STIMULATION LHS CALVES

THIRD HAND
A. GRASP/PINCH (CLOSE)
B. RELEASE (OPEN)
C. WRIST ROTATION (CW)
D. WRIST ROTATION (CCW)
E. TACTILE FEEDBACK

INVOLUNTARY BODY / THIRD HAND

LEFT & ABOVE: Stelarc, *Third Hand*, completed 1980, used in performances between 1980 and 1988.

HELEN CHADWICK

Treading a fine line between seduction and repulsion,
Helen Chadwick's work wrangles with the complexities (and
contradictions) of the human condition.

Chadwick (1953–1996) was a British artist known for her unconventional use of materials to explore the vulnerabilities of the flesh in visceral and poetic form. From her earliest works in the mid-1970s, Chadwick used her body as the material to challenge stereotypical gender representation and assert feminist critique. Combining photography, sculpture and performance, she took an embodied position, questioning binary distinctions between male/female, interior/exterior and mind/body. Her works were personal and political, testing the boundaries of aesthetic sensibility and bodily matter. Material explorations include chocolate, flesh, composting waste, entrails and silk, operating in mutual dialogue with the body and mediated through a range of imaging technologies.

Seen as a forerunner to the YBA (Young British Artists) movement, Chadwick grew to prominence through the 1980s and 1990s, influencing a whole generation of artists through her creative practice, energizing the Beck Road artist community in East London,[1] and as a teacher working across several London art schools.[2] In 1987, Chadwick was the first woman to be nominated for the Turner Prize.

Often irreverent, her series of bronze casts, *Piss Flowers* (1991–92), emerged from a throwaway comment made while on an artist-in-residence programme in Canada. During the stay, Chadwick and her partner, David Notarius, urinated in the snow and cast the melted cavities, observing the differences in flow between male and female trajectories. The works, cast in bronze and upended to form a meadow of flower-like structures, represent a physical and transitory interaction between body and land.

As her enquiry into the body's boundaries penetrated deeper, she included the use of medical imaging techniques in her repertoire. In *Viral Landscapes* (1988–89), she overlaid microscope images of her own cells onto panoramic photographs of coastal landscapes. Cell structures and rock formations, waves and mucus membrane, merge at the point where the bodies of land and water meet.

This shift in scale is also evident in *Unnatural Selection* (1996), work resulting from an embedded residency in the Assisted Conception Unit at King's College Hospital, London. Here, the delicate subject of human fertility is treated sensitively through the creation of enlarged structures depicting micrographs of human embryos alongside other images of natural forms. The works, resembling items of jewellery – a brooch, a necklace, a ring – present the fragility of potential life writ large.

This was her last work. Chadwick's artistic career came to an abrupt end in 1996 when she died from sudden heart failure at the age of 42, possibly caused by a viral infection. Her contribution has been recognized through posthumous exhibitions and publications and her legacy of the exploration of body and medicine in her art lives on.

Visceral confrontation

In *Self-Portrait* (1991), Chadwick confronts our morbid sensibilities and the notion of self as distinct. The work, a large photographic transparency mounted on glass and lit from behind, depicts the artist cradling a human brain in her hands, set against a backdrop of folded cloth, part of the Meat Lamps series.

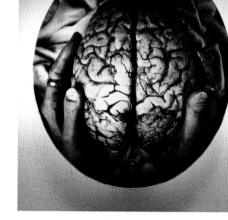

RIGHT: Helen Chadwick, *Self-Portrait*, 1991. Cibachrome transparency, glass, aluminium frame, electrical apparatus.

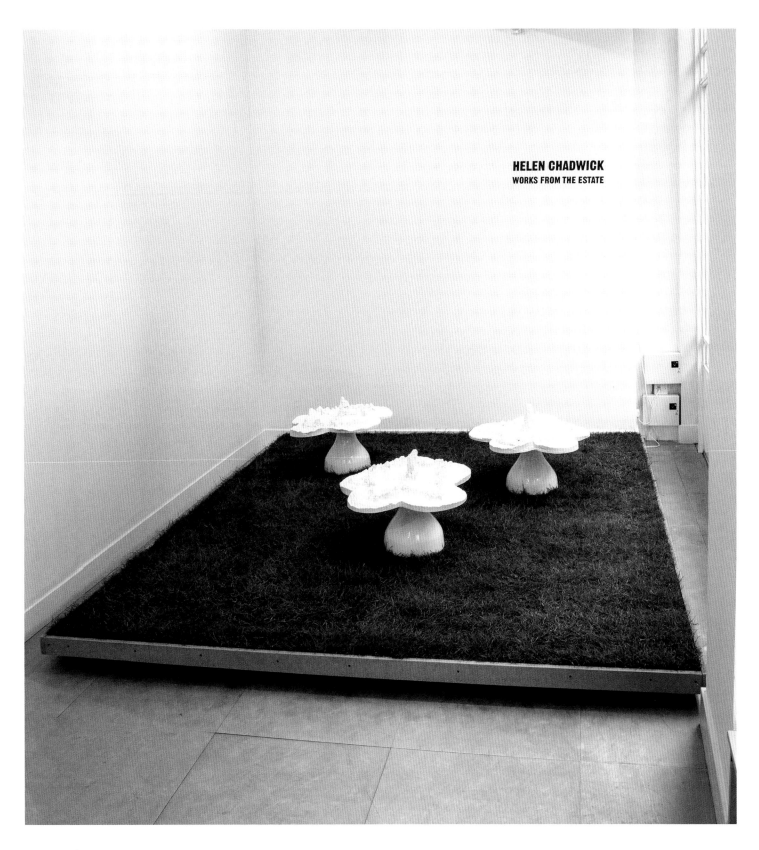

HELEN CHADWICK
WORKS FROM THE ESTATE

ABOVE: Helen
Chadwick, *Piss
Flowers*, 1991–92.
Bronze, cellulose
lacquer.

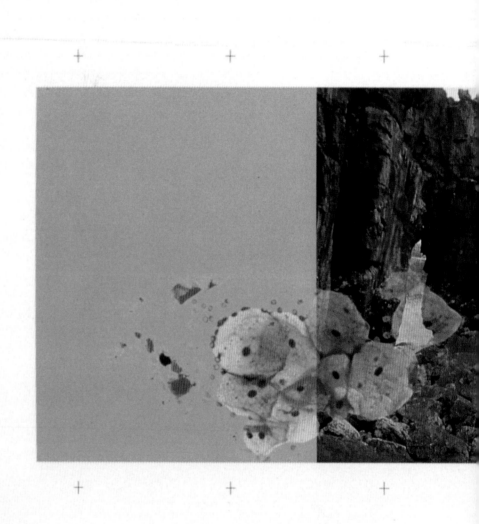

RIGHT: Helen Chadwick,
Viral Landscape No.1,
1988–89. C-print
photograph, powder-
coated steel, aluminium-
faced plywood, Perspex.

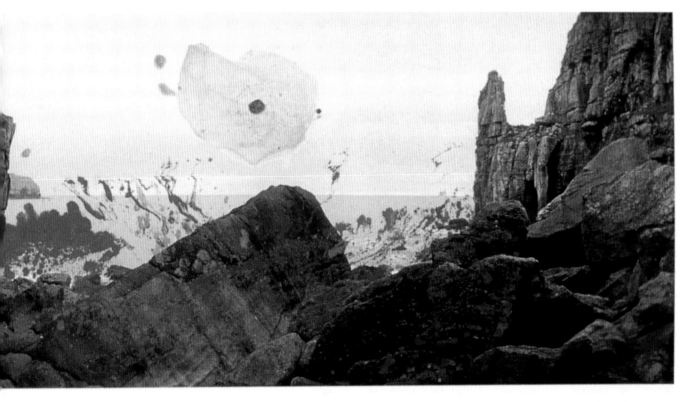

13-MAY-88 11:47

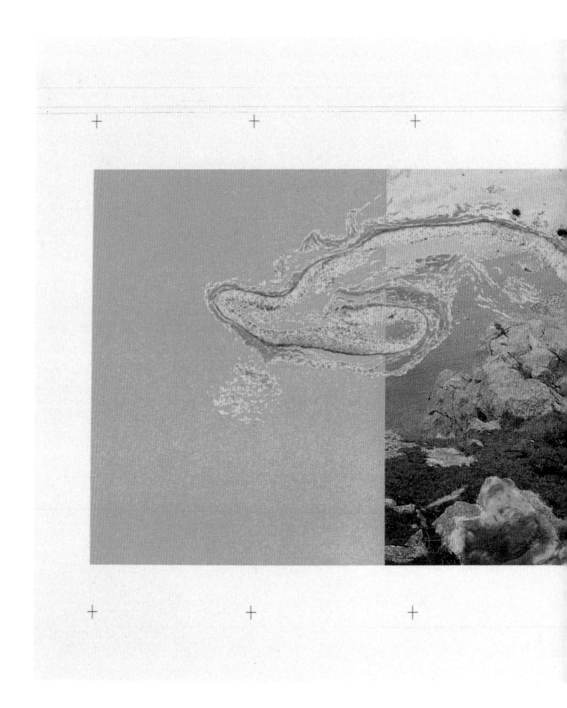

RIGHT: Helen Chadwick,
*Viral Landscape No.
2.* 1988–89. C-print
photograph, powder-
coated steel, aluminium-
faced plywood, Perspex.

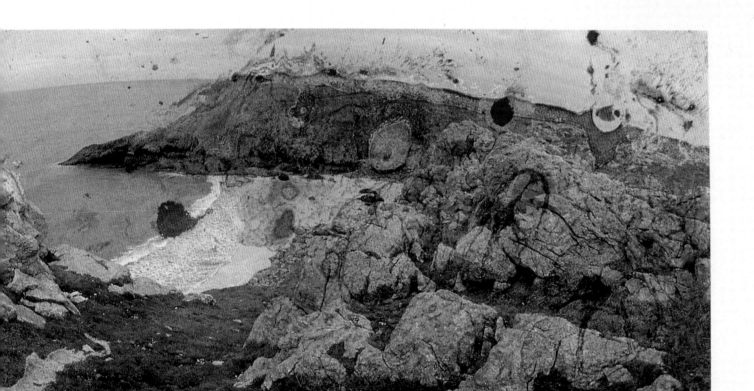

5-AUG-88 16:34

SUSAN ALDWORTH

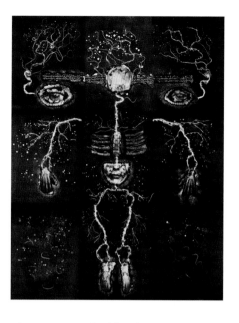

Susan Aldworth (born 1955) is an experimental printmaker and filmmaker whose work references both neuroscience and philosophy. At the heart of her art is an exploration of the fragility of human identity and the nature of consciousness.

Born in Epsom, Surrey, she studied philosophy at Nottingham University and printmaking at Sir John Cass.

An accident in 1999 led her to finding an even closer relationship between philosophy and her artwork. "During a diagnostic brain scan, I found myself lying on a hospital bed watching the anatomical workings of my brain real time on a monitor. It was a seminal moment. I was watching myself think, the mind/body problem playing out in front of my eyes."[1] The experience of observing her brain live on the monitor triggered an ongoing fascination with the relationship between the physical brain and the sense of self. Since then, Aldworth has collaborated with doctors, neuroscientists and neuropsychologists, observing numerous brain scans and undergoing research brain scans herself to try to make sense of the material basis of personality.

In parallel with these investigations, she has experimented with etching techniques in collaboration with master etcher Nigel Oxley and developed a radical method whose chemical processes are analogous to those in the brain.[2]

Much of the scientific understanding of the mind, including a sense of self, identity and personality, involves the study of particular mental disorders. Aldworth's intention as an artist, which is often led by the methodology of scientists, is to explore mental disorders as a way of understanding the mind.

Her work is rooted in individual human experiences, by talking to people who can describe what it feels like to live with a condition like epilepsy or schizophrenia. Her art does not illustrate science, but rather incorporates the anatomical imagery of contemporary neuroscience, providing her with a visual link between the external surface of the body and the subjective experience of being that person.

The Portrait Anatomised (2012) consists of a series of portraits of three people with epilepsy, whom Aldworth met while she was artist-in-residence at St Thomas' Hospital, London. Each of the portraits is made up of nine different prints, which tile together, acting as building blocks for the person. The first portrait was of a young policewoman called Elizabeth who was desperately worried about having children, because of the medication for her epilepsy. The portrait reveals her outer surface but also delves into her internal landscape and her psychology and personality.

Each of the 20 pictures in *Cogito Ergo Sum* (2006) is a frame from a functional magnetic resonance imaging (fMRI) scan – fMRI measures brain activity by detecting changes associated with blood flow. The brain-scan sequence is blown up to 2.5 m (8¼ ft) to put it in an artistic, rather than medical, context. Aldworth explains, "In the work I show an imagination at work; what a scan might look like if it really could visualize what is going on in your mind."[3]

The Brainscape series of etchings explore the relationship between the physical brain and our sense of self and are printed in a rich blue pigment. They are reminiscent of the pioneering cyanotypes of Anna Atkins (1799–1871), but these works are about consciousness, not botany, articulating the subjective experience of being conscious while simultaneously visualizing its objective physical generation: "I let the white of the paper shine back through a confusion of cerebral arteries as a visual equivalence of consciousness."[4]

The *Reassembling the Self* exhibition first took place at the Hatton Gallery and Vane, Newcastle in 2012, and centred on the condition of schizophrenia with the aim of addressing the stigma that surrounds it, with a view to giving the narratives of the condition a public voice. For the exhibition, Aldworth produced a suite of lithographs which she regarded as portraits of schizophrenia itself– reassembled body parts in a series of impossible anatomies intended to make the audience feel uncomfortable and question the fragility of their own identity. The exhibition also included paintings and drawings by two artists with a schizophrenia diagnosis.

In her 2017 exhibition *The Dark Self*, Aldworth continued her exploration of the nature of consciousness by challenging us to reflect upon our nightly transitions from consciousness to oblivion.

ABOVE: Susan Aldworth, *The Portrait Anatomised – Elizabeth*, 2013. Monotype with chine-collé.

RIGHT: Susan Aldworth, *Cogito Ergo Sum 3*, 2006. Giclée prints.

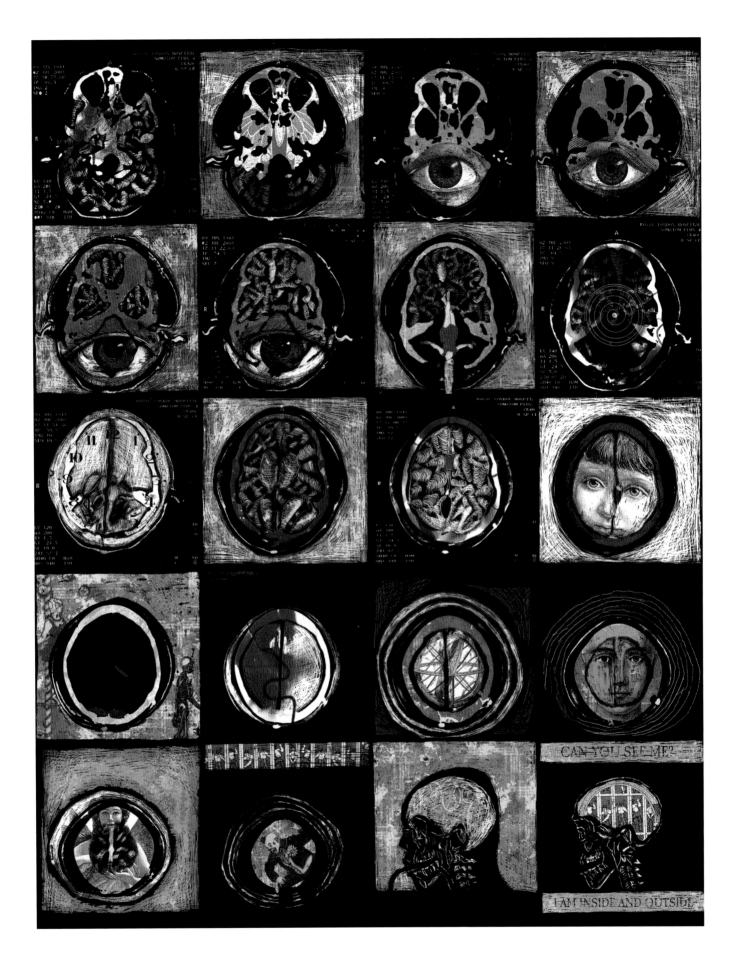

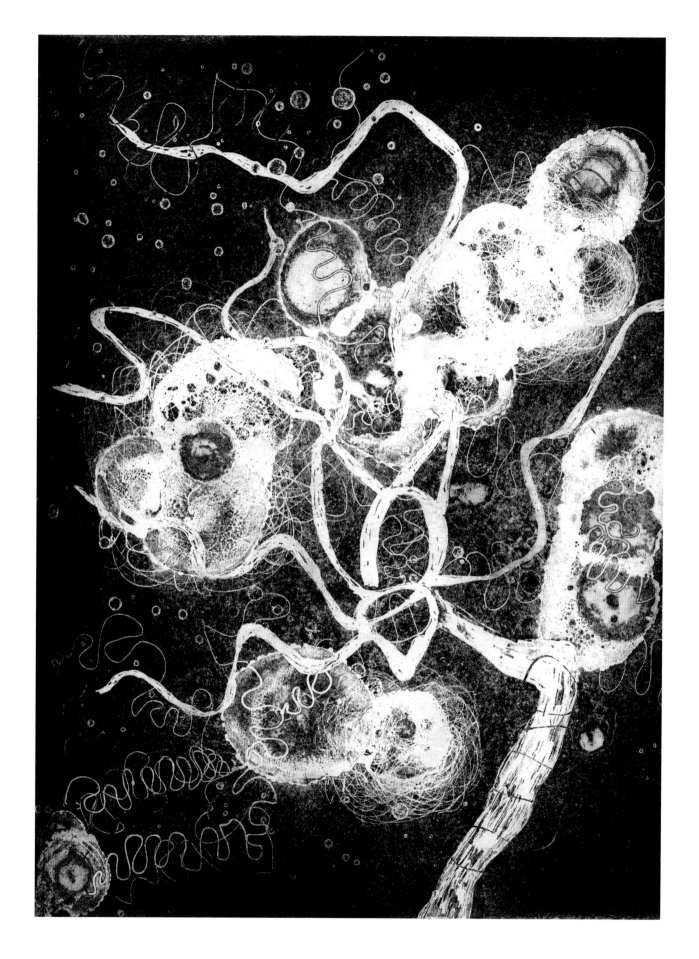

OPPOSITE: Susan Aldworth, *Brainscape 21*, 2005. Etching and aquatint.

RIGHT: Susan Aldworth, *Reassembling the Self 1*, 2012. Lithograph.

HELEN PYNOR

Helen Pynor (born 1964) is a visual artist working at the intersections of art and the life sciences. Her primary concern is with philosophically ambiguous zones such as the life–death boundary, the inter-subjective nature of processes such as organ transplantation, and the animate–inanimate boundary in relation to prosthetics. She works across a range of media, including sculpture, photography, installation, video, media art, performance, wet biology and microscopy.

Helen Pynor went to art college after initially training as a scientist in cell and molecular biology.[1] Experimentation and engagement with biological specimens are essential to her research, and they are sometimes undertaken in extreme conditions, such as heart-transplant operating theatres or abattoir killing floors, and at other times in the environments of scientific laboratories, such as residencies in scientific institutions, including the Max Planck Institute of Molecular Cell Biology and Genetics in Dresden.

Pain, illness and its relationship with the human body are represented in her Red Sea Blue Water series, a collection of photographs of floating and blurred organs. In the work *Head Ache* (2007) from the series, Pynor offers a metaphor for the combination of biological, historical and cultural processes that support the human organism.[2]

Spanning various disciplines, including medicine, science and philosophy, *The Body is a Big Place* (2013) was a collaborative installation by Helen Pynor and Peta Clancy,[3] which re-enacted certain defining aspects of the human heart-transplant process, including the reality that parts of the human body may traverse vast geographic, temporal and interpersonal distances during the transplantation processes. In a series of live performances, a heart perfusion device was used to reanimate a pair of fresh pig hearts. This return to a beating state revealed the process of death as an extended durational moment, rather than an event that occurs in a single moment in time. Pynor said of the work, "Rather than sensationalizing these performative events, we sought to encourage empathic responses from viewers, appealing to their somatic senses and fostering their identification with the hearts they were watching."[4]

Fallen (2017) forms part of an extended exploration into the ambiguity of life's beginnings and endings in the context of chickens raised for human food consumption.[5] The embryos depicted in this series are contained within the tenuous safety of their amniotic sacs, or fall unfettered through space, entangling in ruptured and torn remnants.

In 2017, Pynor was based in the lab of Dr Iris Salecker, a Crick Institute scientist studying the development of the visual circuit in *Drosophila melanogaster* (the common fruit fly), shadowing the experimental work of the lab and engaging in dialogues with scientists. Out of these experiences, Pynor developed visual and material responses that focused on aspects of the lab's work that most intrigued her. *Random Precision. Countless Intimate Acts* (2017) was one of the responses, which consisted of layered opaque, translucent and transparent photographic images suspended from the ceiling, depicting literal and metaphorical aspects of fly metamorphosis.

The thin animate–inanimate boundary in relation to prosthetics is carefully explored in *Habitation* (2019), a project prompted by the hip replacement surgery Pynor required in 2019 because of a congenital hip abnormality. Navigating medical prohibitions, she gained permission to retain the bone material removed from her body during surgery, thereby raising important questions about ownership and personal agency over living tissues excised from the body. She is using the bone material to create a series of bone china objects, transforming her own biohazardous waste into something precious and resonant with meaning.

OPPOSITE: Helen Pynor, *Head Ache* (detail), 2008. C-type photograph on Duratran, face-mounted on glass.

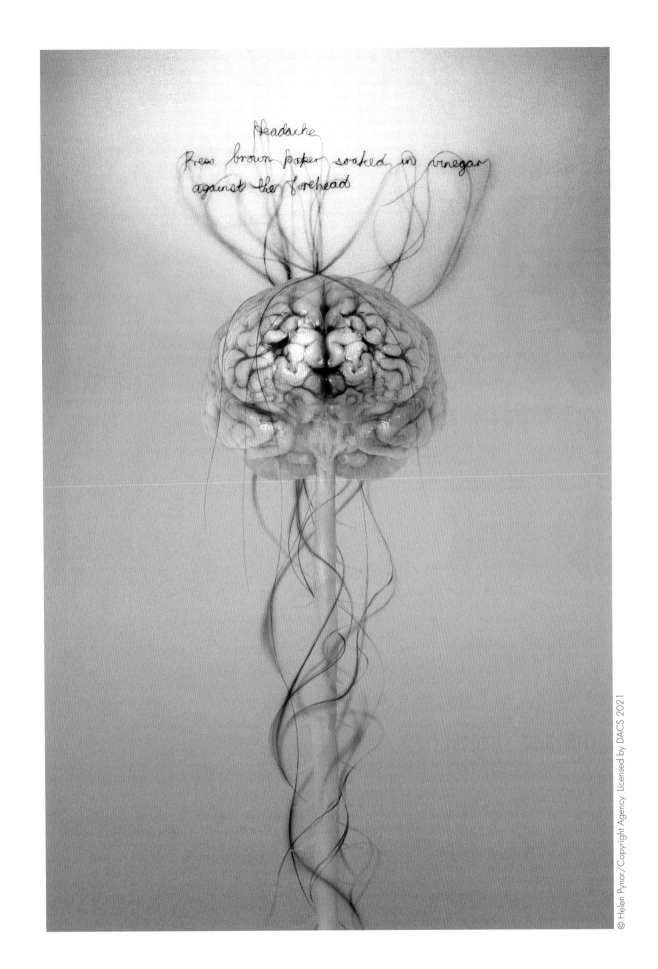

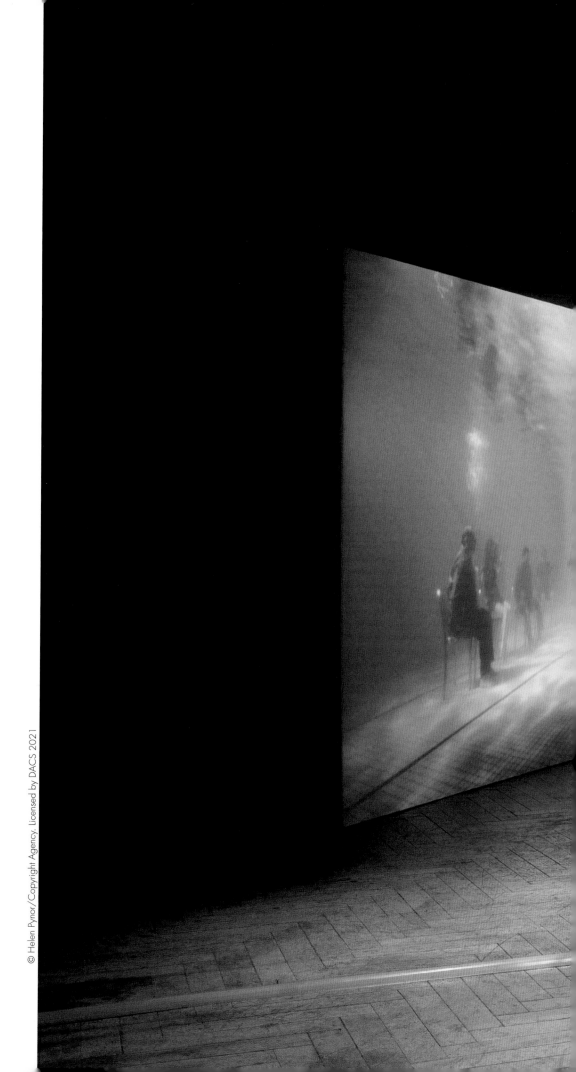

RIGHT: Helen Pynor and Peta Clancy, *The Body is a Big Place*, 2013. A three-channel video projection, single-channel video on monitor, pig hearts performance, soundscape. Installation Galerija Kapelica, Ljubljana, Slovenia.

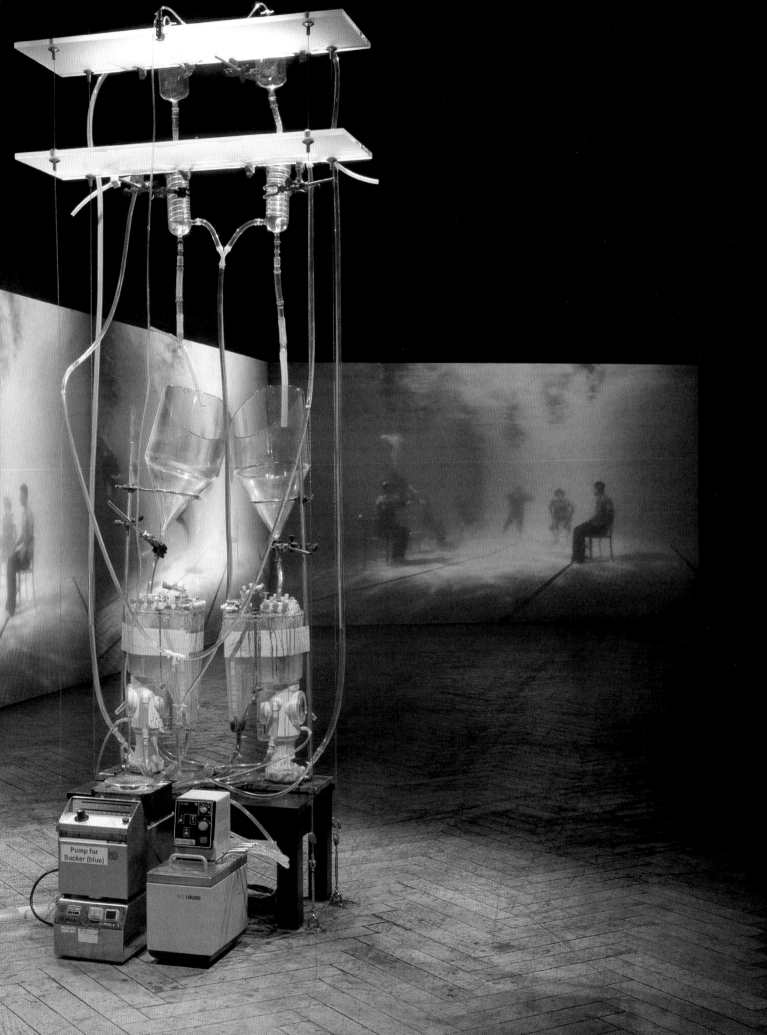

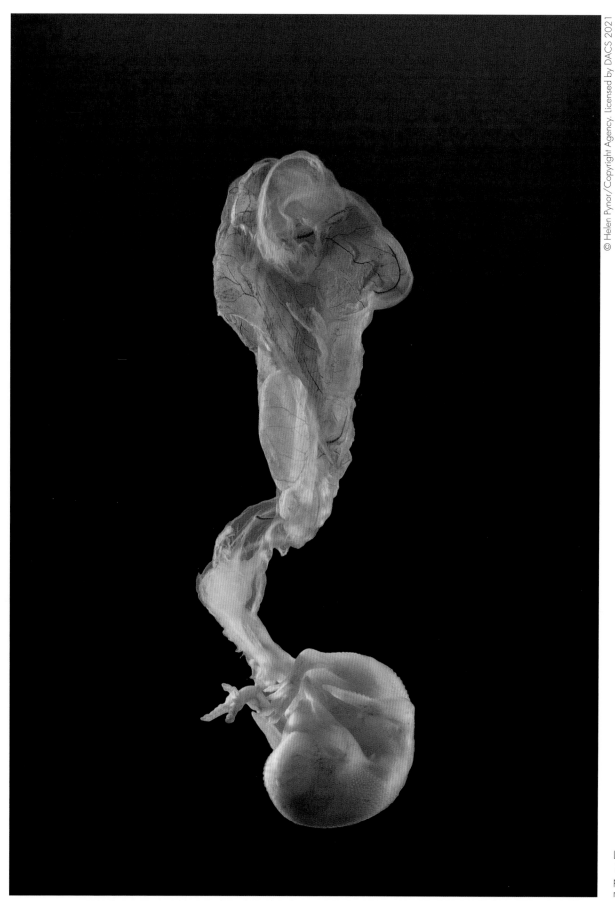

LEFT: Helen Pynor, *Fallen 16*, 2017. Archival pigment print, face-mounted on glass.

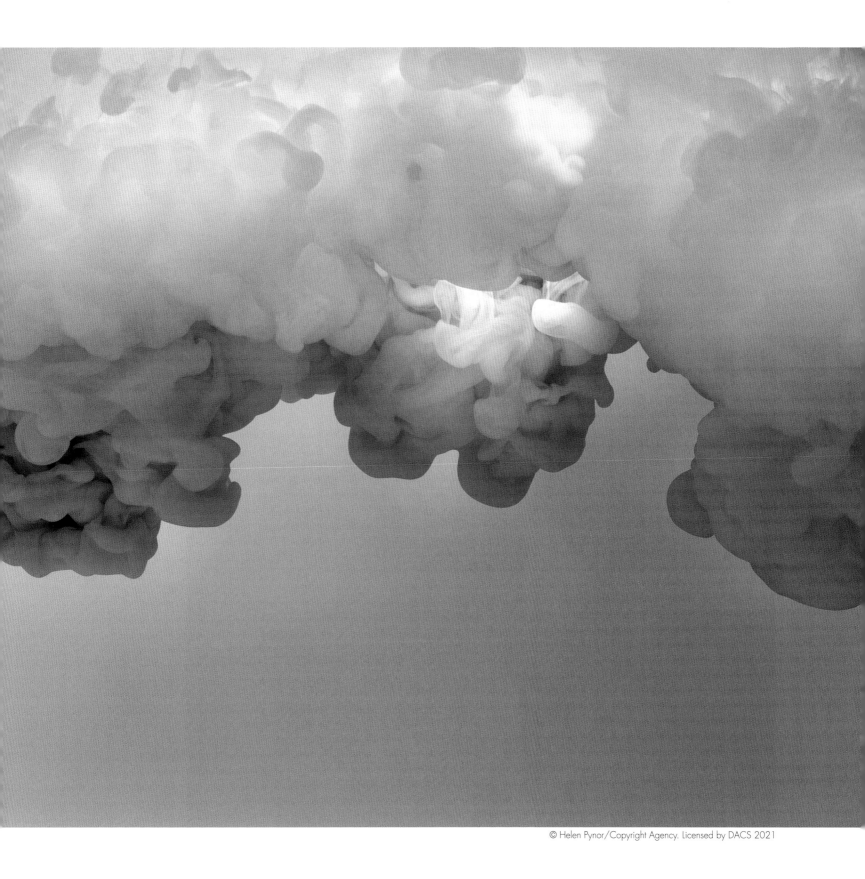

ABOVE: Helen Pynor, *Random Precision. Countless Intimate Acts*, 2017. Pigment and vinyl photographic prints, acrylic, fibre-optic lights, stainless steel.

ANICKA YI

Anicka Yi (born 1971) is a conceptual artist whose practice relates to synthetic biology, bioengineering, extinction and biofiction, creating installations that engage the senses, especially the sense of smell. Her work examines concepts of the biopolitics of the senses or how assumptions and anxieties related to gender, race and class shape physical perception

Anicka Yi began making art in her mid-30s.[1] Without any formal art training she has established herself as an innovative artist through a self-directed study of science. She recruits chemists, biologists and engineers to collaborate with her in making work, and together they explore new avenues of experience. As Yi says, "I think that the role of the artist is really, quite frankly, as much as a scientist, to define what life is and what life can be."[2]

Among her artistic practice, scent has emerged as her trademark, making the viewer do more than only view. She uses scent in a sculptural way, in that it has volume, dimension and range.

Yi often uses non-traditional and contradictory materials in her work – unstable, volatile materials deployed along with very stable industrial materials – either manipulating them or completely transforming them. She has made use of elements that are alive or were recently alive. For instance, she has cultivated human-borne bacteria, and displayed live snails and deep-fried flowers.

Shameplex (2015) features seven rectangular Plexiglas boxes filled with a shallow layer of ultrasonic gel that is typically used during medical ultrasounds during pregnancy. Nickel-plated straight pins are arranged in various geometric patterns within the gel. As time passes, the pins began to corrode, progressively generating a red, rusting pattern, appearing like a kind of bloodletting in the pristine, viscous gel.

In *Biologizing the Machine (tentacular trouble)* (2019), Yi uses a stretched leather-like kelp to create hanging incandescent sculptures, evoking images of organisms such as embryonic organs, cocoons or insect eggs. The ground beneath evokes a swamp from which these organisms and other primordial beings may have come.

At the centre of *Maybe She's Born With It* (2015) sits an amorphous, almost alien form, built from thousands of flowers individually coated in tempura and fried, then fixed in resin. Pumped with air and throbbing ever so slightly, the work suggests living organs, progressively decaying and becoming pungent.

In *Biography* (2019), Yi worked with master perfumer Barnabé Fillion to produce three scents intended to evoke three strong female characters. *Radical Hopelessness* (2019) attempts to conjure Hatshepsut, a long-reigning female pharaoh in ancient Egypt, with a base of sandalwood and patchouli. In *Shigenobu Twilight* (2008), yuzu, shiso and cedar blend in Yi's reconception of Fusako Shigenobu, founder of the Japanese Red Army. *Beyond Skin* (2019) imagines an unnamed female artificial-intelligence entity through a blend of rose, seaweed and suede notes.

Yi's more recent body of work centres on contemporary enquiries into "biologizing the machine" and how new channels of communication can be established between artificial-intelligence entities and organic life forms.

OPPOSITE: Anicka Yi, *Biologizing the Machine (tentacular trouble)*, 2019. Algae, LEDs, animatronic moths, water, pumps. Installed at the 58th International Art Exhibition – La Biennale di Venezia.

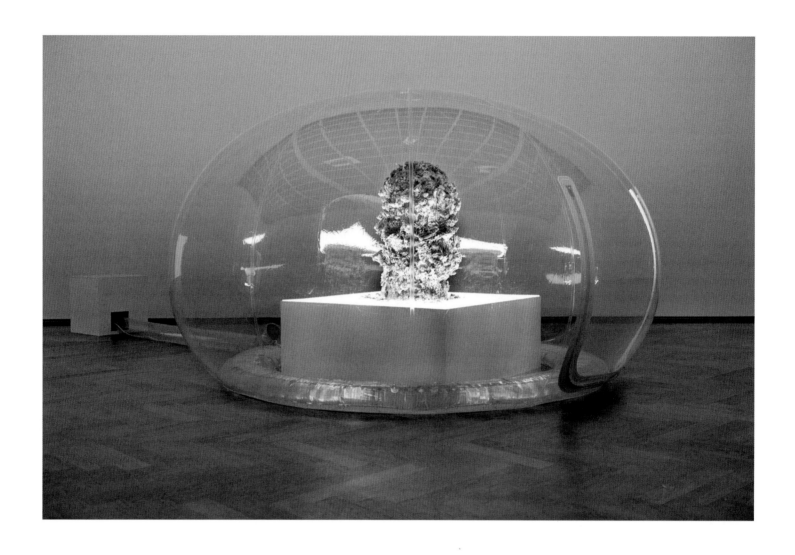

ABOVE: Anicka Yi,
*Maybe She's Born With
It*, 2015. Blower, Mylar,
plastic, resin, tempura-
fried flowers, LED light,
Plexiglas and wood.
Photographed by
Philipp Hänger.

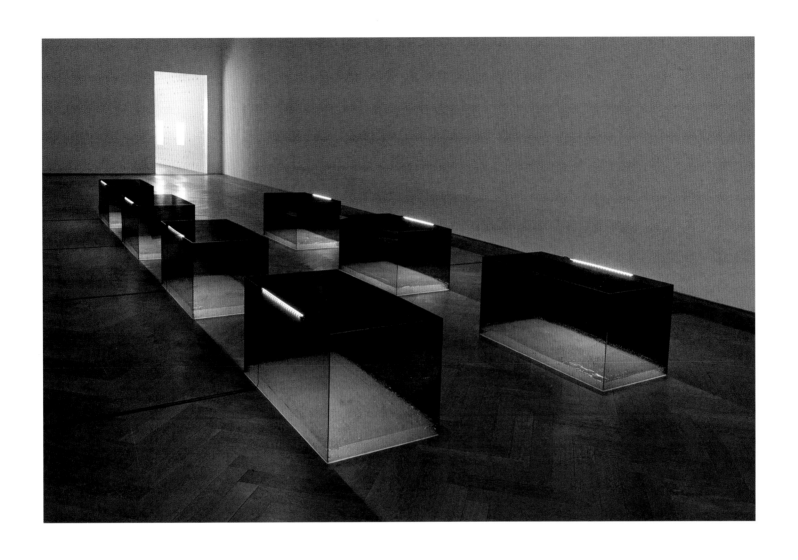

ABOVE: Anicka Yi, *Shameplex*, 2015. Plexiglass, nickel-plated straight pins, ultrasonic gel, and LED strips, seven boxes.

ECOLOGY

&

ENVIRONMENT

The artists represented in this section span four centuries of creative practice that closely observes the environment and engages directly with its inherent ecologies. Through varying degrees of representation, intervention and transformation, they challenge our perceptions of the natural world.

Dedicated to "all lovers and investigators of nature", the collection of Maria Sibylla Merian's engravings, *Metamorphosis insectorum Surinamensium*, depicts the inter-relationships between species, where spiders, ants and hummingbirds share the stage of her attentive eye. Ernst Haeckel's meticulous illustrations magnify the hidden complexities of microorganisms normally beyond our field of vision, his visual translation balancing delicately between subjective and objective depiction. Bringing the elemental forces of nature to life in painterly form, J.M.W. Turner renders the intangibility of atmospheric conditions on canvas. From the minutiae of structures observed through the microscope to the immense power of changing weather patterns, these artists amplify what they see in order to transcend human perception.

From observing the natural world in action to interacting with the processes of scientific research, some artists employ the tools of the laboratory to better understand the flows and cycles of our world. Seemingly transient and impermanent forms, such as cloud formations, solidify when etched into glass in the work of Annie Cattrell, and the accelerated transformation of bone to diamond is documented step-by-step in the work of Ackroyd & Harvey. Here scientific processes are performed, becoming actors in the artistic narrative, intended to communicate, engage and challenge audiences.

There are activist tendencies afoot here. Critical Art Ensemble combine media art, performance and protest to engage people in debates about the current implications and future considerations of biotechnology. This combination of invitation and action can also be seen in the work of Agnes Denes, in her land art interventions and co-created eco-actions, and Olafur Eliasson, through his transformation of habitats and landforms. By shifting contexts and reframing ecosystems, they invite others into the process of making, creating and thinking through their senses, by sowing seeds or listening to melting glacial ice streams.

Combining perspectives from philosophy, art and ecology – and operating at scales from the miniscule to the planetary – the artists here share a deep commitment to restaging the environment which prompts us to reconsider how we perceive, understand and relate to the world around us.

MARIA SIBYLLA MERIAN

Maria Sibylla Merian (1647–1717), an intrepid traveller, journeyed to Suriname in 1699, and took scientific observations from that expedition directly into her intimate and detailed visual work with botanical specimens. She was a scientist working visually, rather than a visual artist working scientifically.

Science and art are woven together in Merian's work. Through her scientific botanical illustrations documenting the reproductive cycles of flowers, Merian refuted the prevailing seventeenth-century wisdom – rooted in both scientific and theological dogma – that insects ("beasts of the devil"), possessed no life cycle and were "borne of mud" by spontaneous generation (abiogenesis). Aristotle had been one of the first to establish spontaneous generation as fact, in his *History of Animals*, in which he stated that worms, fireflies and other insects arose from slime, manure, and sometimes even from the morning dew.[1] But the idea that certain forms of (unobservable) primary substances were the cause of life, and not biogenesis (reproduction), were persistent. Not until the mid-nineteenth century did Louis Pasteur definitively refute spontaneous generation, and in doing so undermine the religious dogma of creationism,[2] which held this to be true.

Within this context, and after her earlier visual investigations into both botanical and insect life, Merian self-funded a trip with her daughter to Suriname[3] in 1699, to undertake further scientific exploration. Before leaving, she stated her intention to complement and enhance what she had found lacking in collections within the Netherlands: "In these [other collections] … I had found innumerable other insects, but found that their origin and their reproduction is unknown, it begs the question as to how they transform, starting from caterpillars and chrysalises and so on." As a result of this trip, and upon her return in 1705, she produced images for the book *Metamorphosis insectorum Surinamensium*. She wrote of her interest, and how it developed, in the foreword:

I spent my time investigating insects. At the beginning, I started with silkworms in my home town of Frankfurt. I realized that other caterpillars produced beautiful butterflies or moths, and that silkworms did the same. This led me to collect all the caterpillars I could find in order to see how they changed.

By visually, and accurately, describing insect metamorphoses (*Metamorphosis* contains 186 insect species), as well as showing their intimate relationships with the plants with which they interacted, and on which they depended for each stage of their life cycle, Merian contributed to studies in the fields of botany, entomology, and what we know today as ecology (see also Ernst Haeckel, page 96) by revealing how insects relate to the larger food chain. In showing, through her visual illustrations, that insects did not arise by spontaneous generation, Merian made a significant contribution to the field of entomology. Since this was a field normally dominated solely by men, her achievements challenged the assumed social roles of women at the time.

Merian also closed the gap between the aesthetics of botanical illustration and scientific method, creating a poetic interaction between image and information, aesthetic and argument – one which represented multiple visions of its subject, rather than separating the scientific viewpoints from the aesthetic ones. She thereby promoted a view that intellectual life, personal observation and creativity can all share the same stage.

OPPOSITE: Jacob
Houbraken, *A portrait
of Maria Sibylla*,
1708–1780. Print
after a portrait by
Georg Gsell.

ABOVE: Maria Sibylla Merian, untitled plate of
branch of guava tree with army ants, pink-toe
tarantulas, huntsman spiders, and ruby-topaz
hummingbird. From *Metamorphosis insectorum
Surinamensium,*1705. Hand-coloured engraving.

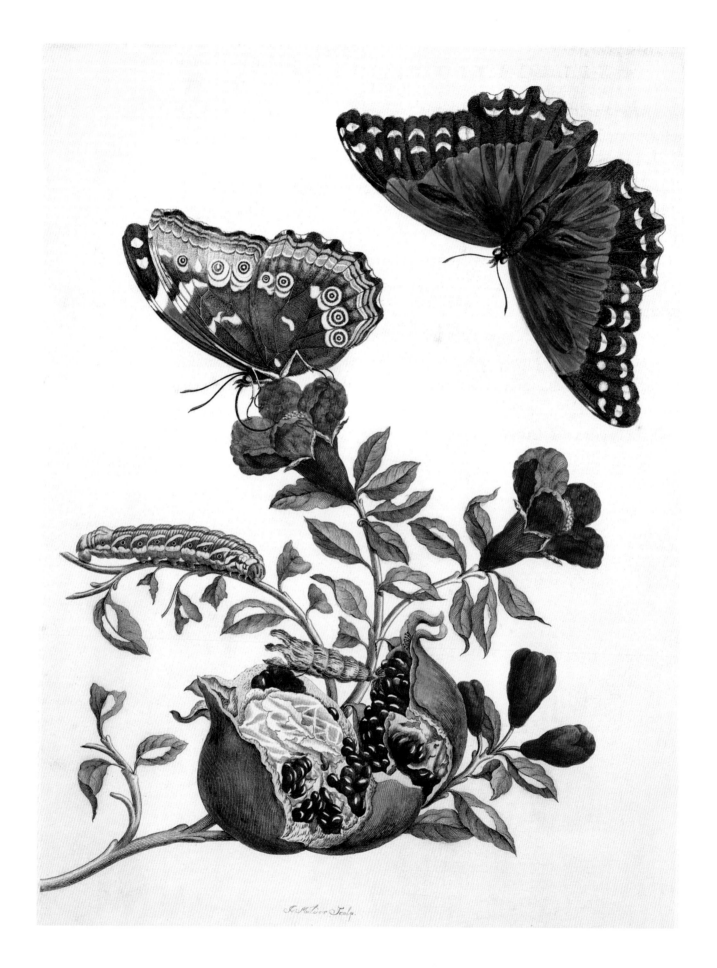

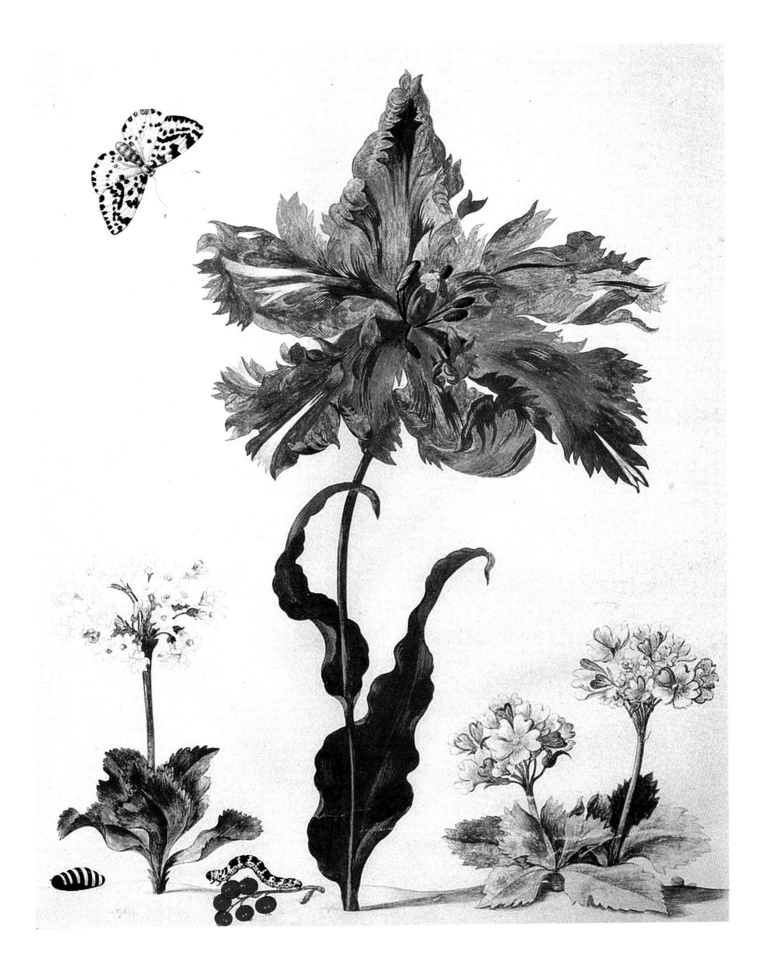

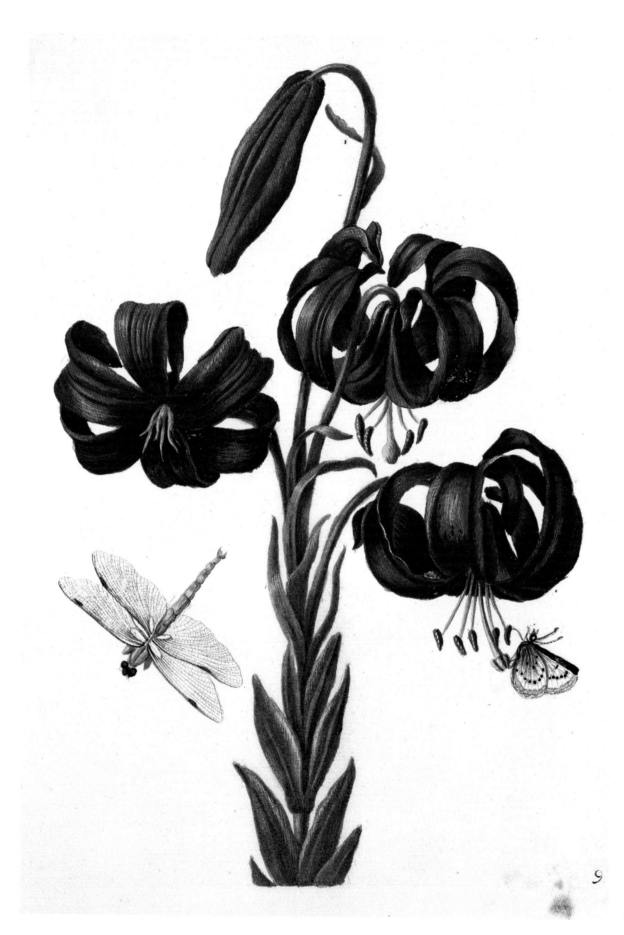

PREVIOUS LEFT:
Maria Sibylla Merian,
untitled plate of
pomegranate with a
butterfly's life cycle.
From *Metamorphosis
Insectorum
Surinamensium*, Plate
No.9, 1726 edition.
Hand-coloured
engraving.

PREVIOUS RIGHT:
Maria Sibylla Merian,
untitled image of a
parrot tulip, auriculas
and redcurrants, with
a magpie moth, its
caterpillar and pupa,
c.1670. Black chalk,
bodycolour, watercolour
and ink on vellum.

LEFT: Maria Sibylla
Merian, untitled plate
of Turk's cap lily (*Lilium
superbum*). From *Neues
Blumenbuch* (*New
Book of Flowers*),
1680. Hand-coloured
engraving.

OPPOSITE: Maria
Sibylla Merian,
untitled plate. From
*Metamorphosis
Insectorum
Surinamensium*,
Plate No.10, 1726
edition. Hand-coloured
engraving.

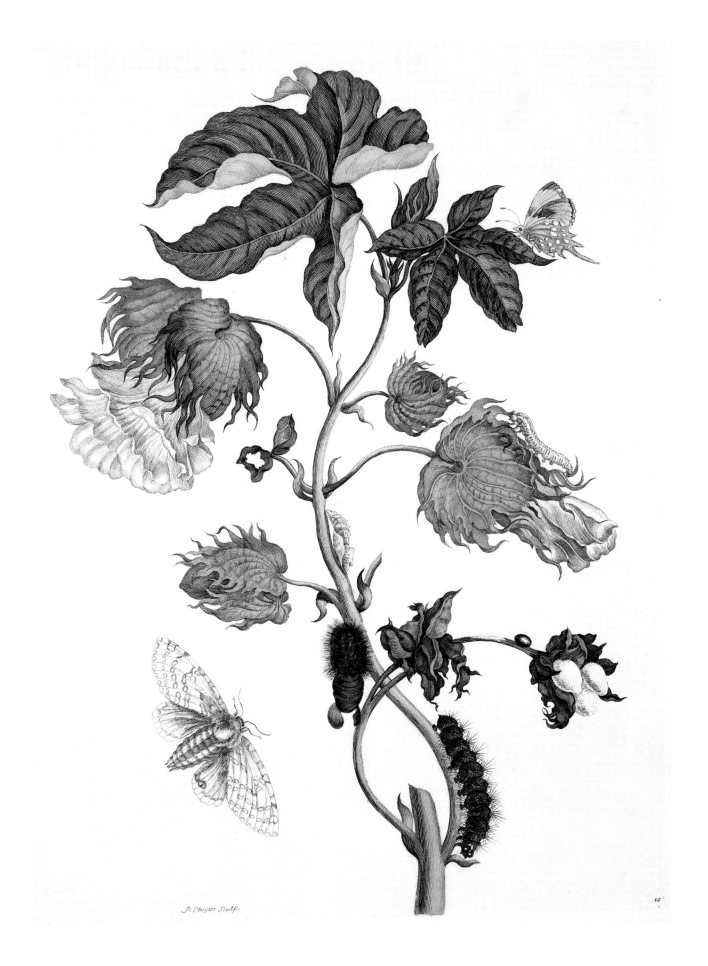

J.M.W. TURNER

Advancing at speed, the train emerges from the mists of a landscape, a symbol of a new technology in an increasingly industrial age. This is in keeping with the journey made by J.M.W. Turner (1775–1851) over a lifetime, through turbulent seascapes and tempests to the brilliance of his Venetian paintings.

Rain, Steam and Speed – The Great Western Railway (1844) is a melding of the new with the old, a seeming acceptance and embracing of what the new technologies of the age could offer. The painting is exhilarating in its immediacy and passionate in the way it is composed, just the front smoke stack of the train rendered in clear focus against the blur of the landscape it leaves behind.

Snow Storm: Steam-Boat off a Harbour's Mouth (1842), painted two years earlier, dynamically captures the experience of a storm at sea. Beleaguered and engulfed, the boat battles the elements as it attempts to make its journey – the technology of the age engaging with the fundamental forces of nature. Paint flows like water enraged by the winds, the action of the scene demanding ever more explosive dashes of colour and contrasts in tone, a vortex of nature finding form through the painter's brush and palette knife.

This is a scene depicted as if experienced directly and then re-enacted in the artist's studio upon the canvas, locating the viewer at the centre of the action. It melds the dramatic light, mist and motion of the event into a dynamic form, crafted to translate the instantaneity of the experience for others to witness.

The many sketches and watercolours made by Turner offer insight into his direct observations of nature. This interest was shared by other artists of his generation, including John Constable, whose meteorological studies of clouds also found expression in rapidly painted renditions.

Turner was acquainted with the notable scientists of the day, the Royal Society sharing a building with the Royal Academy where Turner exhibited. Among those he knew were the physicist and chemist Michael Faraday, the mathematician Mary Somerville, the anatomist and palaeontologist Sir Richard Owen, and the chemist and inventor Humphry Davy. There is also evidence that astronomical discoveries of the day may have influenced the artist's depictions.[1]

Turner appears attracted to the atmospheric qualities of light and its interaction with form, both natural and architectural. This is a very different light to the work of Claude Lorrain, an earlier source of inspiration. Here, light seems timeless, imbuing the landscape with a calming sense of almost permanent transience, the trees, landscape and castle cast in semi-shadow by its divinity.

By contrast, the light in Turner's painting of Interior of a Great House: The Drawing Room, East Cowes Castle (c.1850) positively invades the space, liberating the room's occupants and objects into a seeming sea of colour and tonal interaction. Light is not passive here, but a source of energy, a means to activate the dynamics of the space it illuminates.

This, in turn, hints at the abstractness of the medium itself, as seen vividly in Turner's Venice paintings, and how this can become the starting point for reinterpretation of subject and space in the hands of an artist. The pictures are no longer just about describing something in particular terms but enable also the exploration of what the essence of experiencing a scene in its totality might be.

OPPOSITE: J.M.W. Turner, *Rain, Steam and Speed – The Great Western Railway*, 1844. Oil on canvas.

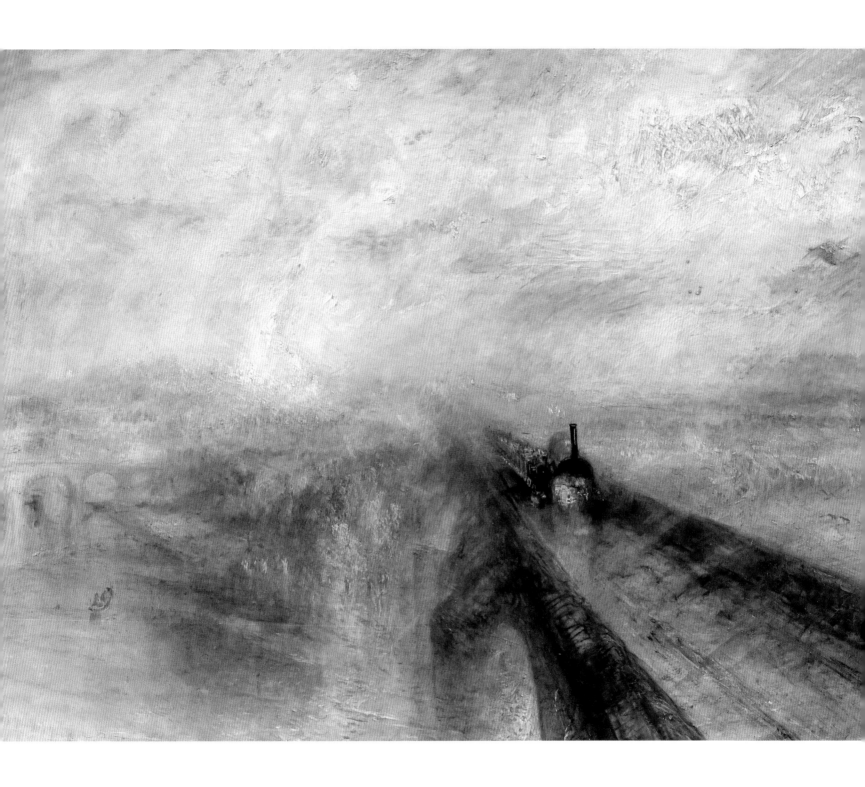

ABOVE: J.M.W. Turner,
*Snow Storm: Steam-Boat
off a Harbour's Mouth,*
1842. Oil on canvas.

ABOVE: John Constable,
*Seascape Study with
Rain Cloud (Rainstorm
over the Sea)*, 1824–
28. Oil on paper.

ABOVE: J.M.W. Turner,
*Interior of a Great
House: The Drawing
Room, East Cowes
Castle*, c.1830. Oil
on canvas

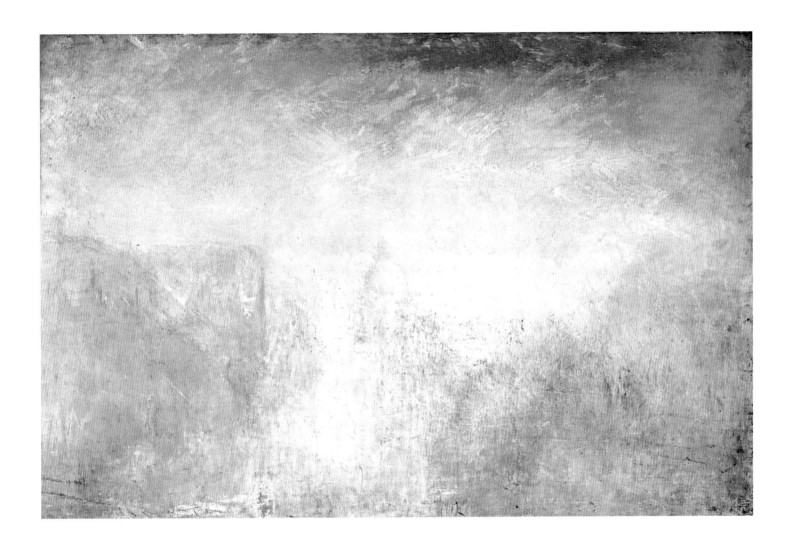

ABOVE: J.M.W. Turner,
Venice with the Salute,
c.1840–45. Oil on
canvas.

ERNST HAECKEL

Ernst Haeckel (1834–1919), was one of the most influential biologists of his time. Champion of Darwin, prominent taxonomist, inventor of the term "ecology", Haeckel is best known today as a popularizer of science, through his lavishly illustrated works. However, with his support for social Darwinism, racial hierarchies and eugenics, his legacy is a mixed one.

Haeckel was born in Prussia, modern-day Germany, in 1834. After studying medicine, he considered becoming an artist,[1] but built a formidable reputation as a zoologist. His studies of radiolaria, a form of plankton, were of particular note, with the *Monograph on Radiolarians* published in 1862. Further important zoological works followed, including his *General Morphology of Organisms* (1866), *The Anthropogeny or Developmental History of Man* (1874), and *The Gastrea Theory* (1874), which linked phylogeny with both evolution and the development of the embryo.

He was never far from controversy, championing Charles Darwin's theory of evolution (1859) at a time when it was extremely contested. But he also extended and interpreted Darwin's science in ways Darwin had never intended. Although his *Anthropogeny* acknowledges the relatedness of all humans with our primate cousins, it presents a social Darwinist[2] concept of "race" – in which evolution is manifest in culture – thus enabling Haeckel to rank human races into a hierarchy, placing Europeans at the top and Africans and other races below. Haeckel's racial and eugenic theories have been cited as an influence on subsequent Nazi racial

theories, but the truth is more complex, and Nazi authorities were somewhat ambivalent about Haeckel.[3] Today, the biological concept of human "race" is rejected by anthropologists[4] and social Darwinism is discredited.

Controversy also surrounded his embryological lithographs (see page 100), which show the strong resemblances between embryos of very distantly related classes of animal. Such resemblances were unwelcome enough to those who believed in divine creation, but Haeckel was also accused by fellow scientists of letting his desire to demonstrate strong similarities compromise the scientific objectivity of his illustrations.

In later life, Haeckel wrote for a popular, as well as a scientific, audience. His most enduring work, *Kunstformen der Natur* (*Artforms in Nature*), was published as a series of 10 booklets, each with 10 plates, between 1899 and 1904 (see opposite page). *Artforms in Nature* is a visual argument for Haeckel's concept of nature as ornament[5] (analogous to ornament in design and architecture), and the symmetries within plates and between plates reveal the relatedness of all life.[6] Nature is rendered beautiful, accessible and appropriately domesticated for the homes of his popular audience.

Finding symmetry and beauty in nature

This plate from *Artforms in Nature* shows four images of Discomedusae – a subclass of jellyfish. Each is labelled with a number corresponding to a short scientific text by Haeckel. Three species are represented as whole organisms, while the bottom image shows, anatomically, the "umbrella" and "subumbrella" of the creature above it. The colour lithograph, made to Haeckel's design by Adolf Giltsch, is a dazzling and dramatic display of "nature", intended to reveal symmetries between different kinds of organisms – according to a logic provided by Darwinian evolution. Haeckel's aestheticized nature (an aesthetic he believed real) was influential on the art nouveau (Jugendstil) art and design movement – a relationship apparent in the sinuous, arabesque lines of the jellyfishes' tentacles.

OPPOSITE: Ernst Haeckel, Discomedusae, Plate 8, lithograph from *Artforms in Nature*, 1899–1904.

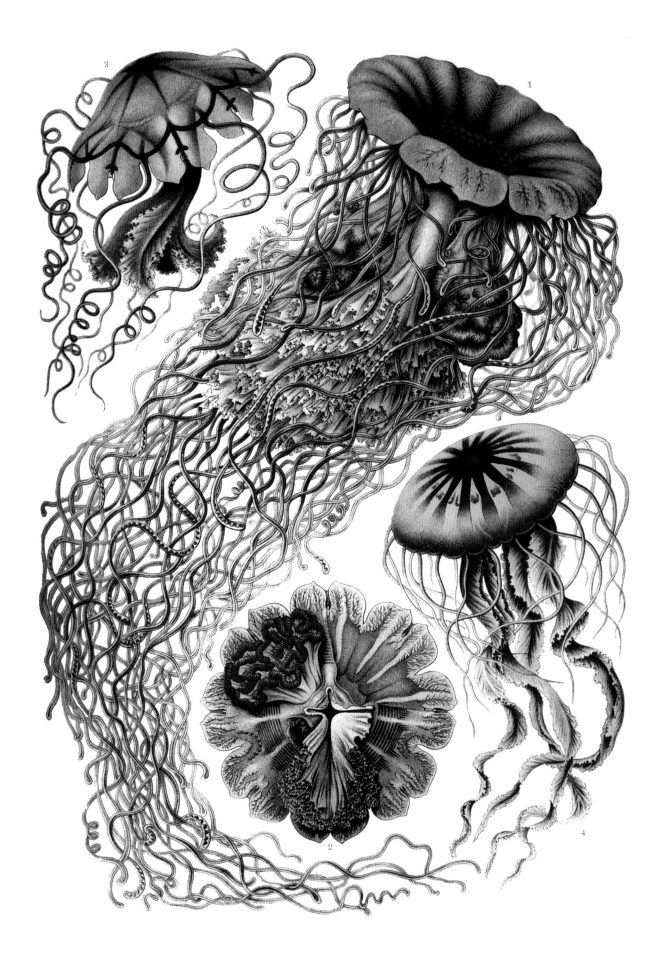

RIGHT: Ernst Haeckel, *Monophyletischer Stammbaum der Organismen* (monophyletic genealogical tree of organisms). From *General Morphology of the Organisms*, 1866. In such diagrams, Haeckel related classification of form to proposed evolutionary development.

LEFT: Ernst Haeckel, Arachnida, Plate 66, lithograph, from *Artforms in Nature*, 1899–1904. The arachnids are displayed, ignoring scale, to reveal symmetries across families, genera, orders and species.

ABOVE: Ernst Haeckel, drawings of embryos, in columns (from left to right): fish, salamander, turtle, chick, pig, cow, rabbit and human. From *Anthropogenie* (German first edition), 1874. The similarities between different classes and orders of animal are made obvious in this illustration, as Haeckel intended.

OPPOSITE: Ernst Haeckel, Ascidiae, Plate 85, lithograph, from *Artforms in Nature*, 1899–1904. The tunicates or sea squirts. These primitive creatures possess a cartilaginous notochord, found embryonically in all animals with backbones

AGNES DENES

Often referred to as the "grandmother" of the environmental art movement, Agnes Denes is a pioneer in the field with a long-standing career combining political action, speculative geometry and poetic ritual.

Born in Budapest in 1931, and raised in Sweden following the Nazi occupation of Hungary, Denes settled with her family in the United States, where she lives today. Her artistic education initially centred on painting, but she soon rejected canvas for a wider range of media, including drawing, sculpture, land art and community participation. Her practice lies at the intersection of disciplines, connecting science and art, philosophy and psychology, and linguistics and ecology.

Denes first gained international attention in the 1960s, her early works expressing her "eco-logical" thinking through isometric drawings, monoprints and sculptural forms. Geometric and pyramidal structures play with scale and spatial relations, with ideas proposed in drawings later coming to fruition as land-art projects, some taking decades to realize. Early works include *Rice/Tree/Burial with Time Capsule* (1968), a ritual event voicing environmental concerns through three symbolic acts: the planting of rice, the chaining of trees, and the burial of poetry. From the 1980s onwards, she worked with the land to make long-lasting earthworks such as *Tree Mountain – A Living Time Capsule* (1992–96). This massive land reclamation project took 14 years to develop and involved the planting of 11,000 trees, by 11,000 people, each receiving a certificate recognizing them as its official custodian. The virgin forest situated upon a man-made mountain in Finland, is the world's largest artistic living monument, set out in a mathematical pattern

inspired by the geometry of sunflowers. Under protection for at least 400 years, the work stands as testament to Denes's artistic vision to "bioremediate" the earth, raise collective consciousness and act beyond an individual human timescale. She is currently working on *A Forest For New York – A Peace Park for Mind and Soul* (2014–ongoing) that aims to plant 100,000 trees on a 50-hectare (120-acre) site of barren land at Edgemere Landfill in

Queens. Through this project she hopes that "New York will be known as the home of a unique forest, a living art gallery, a peace park, a tourist destination … a sanctuary."[1]

Denes has written six books and numerous articles, and lectures internationally on art and environment. In 2019, The Shed in New York paid tribute to her 50-year career with a major retrospective exhibition of her work.

Reclaiming New York City

Agnes Denes's best-known work is *Wheatfield – A Confrontation* (1982), a large intervention on a two-acre (0.8-hectare) landfill site in Lower Manhattan, one of the most expensive pieces of land in New York City. Supported by the Public Art Fund and created over a four-month period, Denes oversaw the transformation of the site into a lush field of golden wheat, yielding a crop of over 1,000 pounds (450 kilograms) of wheat. This symbolic act of land reclamation raised myriad questions about resource, value, energy, waste and commerce – which extended through a travelling exhibition, *The International Art Show for the End of World Hunger*, Minnesota Museum of Art (1987–90). The show toured to 28 cities and distributed the harvested grain around the globe.

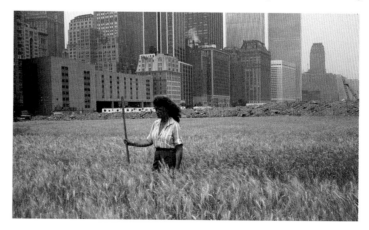

LEFT: Agnes Denes, *Wheatfield – A Confrontation*, Battery Park Landfill, Downtown Manhattan, 1982. The artist herself is shown standing in the wheatfield.

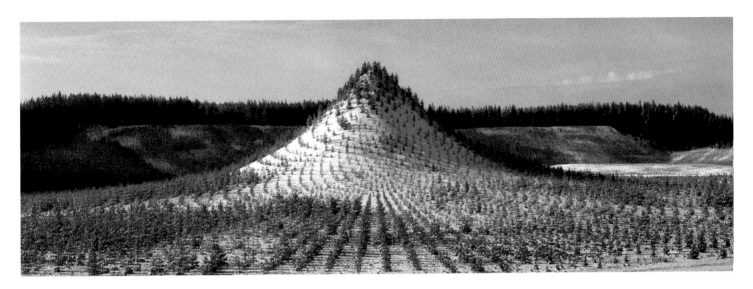

ABOVE: Agnes Denes,
Tree Mountain – A
Living Time Capsule –
11,000 Trees, 11,000
People, 400 Years,
1992–96, Ylöjärvi,
Finland.

ABOVE & OPPOSITE: Agnes Denes, *A Forest for New York – A Peace Park for Mind and Soul*. A project proposal for the Edgemere Landfill, Queens, New York © 2014 Agnes Denes.

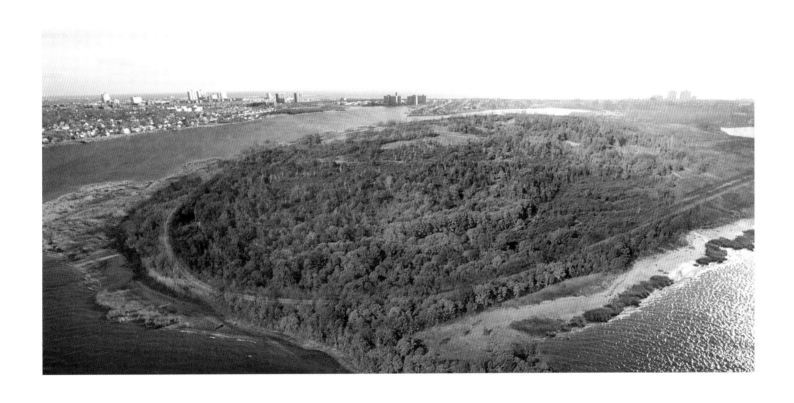

ACKROYD & HARVEY

Through Arctic expeditions, architectural interventions and processional performances, Ackroyd & Harvey combine politics and poetics to raise environmental awareness.

Heather Ackroyd (born 1959) and Dan Harvey (born 1959) have been collaborating for over 20 years, creating artworks, installations and events. Their process-based practice combines ecology and history, art and activism, to construct and reconstruct grand narratives. They work with living materials, such as grass and seedlings, and create events and actions, their transient work embodying interconnected processes of growth and decay, time and tide.

For many years, grass has been a signature medium for the artists, who work with its inherent photosensitive properties. Following a residency with the Institute of Grassland and Environmental Research in Aberystwyth, Wales, in 2000, they developed a chlorophyll-based photographic process projecting a negative image onto the growing surface. The areas not receiving light lose colour, resulting in a positive image rendered in the grass. When exhibited, the works must be viewed under low light to slow down the gradual, and inevitable, loss of the image. Often depicting portraits, from intimate to monumental in scale, the images are highly evocative, alluding to the impermanence of memory and the passing of time. At architectural scale, the artists have covered the facades of buildings with living matter, transforming solid wall into living substrate and, more recently, they have created coats of grass, worn as part of the environmental protests of 2019.

Ackroyd & Harvey are material storytellers, their projects interweaving disparate historical times and disciplinary languages. *Polar Diamond* (2009) is a complex unfolding of narratives between species extinction and material worth. Following an Arctic expedition in 2004, the artists obtained a leg bone of a polar bear from a Svalbard research institution. The bone was cremated and reduced to carbon

RIGHT: Ackroyd & Harvey, the burning of the bone for *Polar Diamond*, 2010.

OPPOSITE LEFT: Ackroyd & Harvey, capturing carbon from the burnt bone for *Polar Diamond*, 2010.

OPPOSITE RIGHT: Ackroyd & Harvey, *Polar Diamond*, 2010.

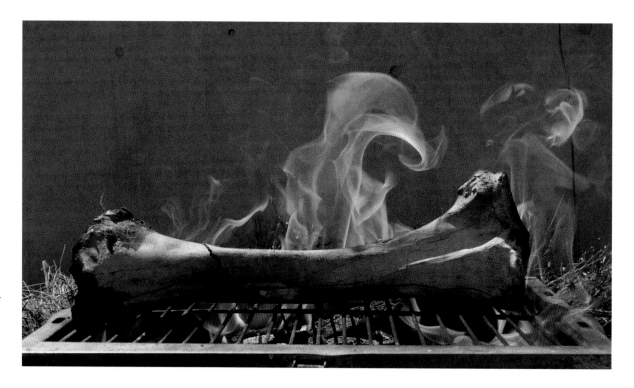

graphite, which was then converted into a diamond through a rapid-acceleration process. This transformation, from embodied bone to a most highly valued material substance, comments on loss, rarity and relative values.

In *Beuys' Acorns* (2007–ongoing), they pay homage to a seminal environmental intervention created by artist Joseph Beuys, which involved the planting of 7,000 oak saplings across the city of Kassel, Germany, between 1982 and 1987. In 2007, Ackroyd & Harvey visited Kassel and collected hundreds of acorns to begin the process of germination. In the years since, the young trees have toured

venues across the globe and formed the basis of numerous artworks and events in galleries, museums and public spaces – including as a contribution to global environmental meetings, such as the United Nations Climate Change Conference, COP 21, in Paris, in December 2016. The saplings serve to provoke discussion and extend research, each tour involving public conversations with invited specialists from the fields of science, law, art, architecture and politics. This open-ended process of co-enquiry critically examines the roles that trees play in our urban environments and aims to solidify their cultural and environmental significance.

Ackroyd & Harvey have built an international reputation through their commitment to environmental action. From global conditions to local ecologies, their work remains grounded in securing social and environmental justice for key causes, ranging from rural English landscapes threatened by fossil-fuel exploitation to species extinction and far-reaching planetary concerns.

BELOW: Ackroyd &
Harvey, *Mother and
Child*, 2001. This
shows the process of
image degradation as
the portrait gradually
fades and dies.

RIGHT: Ackroyd & Harvey, seedlings from *Beuys' Acorns*, 2007– ongoing. Presented at London's Southbank Centre, 2012.

BELOW: *Grass Coats* worn at Extinction Rebellion, London Fashion Week, 2019.

ANNIE CATTRELL

Annie Cattrell (born 1962) is a multidisciplinary visual artist whose practice is often informed by working with specialists in neuroscience, meteorology, engineering, psychiatry and the history of science. This cross-disciplinary approach has enabled her to learn about cutting-edge research and detailed information in these fields.

Cattrell was born in Glasgow to a father who was a medical physicist and a mother who was a painter and art teacher. The family moved to Edinburgh, and from the age of five, Cattrell attended a Steiner School, which encouraged pupils to make interdisciplinary connections between all taught subjects. This cross-disciplinary focus has been one of the main values that has remained with her and subsequently influenced her thinking and general approach to research and making work.[1] Initial focus in her work was on understanding how the human body and mind work, in order to grasp the "physicality of consciousness".[2]

Cattrell's work involves cross-disciplinary discussions and is informed by a dialogue between the empirical, phenomenological and theoretical, "by acts of paying attention, noticing, contemplating and watching. At times, it seems almost forensic".[3] Over the years, she has considered and adopted some objective scientific conventions as part of her own artistic and aesthetic methodologies, while being interested in where and how the scientific and the poetic meet.

She is drawn to discrepancies and inaccuracies, seeing if and when structures, patterns or meanings emerge. Part of this process involves observing subtle topographic changes in the landscape, as in works such as *Echo* (2007) and *Seer* (2018) where time is physically embedded in the work, or atmospheric fluctuations and weather conditions, as in *Currents* (2002), or more intimately inside the human body and brain, as in *Capacity* (2000).

Capacity is a fragile construction of borosilicate glass made by human breath to form the delicate structure of human lungs. The use of a material usually used to make test tubes by glass blowing is utilized by the artist in a poetic way that reminds us of our own vulnerability.

New digital approaches led Cattrell to explore and use state-of-the-art technologies, such as topographical Lydar laser scanning, a virtual casting process that proved critical when creating *Echo*. She has also used fMRI, MRI and PET brain- and body-scanning techniques[4] and data to realize a series of works about the body and brain.

Sense (2003) displays sculptural reconstructions of the areas of the brain activated by the work of the five different senses, showing the viewer what sensing neurologically is and giving the sense regions form. It is the culmination of three years of research, studying scientific texts as well as involving dialogues and collaborations with neuroscientists, who granted her access to contemporary data on brain activity from medical scanning techniques.

From Within (2006) is a life-size cast from a human skull, which maps the delicate channels inscribed on the interior of the skull, transforming the protective shell of the cranium into precious objects. Depending on the light and viewing angle, concavity and convexity alternate.

The nature of impermanence and the transitory were part of Cattrell's thinking behind *Conditions* (2007). In this work, typical cloud formations in each month of a year are scaled down and etched inside solid. optical-glass blocks. Informed by dialogues with meteorologist Stan Cornford, the artist created a fluid, multilayered work revealing the 12-monthly cloud rhythms and the passage of time in one view.

The process of drawing is significant to Cattrell, which she approaches in part by referencing space, time, volume, and yearly density. Some drawings, such as *Forces* (2005), are made using a knife to produce marks. The shaped incisions penetrate the thick watercolour paper and reference directional flow, where they physically alter the integrity of the paper, which weakens and begins to sag and buckle, making it appear three-dimensional.

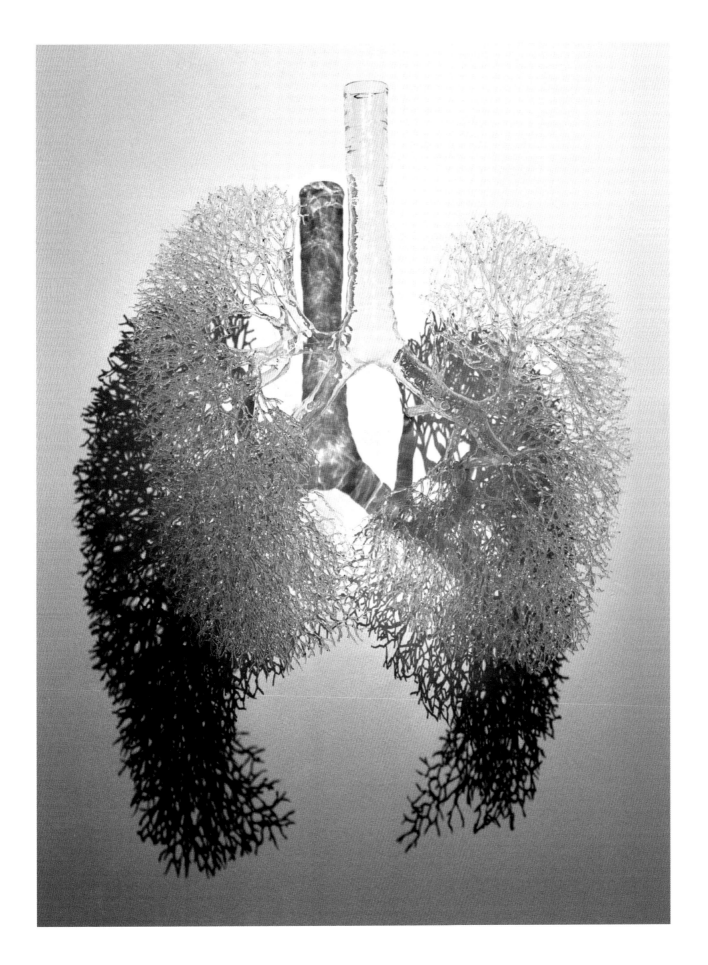

ANNIE CATTRELL

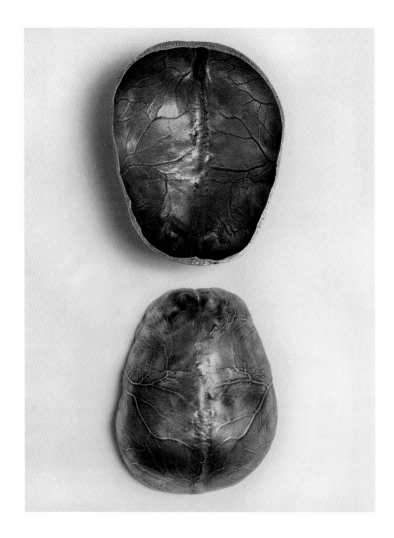

RIGHT: Annie Cattrell,
From Within, 2006.
Silvered bronze,
life-size casts from
a human skull.

BELOW: Annie Cattrell,
Conditions, 2007.
Sub-surface-etched
optical glass.

OPPOSITE: Annie
Cattrell, *Forces*, 2005.
300-gram Bockingford
watercolour paper.

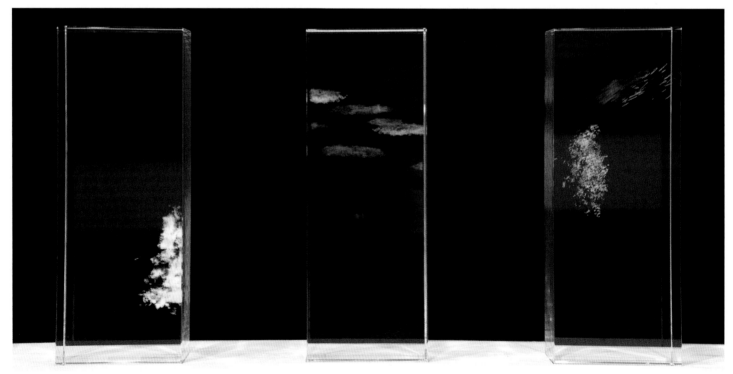

ANNIE CATTRELL

OLAFUR ELIASSON

"Art does not show people what to do, yet engaging with a good work of art can connect you to your senses, body, and mind. It can make the world felt. And this felt feeling may spur thinking, engagement, and even action."

Olafur Eliasson, 2016[1]

Born in Copenhagen, Denmark in 1967, Olafur Eliasson grew up in both Denmark and Iceland, and had the first exhibition of his artworks aged 15. He was a keen breakdancer in his teens, and in 1984, with two friends, won the Scandinavian breakdancing championship[2] – a dancer's interest in the body in relation to space remains apparent in his work.

Important themes in Eliasson's work include our relationship to nature and landscape, and the perception of light and space as embodied experience (the immersive installations are reminiscent of artists such as Robert Irwin). His works are investigations, underpinned by scientific research. For example, in *360° room for all colours* (2002) (see page 116), the slowly changing colours in the immersive installation utilize the after-image of the eye so that viewers perceive more colours than are actually present.

In *Riverbed* (2014), a work exploring our relationship with nature and landscape, the artist constructed a "natural" riverbed running through several spaces in Denmark's Louisiana Museum of Modern Art. A small stream animates an inert, almost monochrome landscape. Nature is encountered, incongruously, within an art gallery and, as with *The Weather Project* (2003–04), the illusion is compelling even though we know intellectually it is artifice. *Riverbed* challenges our categories of nature and culture, while offering a laboratory for the study of people in their physical interaction with this environment. This human, unpredictable interaction completes the work.

Eliasson's environmental concerns, apparent in *Riverbed*, are explicit in *Ice Watch* (2014). Blocks of ice from the Greenland ice sheet were installed in Copenhagen (2014), Paris (2015) (coinciding with the United Nations Climate Change Conference, COP 21) and London (2018–19). *Ice Watch* presented a tangible, ephemeral reminder of the melting of Arctic ice and warming of the climate. The ice blocks, installed in the shape of a clock, or "watch"[3], warn that time is passing and something must be done – a call to action.

The Weather Project

The Sun, larger than life, hangs startlingly, impossibly, at the far end of the Turbine Hall of the Tate Modern, London, shrouded in mist. The viewer understands intellectually that this cannot be *the* Sun, yet the illusion is so compelling it can induce a feeling of awe. On the ceiling, antlike human figures move – also an impossibility, the result of a mirrored surface that doubles the enormous volume of the Turbine Hall. The realization dawns that this is not the full solar disc, but a semi-circular half Sun, reflected to complete the circle. At the far end of the Hall, the illusion is completely unmasked: the electrical connections are visible at the rear of the bank of 200 sodium lights that make up the Sun.

Eliasson may be wary of evoking the sublime,[4] yet even his unmasking of his illusion seems unable to completely negate the sense of awe and mystery in this vast space. Perhaps here lies one key to the work: we encounter awe and mystery despite our intellectual knowledge and understanding of physics and logic. Exposure of this tension between knowing and feeling may remind us of the difficult relationship between objective truth and the many illusions and simulations that haunt our contemporary lives.

Yet, there is another surprising, delightful aspect to this work. Despite the awe-inspiring setting, there is lightness, as children and adults make playful shapes with their bodies, visible in their distant reflection far above.

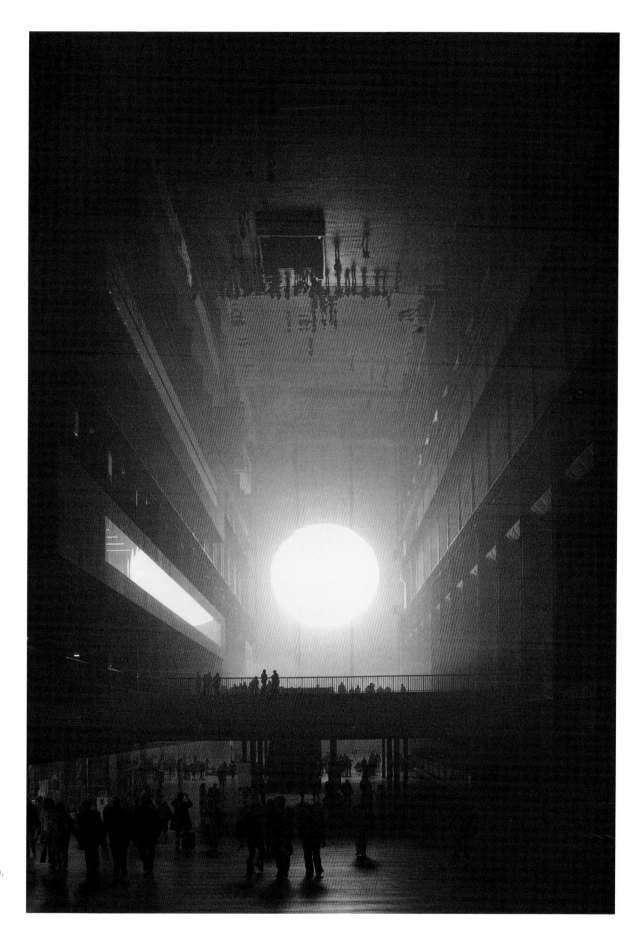

RIGHT: Olafur Eliasson, *The Weather Project*, 2003–04. Tate Modern, London.

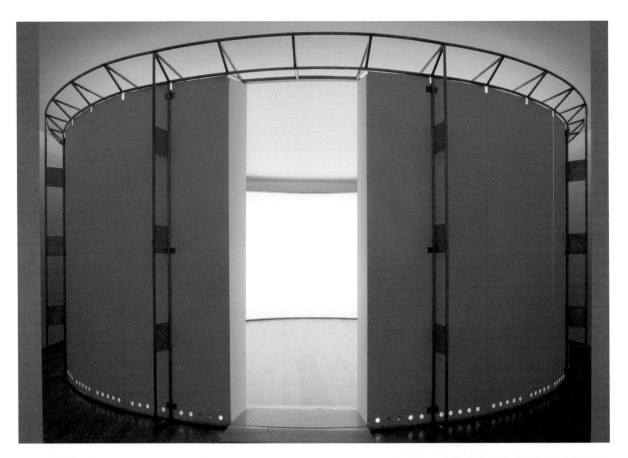

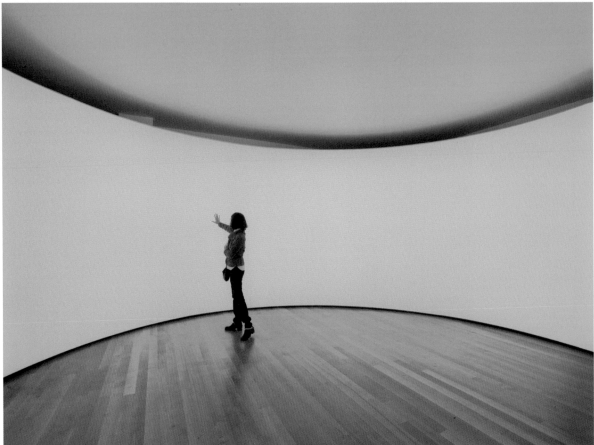

ABOVE: Olafur Eliasson, *360° room for all colours*, 2002. Kunstmuseum Wolfsburg, Germany, 2004.

RIGHT: Olafur Eliasson, *360° room for all colours*, 2002. Museum of Modern Art, New York, 2008.

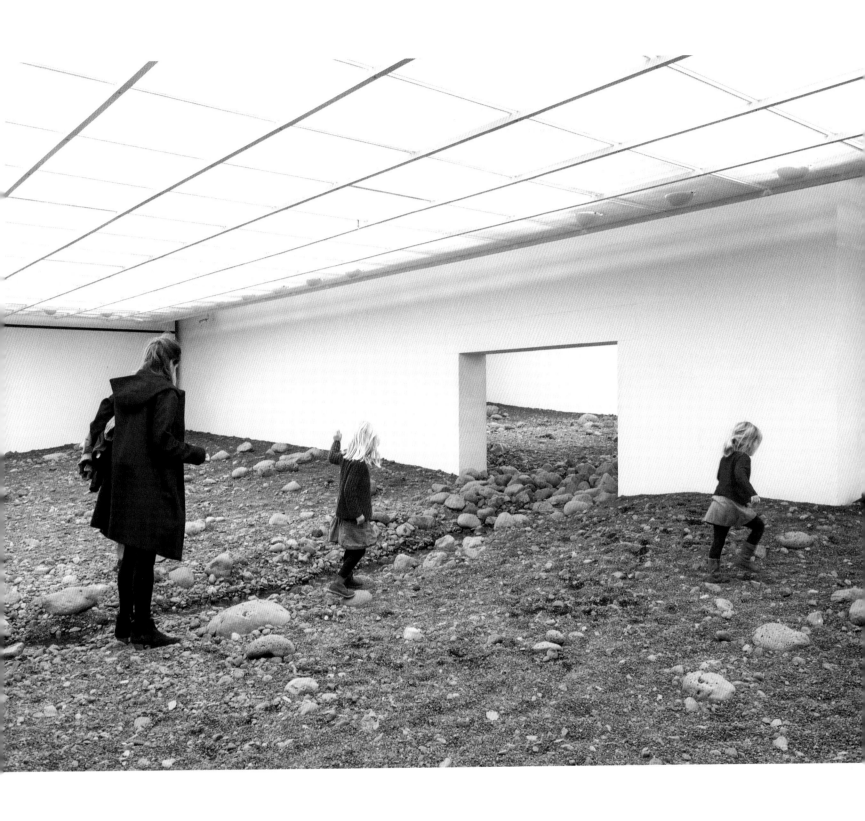

ABOVE: Olafur Eliasson,
Riverbed, 2014.
Louisiana Museum of
Modern Art.

LEFT: Olafur Eliasson,
Ice Watch, 2014.
Place du Panthéon,
Paris, 2015.

CRITICAL ART ENSEMBLE

If science was once largely the preserve of the self-driven amateur (such as Leonardo da Vinci, page 48), today it is not only enormously influential in the lives of most on the planet, but also professionalized, institutionalized and regulated. It often requires funding that only states, corporations, universities or other large institutions can provide. The average citizen is generally distanced from participation in, or control over, the science and technology that profoundly affect their life, and this gap presents challenges to democratic politics. It is this gap that is a key area of exploration for the Critical Art Ensemble.

Critical Art Ensemble was founded in 1987 in the USA. Their work can be related to the conceptual art movement as well as to DIY (do-it-yourself)[1] and the Situationist International[2], and environmental artists such as Joseph Beuys. While their work is realized in installations, art exhibitions, performances and publications, including seven books,[3] it is arguably their social interventions themselves, their détournement[4] or subversions of technical and scientific processes for political effect, that are the real work. Their creative process involves collaboration with scientists and technicians, and is inherently interdisciplinary, drawing especially upon biotechnology and, latterly, physics.

Critical Art Ensemble provocatively expose and question the social and political dimensions of developments in science and technology. *Cult of the New Eve* (1999–2000) explored the perception of science as a quasi-religious phenomenon. The group, with Paul Vanouse and Faith Wilding, created a pseudo-religious cult around the anonymous subject of the Human Genome Project. Gene sequences from the "New Eve" were spliced into yeast cells used to produce wafers and beer, and these foods were ritually consumed by members of the public. In *GenTerra* (2001–03), also based upon biotechnology, Critical Art Ensemble and Beatriz da Costa allowed members of the public to create their own transgenic bacteria, and then decide whether the (harmless) bacteria should be released. *GenTerra* was presented as a for-profit company, raising questions about the involvement of the corporate sector in ethical scientific debates. *Radiation Burn: A Temporary Monument to Public Safety* (2010) simulated a dirty-bomb explosion in a public park in Halle, Germany, drawing attention to the exaggeration by the authorities of the risks of such acts of terrorism.

Seized!

In 2004, the Buffalo[5], New York, home of Professor Steve Kurtz, a founding member of Critical Art Ensemble, was raided by the FBI who were investigating Professor Kurtz on suspicion of bioterrorism offences. The incident followed the tragic death from heart failure of Kurtz's wife, Hope, a fellow founding member of the group. The presence of a laboratory and (harmless) bacterial samples at their home aroused the suspicions of the authorities. Although a federal grand jury failed to bring charges of bioterrorism, charges of mail and wire fraud were brought against Kurtz and scientific collaborator Professor Robert Ferrell. The case against Kurtz was finally dismissed in 2009. Photographs, plus documentation and ephemera relating to the raid, were exhibited in a 2008 exhibition, *SEIZED*, at Hallwalls Contemporary Arts Center in Buffalo. The campaign against the prosecution of Kurtz received international support. An editorial in the journal *Nature* stated:

> Kurtz's work is at times critical of science, but researchers should nevertheless be willing to support him … Art and science are forms of human enquiry that can be illuminating and controversial, and the freedoms of both must be preserved as part of a healthy democracy — as must a sense of proportion.[6]

OPPOSITE: Critical Art Ensemble. The *GenTerra* research and development group at the University of Pittsburgh laboratory, 2001.

RIGHT: Critical Art Ensemble, Paul Vanouse and Faith Wilding, *Cult of the New Eve*, 1999–2000.

ABOVE: Critical Art Ensemble and Beatriz da Costa,
GenTerra 2001–03. Darwin Centre, Museum of
Natural History, London, 2003. Participants decide
whether to activate the machine that will release
bacteria.

ABOVE: Critical Art Ensemble, *Radiation Burn:
A Temporary Monument to Public Safety*, 2010.
Halle, Germany.

MACHINES
&
SYSTEMS

This section covers a broad spectrum of investigation and experimentation by artists concerning the mechanics and ordering of space, form and interaction, and the use of different technologies and media to achieve this.

Historically, the emergence of mathematics as a means of quantifying has evolved to encompass computation that enables and facilitates innovation. This is evident in the many mechanical and digital inventions with which we are so familiar today. Mathematics has also become a language of science that, although abstract, can be used to express ideas of forms, both tangible and intangible. In addition, many inventions, beginning with the telescope and microscope, have dramatically extended our senses and, together with now-familiar concepts such as perspective, have radically altered our ways of seeing and comprehending the universe. This new vision and conceptualization has found form and expression in the work of artists over the centuries.

Abstraction emerged significantly in the early part of the twentieth century as a way of exploring the essential building blocks with which an artist can compose. This included experiments with colour, line, geometry of space and physical constructions. The inclusion of time and higher dimensions in these systems has resulted in notions of space that go beyond classical Euclidean geometry, and these also present themselves in the work of both artists and scientists. The artists presented here explore abstraction in different ways, imparting insights into the human mind through the creation of artworks that explore the nature of what it is we perceive and how we can compose with artificially derived elements that are conceived from that experience. Time can be expressed kinetically, as may be seen in the constructions of Alexander Calder, Nam June Paik and László Moholy-Nagy, or as sequential images as in the photography of Eadweard Muybridge.

Human experiences of the world are to be found in the paintings of Paul Klee and the work of artists presented in New Abstractions, some of whom also explore systematic principles of ordering space, as found in the artwork of Kenneth and Mary Martin. Energy, light and refraction are engaged with in the work of Fred Eversley, while Mario Klingemann explores the realm of the digital, creating with algorithms and data, and investigates artificial neural networks. These diverse ways of composing and constructing may be found in various combinations in each of the artists presented.

EADWEARD MUYBRIDGE

Does a trotting horse have all four feet off the ground at any stage of its movement?

This was a question that Eadweard Muybridge (1830–1904) was asked to solve with his method of instantaneous photography, which became the catalyst for his pioneering work in photographic studies of animal and human movement. He was one of the first photographers to use multiple cameras to capture motion and then project the findings with his creation of the zoopraxiscope, a device for projecting motion pictures that pre-dated the flexible perforated film strip.

He was born Edward James Muggeridge, but would later change his name twice during his lifetime, from Muggeridge to Muybridge in 1855 and from Edward to Eadweard in 1861.

At the age of 20, he emigrated to the USA, first to New York and then, in 1855, to San Francisco, where he established himself as a successful bookseller. It was at this time that he came into contact with photographers and their work, in particular Silas T. Selleck and Charles L. Weed.

Following a serious accident, he returned to England in 1860 to convalesce. It was during this time that he discussed, with local photographer Arthur Brown, the method of instantaneous photography and the chemical mixtures required to achieve it. He returned to San Francisco in 1865, taking up photography full time. With a mobile studio he called "Helios", he set out to record the scenery of the American west, producing a wide array of panoramic views of San Francisco and landscape photographs, most famously of Yosemite Valley.

In 1872, Muybridge was commissioned to solve the "trotting horse" question by Governor Stanford of California, a businessman and racehorse owner. Muybridge began photographing Stanford's horse Occident in a sequence of shots, eventually managing to shoot a small and very fuzzy picture of Occident running in 1873. Due to the quality of the image, however, the question of whether there was a moment during a trot where all four of the horse's feet left the ground at the same time was left unanswered. Photographic confirmation that they did in fact all leave the ground eventually came a year later.

With further funding from Stanford, Muybridge devised a more complex method of photographing horses in motion and, in June 1878, Muybridge created a sequential series of photographs with a battery of 12 cameras along the racetrack at Stanford's Palo Alto Stock Farm.

This work was a shift in Muybridge's career as a landscape photographer and became the launching point for the first scientific study of motion using photography. With the help of engineers from the Central Pacific Railroad Company, Muybridge mastered the method by which electromagnets holding the shutters in place could be released on a timer mechanism as the subject passed in front of the bank of cameras.

The electrical shutters fired so fast that it captured in startling detail images of animals in motion, which had formerly appeared in photographs as little more than indistinct blurs.

In the 1880s, the University of Pennsylvania sponsored Muybridge's research to photograph people in a studio and animals from the Philadelphia Zoo in order to study their movement. This resulted in the publication of *Animal Locomotion: An Electro-Photographic Investigation of Consecutive Phases of Animal Movements* (1887), with 781 plates comprising 20,000 photographs. His studies of people mostly depict men in athletic pursuits, while women perform domestic duties or appear coyly alluring. These gendered themes mean that these images not only document physical differences but the social mores of Muybridge's time.

In the later years of his life, Muybridge published *Animals in Motion* (1899) and *The Human Figure in Motion* (1901).

His explorations in photography and publications provided inspiration to artists and scientists alike, most notably Thomas Edison, Étienne-Jules Marey, Edgar Degas and Francis Bacon, and is regarded as both an innovation in photography and the science of movement.

OPPOSITE: Eadweard Muybridge, racehorse "Annie G." galloping, 1872–75. From *Animal Locomotion*, Plate No. 626, 1887.

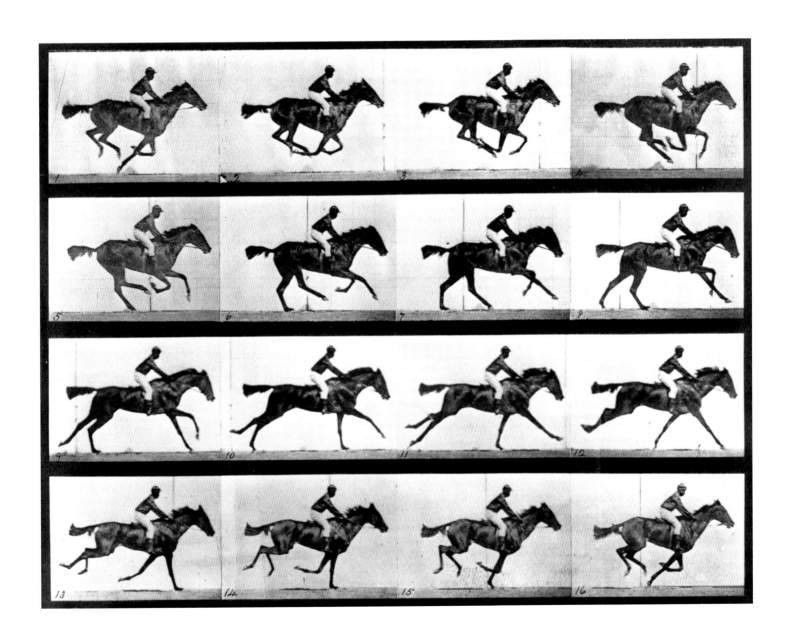

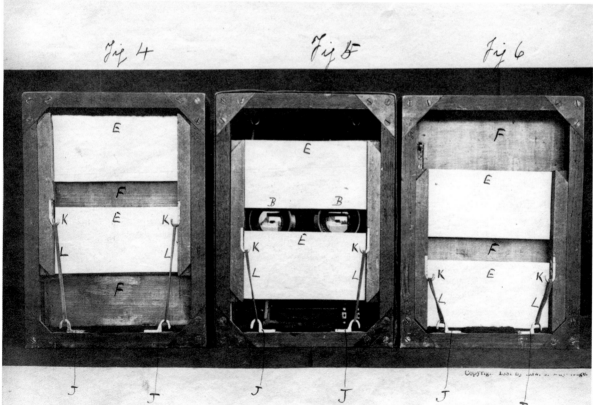

ABOVE: Eadweard Muybridge, the experimental camera shed at Palo Alto, California, 1877–79.

LEFT: Eadweard Muybridge, camera shutters from the Palo Alto experiments, 1878–79. The image shows the shutters in position before, during and after the subject has passed the camera.

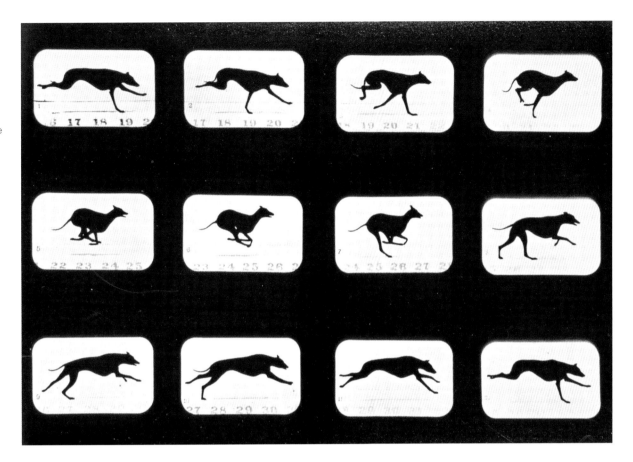

THE FLIGHT OF BIRDS.

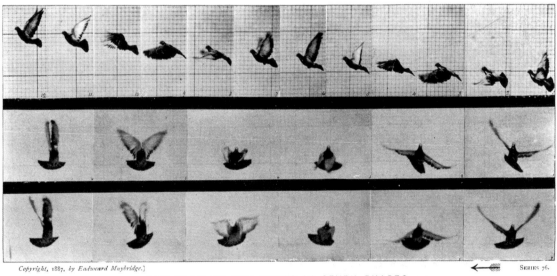

Copyright, 1887, by Eadweard Muybridge. ← SERIES 76.

ONE FLAP OF THE WINGS IN SEVEN PHASES.

PHOTOGRAPHED SYNCHRONOUSLY FROM TWO POINTS OF VIEW.

Homing Pigeon.

Time-intervals : ·019 second.

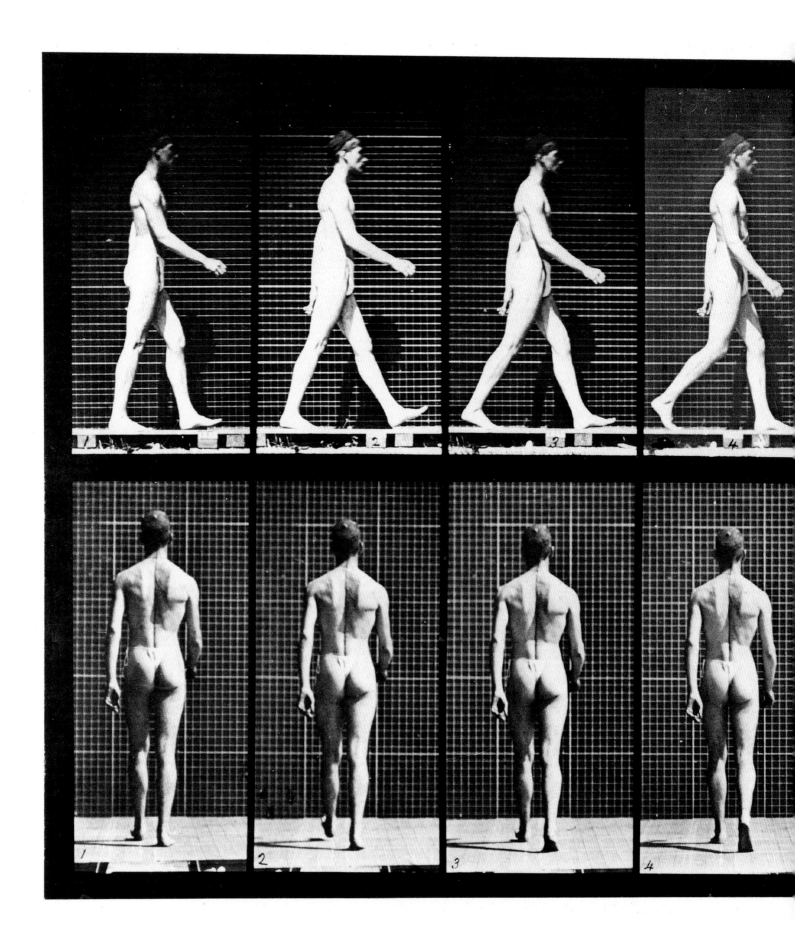

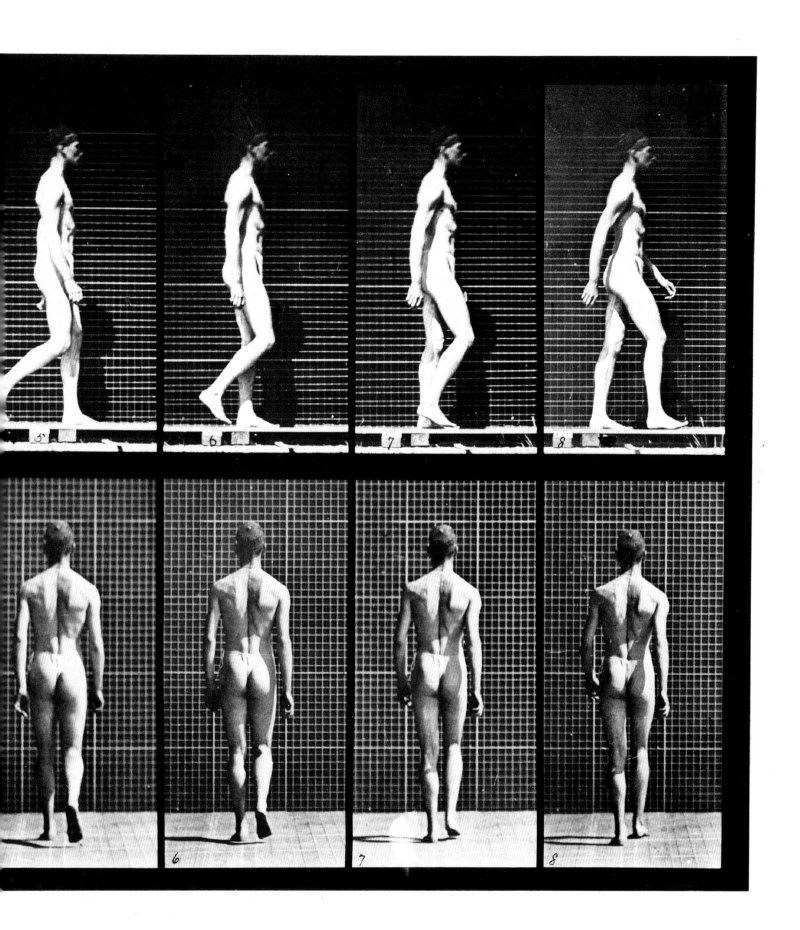

PAUL KLEE

Paul Klee (1879–1940) was influential both as an artist and educator. His art, as well as his journals and notebooks (subsequently published), chart a journey of invention with graphic and pictorial form, exploring ideas relating to stasis, movement and articulation of pictorial space. His connection with *Der Blaue Reiter* brought him into contact with other pioneering abstract artists of the early twentieth century, including Wassily Kandinsky and Franz Marc.

This was also a time of discoveries in the fields of science, which opened up to the imagination new ways of interpreting the world and our place within the cosmos. Albert Einstein contributed to redefining physics, while quantum chemistry began to reveal more about the fundamental atomic building blocks of nature.[1]

When Paul Klee decided to take "a line for a walk", he was developing a graphic process of interpretation and invention of how we perceive what we see. Through his art and his lectures at the Bauhaus, Klee enabled others to learn about composition and design from fundamental principles as he conceived them.[2]

Artists over the centuries have been intrigued by how to classify colour, hue and tone because these are among the building blocks for creating an image. Klee was also fascinated by this and we can see in the journals, drawings and watercolours his attempts to define principles for chromatic ordering. *Static-Dynamic Gradation* (1923) explores this, with the colour becoming increasingly chromatic and brilliant as the eye is drawn to the centre of the image from the more tonal and dark outer edges.

Although not intended to be scientific, Klee's approach was to describe processes that allow an artist to construct images that represent their ideas in a systematic way. He also notes, "The study of creation deals with the ways that lead to form. It is the study of form, but emphasizes the paths to form rather than the form itself." Of his own work, he noted: "Ingres is said to have created an artistic order out of rest: I should like to create an order from feeling and, going still further, from motion."[3]

For his art, Klee draws upon the natural world, architecture, the body and mind for inspiration. His work is a synthesis of forms we might recognize, but presented in ways that allow us to interpret them; the moon becomes a coloured shape as part of an abstract composition. In *Pastorale (Rhythms)* (1927), plant-like structures populate the surface. As in music, there is a visual notation being employed that provides a structure upon which the theme of the image is defined.

There is also a playful aspect to Klee's work, which can be seen in *They're Biting* (1920), a circular relationship between human and nature, perhaps depicting the artist's visits to the sea at this time to go fishing.[4]

Klee also experimented with the media he used, employing in this artwork a tracing technique he described as *olfarbzeichnungen* (oil-colour drawings) to apply the black oil paint drawing onto a watercoloured paper. In other works, he used unconventional supports and surfaces to paint on, making them physically suggestive of the visual forms and shapes he is composing with.

The spaces in Klee's imagined pictorial worlds find a balance between order and a dynamic that invokes a "temporal" space; they speak of the personal and the world around us in ways that encourage interpretation. They are celebrations of the experiences life affords and that we reaffirm on their viewing.

OPPOSITE: Paul Klee, *Sie beissen an / They're Biting*, 1920. Watercolour and oil-colour drawing on paper.

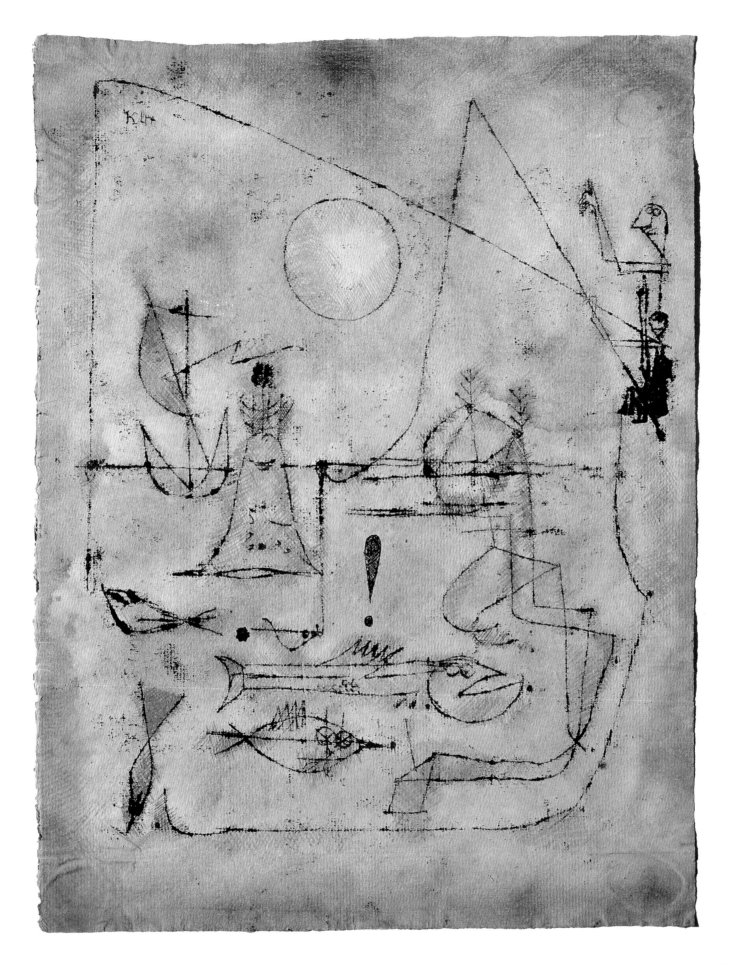

PAUL KLEE

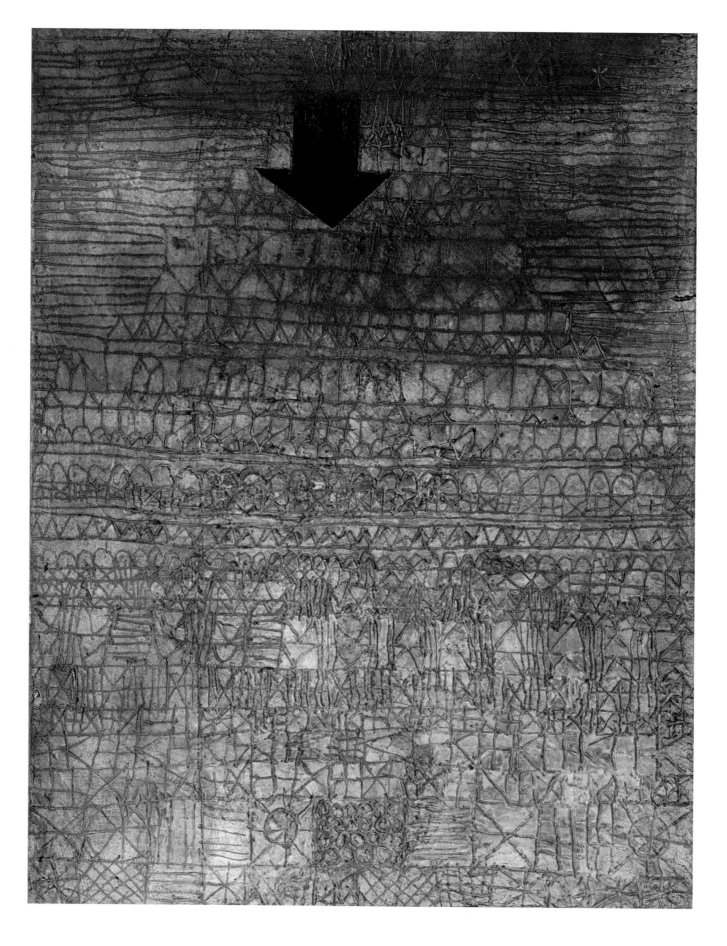

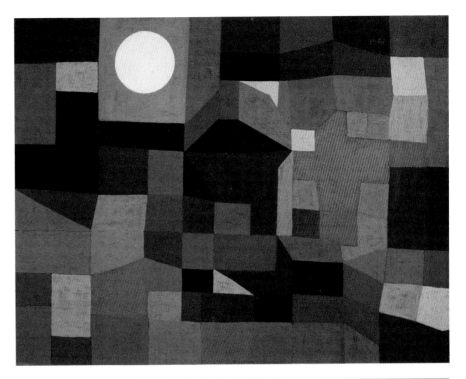

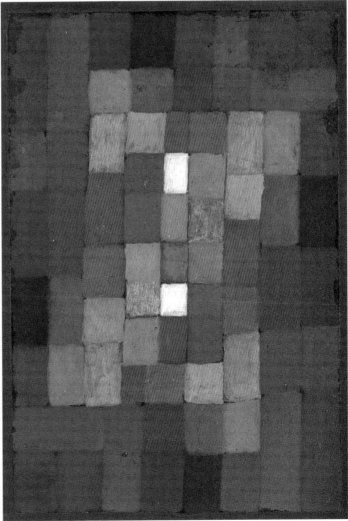

RIGHT: Paul Klee,
*Static-Dynamic
Intensification*, 1923.
Oil on canvas.

ABOVE: Paul Klee,
Fire at Full Moon,
1933. Oil on canvas.

OPPOSITE: Paul Klee,
Stricken City, 1936. Oil
on canvas.

LÁSZLÓ MOHOLY-NAGY

László Moholy-Nagy (1895–1946) was a Hungarian painter and photographer, sculptor, writer and much more, whose work embraced abstraction and new technologies.

Moholy-Nagy worked across numerous disciplines in the early and middle part of the twentieth century. Influenced by constructivism, he became a well-known professor at the Bauhaus, the influential German art school that sought to integrate the aesthetic principles attributed to the arts with technology, mass production, industry and functionality. While the Bauhaus was at the forefront of developing these new approaches to the relationship between art, design, industry and technology, Moholy-Nagy was one of the most prolific of its practitioners and was committed to radical experimentation.

Moholy-Nagy moved from Hungary to Berlin in 1920, where he met his first wife, Lucia. Even during the First World War, he had continued with a range of creative activities, and now it was Lucia who introduced him to the technique of making images called photograms. This involved working without a camera and directly exposing objects to light-sensitive paper, resulting in a "rendering of the familiar as strange" that involved playing with negative and positive images.[1]

The formal abstractions and experiments Moholy-Nagy undertook within the medium of photography, and his interest in exploring the potential of escaping the documentary nature of the photographic image, later led to his sculptural work *Light Prop for an Electric Stage (Light-Space Modulator)* (1929–30). This, in turn, became the subject matter for the black-and-white film *A Lightplay: Black White Gray* (1926). In this experimental abstract film, which involves a mechanical sculpture with light as its medium, he attempts to show how seeing is possible from multiple viewpoints and perspectives, echoing the work and investigations of cubist artists. His intention was to demonstrate how images, including still photographs and moving images such as film and cinema, had replaced traditional painting with what he termed "a culture of light", where objects moved through time and space (kinetics). He viewed photography and film as the media of the future and, in using the science of light in combination with creative media, he sought to blur the line between them.[2]

As well as working with both his first wife Lucia and his second wife Sybille Pietzsche (with whom he produced *A Lightplay: Black White Gray*, 1926), Moholy-Nagy collaborated creatively with – and influenced – many artists. These include Walter Gropius, Herbert Bayer, Marcel Breuer, György Kepes, and Istvan Seboek, the architect who worked with him on building *Light Prop for an Electric Stage*.

After travelling from Germany to London, he undertook commercial work, including poster design work for London Underground. Then, in 1939, Moholy-Nagy opened the School of Design in Chicago, and made courses in what was termed the "light laboratory", a part of the programme of study. The focus within this part of the curriculum, based like so much of his work on abstract compositions, was on expanding the experimentation initiated by his work and exploring technology, the science of "vision" and art. The school closed after a year due to lack of financial support. However, an entirely new visual language based on the interrelationships between art and technology would emerge from Moholy-Nagy's many cross-disciplinary experiments – one that continues to be highly influential today. As an extension and development of the ideas outlined in his 1938 book *The New Vision*, his further book *Vision in Motion* (1947) was published posthumously. In it, Moholy-Nagy outlined the School of Design curriculum, alongside his proposals for the integration of film, photography, painting, literature and science.

OPPOSITE: László Moholy-Nagy, *Yellow Circle*, 1921. Oil on canvas. This work is influenced by constructivism, but there is also a clear relationship between such early images as this and the later formal explorations with light kinetic sculptures.

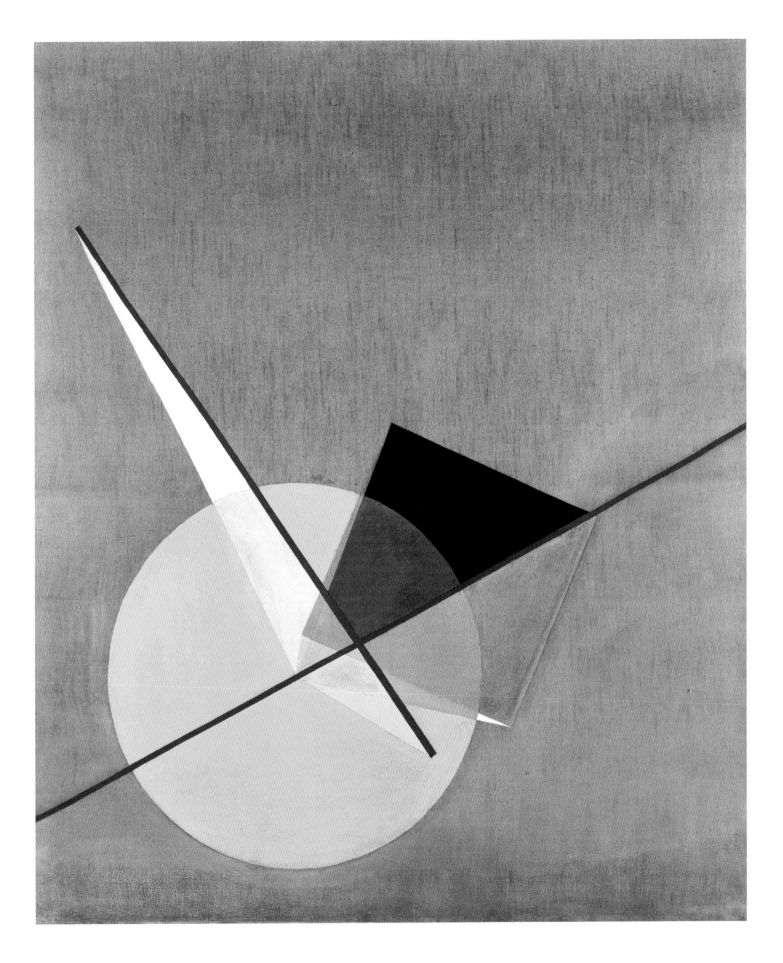

LÁSZLÓ MOHOLY-NAGY

LEFT: László Moholy-Nagy, *Untitled*, 1923. Photogram, gelatin silver print. Such images were produced by direct contact between objects and light-sensitive paper; exploring the medium of light and photography, without seeking to use a camera to directly replicate things "seen".

BELOW: László Moholy-Nagy, *Untitled*, 1927. Photogram. Influenced by both cubism and Constructivism, such images played with the notion of a single viewpoint, introducing multiple perspectives.

OPPOSITE: László Moholy-Nagy, *Leda und der Schwan* (*Leda and the swan*), 1925. Gelatin silver print.

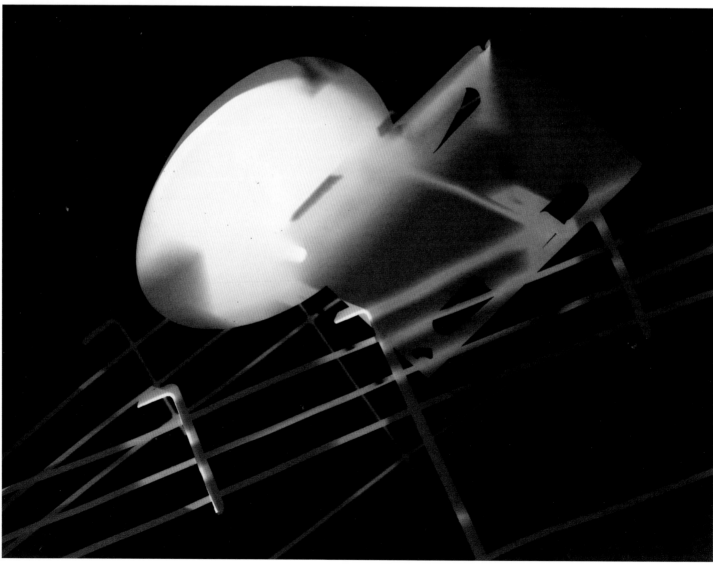

ABOVE: László Moholy-Nagy, *Light Prop for an Electric Stage (Light-Space Modulator)*, 1930, pictured on display in 1975. The first kinetic sculpture.

OPPOSITE: László Moholy-Nagy, *Light Prop for an Electric Stage (Light-Space Modulator)*, 1930.

ALEXANDER CALDER

Combining dynamic energy with the aesthetics of abstraction, the work of Alexander Calder hangs in perfect balance.

Alexander Calder (1898–1976) was an American sculptor, born of artist parents[1] who encouraged his creative expression from an early age. Given access to his own workshop and plentiful materials, he soon developed adept construction skills and gifted his parents his first kinetic sculpture at the tender age of nine. Initially, he pursued a career in engineering following the completion of his first degree, and his early work experience involved hydraulics and automotive engineering. Then, in 1922, inspired by a logging camp landscape in Washington, he turned towards the arts.

He moved between Paris and New York in the 1920s, and his early experimental works included *Cirque Calder*, a unique work of performance art constructed from wire, cloth and found materials. His love of manipulation and material juxtaposition resulted in multiple manifestations, including small-scale hacked "household objects"; numerous sculptural suspensions; freestanding sculptures; and large-scale public art works. Though his early wire sculptures were figurative, he became increasingly concerned with pursuing pure abstraction following his experience of Piet Mondrian's studio environment in 1930. Other peers at this time included artists Fernand Léger and Marcel Duchamp, and his pioneering role as an avant-garde artist helped him secure solo exhibitions in New York, Paris and Berlin.

Common themes and concerns permeate Calder's rich and prolific career. Often starting small and experimental, his works evolved in scale and ambition as ideas and professional opportunity permitted. Calder balanced pragmatism and ambition depending on circumstance. For example, during the Second World War, when metal was scarce, he turned to wood and scavenged materials to make a series of Constellations suggestive of "some kind of cosmic nuclear gases," to quote the artist. Later on, he took on numerous large-scale commissions that enabled him to push the possibilities of abstraction in sculptural form to a monumental scale.

While certainly more at home with three dimensions, Calder also produced paintings, drawings and graphical works, and numerous colourful lithographs and posters. He was able to turn his hand to any creative challenge, from theatre sets to jewellery designs, tapestries to political posters.

By the 1960s, Calder's talents were world-renowned, and retrospective exhibitions were held at the Guggenheim Museum in New York (1964) and the Fondation Maeght in France (1969). Just weeks before his death aged 78, he attended the opening of his largest solo show, *Calder's Universe*, at the Whitney Museum of American Art in New York (1976). Across his long and energetic career, with each period productive and dynamic, Calder balanced a profound dedication to artistic exploration with a lightness of touch, the quality of someone who observes the world intently and delights in all it holds.

Kinetic sculptures

Calder is most renowned for his kinetic sculptures, the *mobiles* (moved by air currents or motors) and the standing mobiles (stationary bases with mobile elements), where abstract geometric forms are suspended in perfect balance.

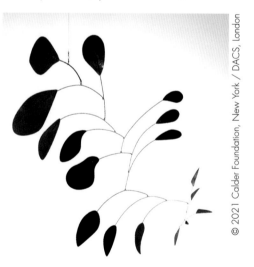

ABOVE: Alexander Calder, *Untitled*, 1941. Sheet metal, rod, wire, and paint. Height: 152 cm (60 in).

© 2021 Calder Foundation, New York / DACS, London

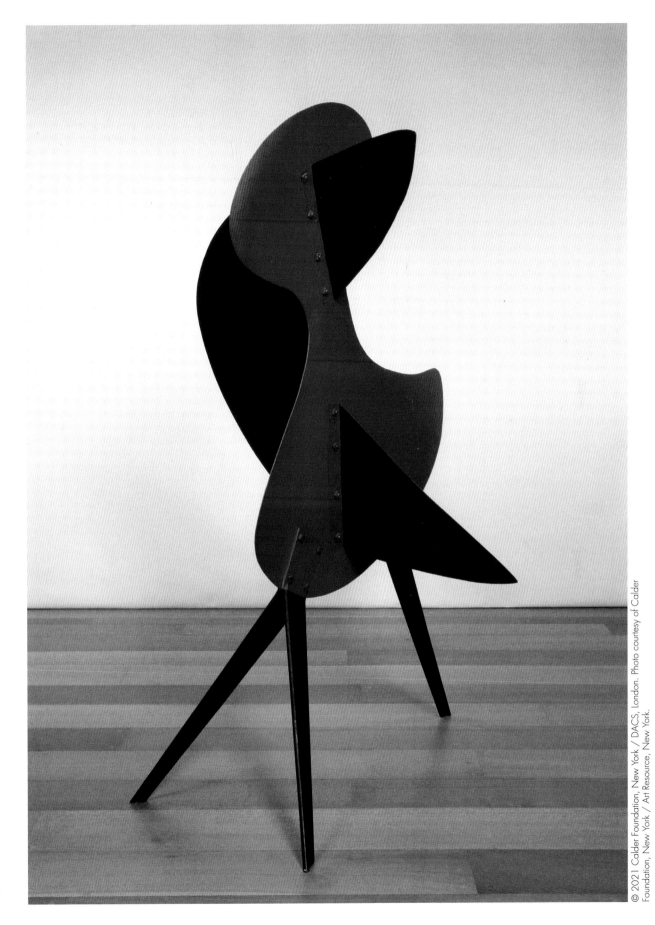

RIGHT: Alexander Calder. *Big Bird*. 1937. Sheet metal, bolts, and paint.

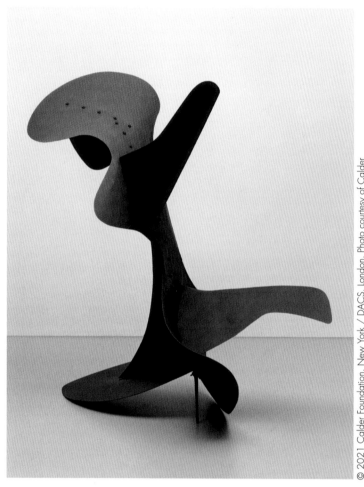

ABOVE: Alexander Calder. *Devil Fish*, 1937. Sheet metal, bolts, and paint.

ABOVE RIGHT: Alexander Calder. *Morning Star*, 1943. Painted sheet steel, steel wire, and painted and unpainted wood.

OPPOSITE: Alexander Calder, *Birthday Cake*, 1956. Tin cans, aluminium and wire.

NEW ABSTRACTIONS

In the early part of the twentieth century, new concepts of space and time were informing changes in scientific and artistic thinking. Advances in mathematics proposed new geometries with interest in higher-dimensional spaces than the three dimensions defined by Euclidean geometry. This led to new representations by artists of what the fourth and higher dimensions might be and how they could be interpreted.[1]

Artists associated with analytical cubism in France (c.1907) explored how observed forms in nature could be depicted from varying angles, giving the impression of three-dimensional constructions derived over a period of time.[2] Reinterpretation of pictorial space, as seen in the paintings of Georges Braque and Pablo Picasso, among others, allowed for the melding of forms to impart a more complex reading of the subject, the abstraction fragmenting and redistributing portions of space to create a new, amalgamated "simultaneous" space. The concluding form appears to be perpetually in a state of flux;[3] a recognizable object is still comprehensible but depicted in a way that challenges spatial interpretation.[4]

Filippo Tommaso Marinetti's book *The Manifesto of Futurism* (1909) expounded a rejection of the past and embraced instead speed, machinery, industry, war and youth.[5] The dynamics of industry and movement are embraced in artworks by Giacomo Balla, Umberto Boccioni and Gino Severini, contributing to the futurists' ambition to modernize and culturally rejuvenate Italy.[6] Boccioni's interpretation of simultaneity was different to that found in analytical cubism and is expressed as a "style of movement"[7] and

in the concept of a unique form that gives continuity in space.[8]

The 0,10 Exhibition in Petrograd (1915) presented abstract paintings by a group of artists whose works were a radical departure from earlier pictorial conventions in Russia. Notions of higher dimensions were explored through the intersections of geometry, surface and time in the planar compositions of the suprematist artists. The painter Kazimir Malevich wrote, "Space is a receptacle without dimension into which the intellect puts its creation. May I also put in my creative form."[9] He also stated, "The main basis of the new painterly science has disclosed a new circumstance: time, and has called it the fourth dimension of the object."[10]

Constructivism, both within Russia and in its wider European manifestations, also welcomed new technologies and media to create artworks that explore the temporal experience of spatial interaction between two and three dimensions, incorporating architectonic, kinetic, constructed, optical, photographic, pictorial and graphic elements. Evidence of how different artists interpreted abstraction and higher dimensions can be found in the work of El Lissitzky, Lyubov Popova and László Moholy-Nagy.[11]

The De Stijl artists (1917) sought to go

beyond cubism, advocating total abstraction in art as a way to eradicate subjectivity in the creation and interpretation of form.[12] Along with the Dutch theosophist M.H.J. Schoenmaekers, Piet Mondrian believed that visual phenomena have underlying universal mathematical harmonies.[13] The preoccupation with how the fourth dimension might be defined also embraced time and movement in Theo van Doesburg's explorations with film and architectural space, which followed the earlier neo-plasticist paintings.

The investigation of space and time expressed by artists and scientists over subsequent generations continues to challenge our perception and inform and inspire research and art today.

OPPOSITE: Georges Braque, *La Mandora*, 1909–10. Oil on canvas.

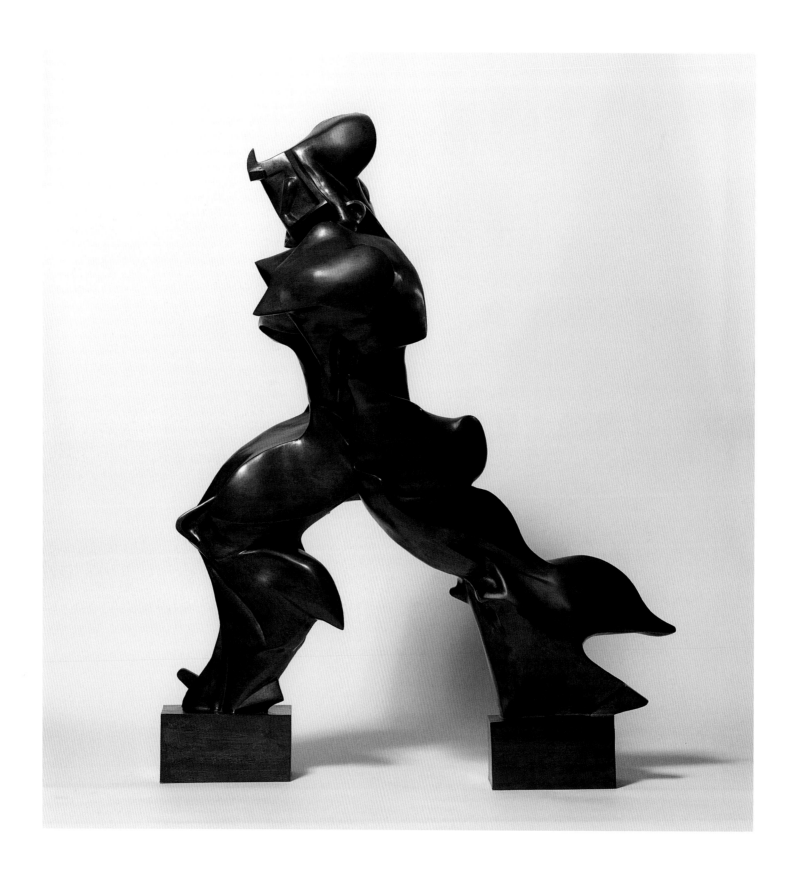

ABOVE: Umberto
Boccioni, *Unique Forms
of Continuity in Space*,
1913. Cast bronze.

ABOVE: The 0,10 Exhibition, presented by the
Dobychina Art Bureau at Marsovo Pole, Petrograd,
19 December, 1915 – 17 January, 1916.

NEW ABSTRACTIONS

RIGHT: Lyubov Popova,
Painterly Architectonic,
1916. Oil on board.

ABOVE: Piet Mondrian,
*No. VI / Composition
No.II*, 1920. Oil on
canvas.

KENNETH AND MARY MARTIN

Faced with a wide array of choices when deciding what to compose, some artists draw inspiration from what they see around them: perhaps an interior, a view of a landscape, or a still-life composition. But for an artist who wishes to compose an image not dependent on realizing a likeness of something in nature, there are other choices that can be made.

While all images are by their nature abstract (i.e. they are interpretations and compositions of observed natural forms or of formal elements not found within nature), there are some artworks that are composed by including only visual forms and elements that have been created by the human mind. Two artists who have pioneered this way of working are Kenneth Martin (1905–84) and Mary Martin (1907–69).

While each worked independently as artists, they did share common interests and explored themes that are fundamental to understanding systematic composition (by creating a set of predetermined rules for making an artwork). Their work also influenced their contemporaries, both in the UK and internationally, and subsequent generations of artists.[1]

Kenneth and Mary Martin emerged as artists from the destruction wrought by the First and Second World Wars. As countries rebuilt, so a new optimism found expression in the work of artists seeking to contribute to renewal. There was a pressing need to find a rationale for how to construct. Modernism was being defined as a way of inventing and making that also acquired a social dimension, and this was a driving force for artists including the Martins.[2]

Their approach encompassed exploring fundamental pictorial and sculptural elements.[3] This meant considering space, light, colour, orientation (direction), proportion and articulation (construction). For Kenneth Martin, this involved investigating spatial ordering, and developing mathematically defined relationships between elements. In his set of mobiles, this resulted in composing meticulously calculated drawings that served as mechanical drawings for the making and construction of the artworks.

In his Chance and Order series of drawings and paintings, we can observe different ordering principles at play as the location of lines connecting points on a grid are determined through sequential ordering of elements according to invented rules and through a process of chance allocation.[4]

Mary Martin's approach also explored ways of systematically ordering space, embracing reflections of light within wall reliefs composed of geometric elements to form the overall construction. Within each work, there are a number of possible ways (permutations) to order the compositional elements selected for orientation (up, down, left, right) and the number of different ways they can be ordered in groups, the whole generating an overall geometry of space (square, rectangular, diagonal, cruciform).[5]

Light also meets colour in Mary Martin's later compositions with Perspex, artworks that play with transparency and opacity in the rectilinear compositions. In them, proportions between each element are carefully considered, exploring mathematical relationships defined by Fibonacci sequences, an ordering principle also observed in natural growth forms such as plants.[6]

In both artists' work, we can observe the desire to find ways to construct new forms using artificially defined relationships. There are synergies here with architecture and design to be found in an increasingly mechanized and computationally interconnected society. There is also a poetry of form that invokes analogy with musical composition and the incorporation of time as an element within the artworks' construction. These are artworks that encourage contemplation of the choices made in their composition.

OPPOSITE: Kenneth Martin, *Small Screw Mobile*, 1953. Brass and steel.

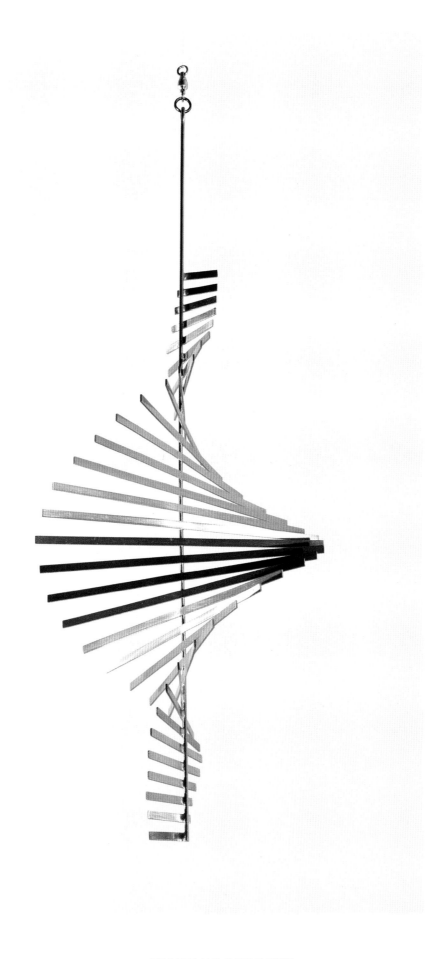

RIGHT: Kenneth Martin, *Chance and Order Group VII, Drawing 6*, 1971. Crayon, graphite and watercolour on paper.

OPPOSITE: Mary Martin, *Perspex Group on Orange (B)*, 1969. Perspex and wood.

KENNETH AND MARY MARTIN

ABOVE: Mary Martin,
Inversions, 1966.
Aluminium, oil paint and
wood.

ABOVE: Kenneth Martin,
*Chance, Order, Change
12 (Four Colours)*, 1980.
Oil on canvas.

NAM JUNE PAIK

"Feedback", "interference", "static" – these are just a few of the words to enter the popular lexicon with the advent of the television age, terms not lost on Nam June Paik (1932–2006), who pioneered the use of video in art.

Today we take it for granted that we carry a smartphone with much greater processing power than these earlier devices as well as a miniature, high-definition screen. In the 1960s, there was no satellite TV, no programming on demand.

Paik's world was one of emergent and advancing technologies, of Sputnik and the space race, valves and transistors, and yet his points of reference hark further back while the implications of his work continue to resonate today. Born in Seoul, Korea, in 1932, he studied in Japan and then Germany before moving to the USA to live from 1964.[1]

His is a knowing art, one based on contemplation and identifying the paradoxes posed by technology, new and old, and how this relates to interaction with time, machines and the human spirit. It is also playful, enjoying the visual and performative conundrums that engage, beguile and challenge our expectations.

A piano is stripped bare, revealing the mechanism. Video cameras and lights hover and gaze from strategically located positions, their images relayed to a jumble of monitors above. An automated process begins and the piano begins to play itself, while video sequences simultaneously reveal moving images of pre-recorded video fragments and live feed from the video cameras. The sporadic "music" appears random, inviting consideration of the many possible states in which action and repose, sound and silence, can manifest themselves. There is the anticipation of what is, in relation to what might be, as we consider the possible pasts and futures of this artwork.

About his own work, Paik states, "Music is the manipulation of time ... As painters understand abstract *space*, I understand abstract *time*."[2] Allusions, perhaps, to the physics of both time and space. Taking another perspective, we are perhaps now too used to relating to a television as a passive observer, a predetermined diet of content prepared for our "entertainment".[3]

TV Buddha (1974) is a Buddha sculpture contemplating his image while we look on. We are no longer located in the role of the television spectator, yet we are engaged in witnessing the real-time contemplation of an event that is potentially timeless; we become the spectator of the spectacle. This can be seen as a playful conundrum of time and existence, that both draws you in and yet is intrinsically self-contained.

By contrast, *Electronic Superhighway: Continental U.S., Alaska, Hawaii* (1995) is almost overwhelming, a vast structure incorporating 51 sets of monitors, neon lighting and a live feed, assembled in the form of the USA. This is cacophony writ large, yet the unifying geography of its form both contains and enables its reading over time. With Paik's work, a melding of the performative with the familiar set in a context not previously envisioned offers new possible ways of interpreting both how and what we see.

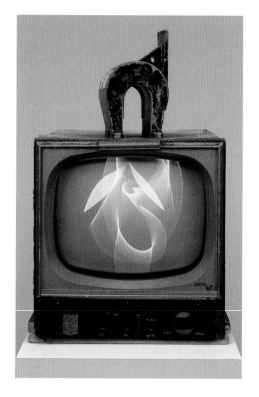

ABOVE: Nam June Paik, *Magnet TV*, 1965. Modified black-and-white television set and magnet.

OPPOSITE: Nam June Paik, *Piano Piece*, 1993. Closed-circuit video sculpture.

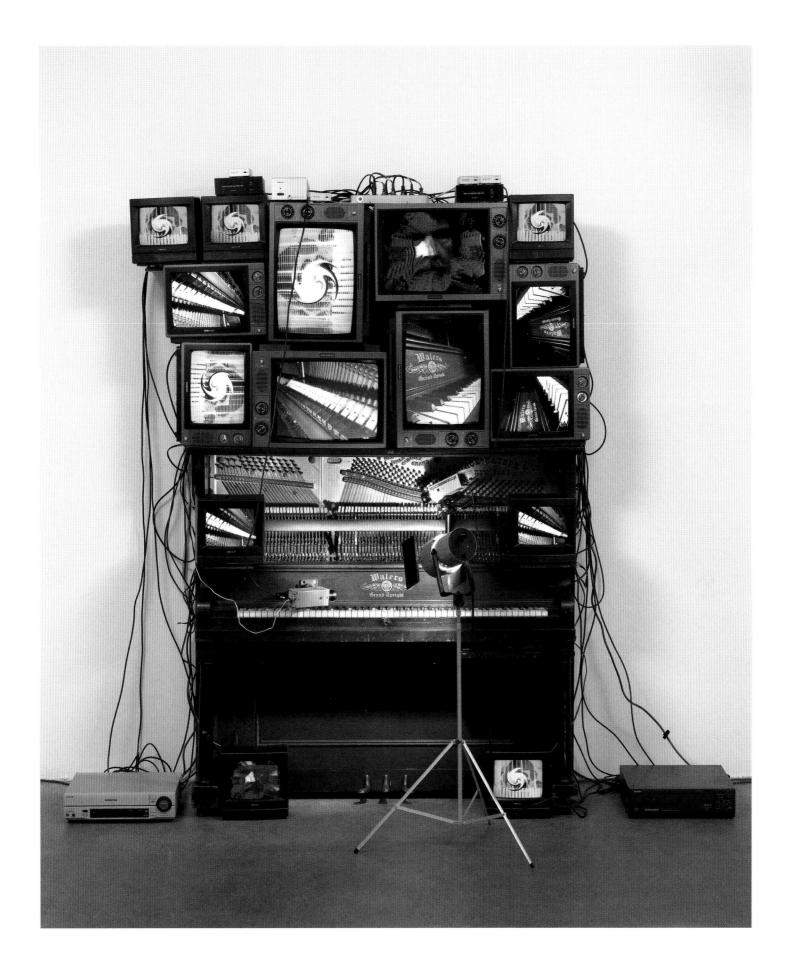

RIGHT: Nam June Paik,
TV Buddha, 1974.
Install view, Museum of
Modern Art, New York
1977.

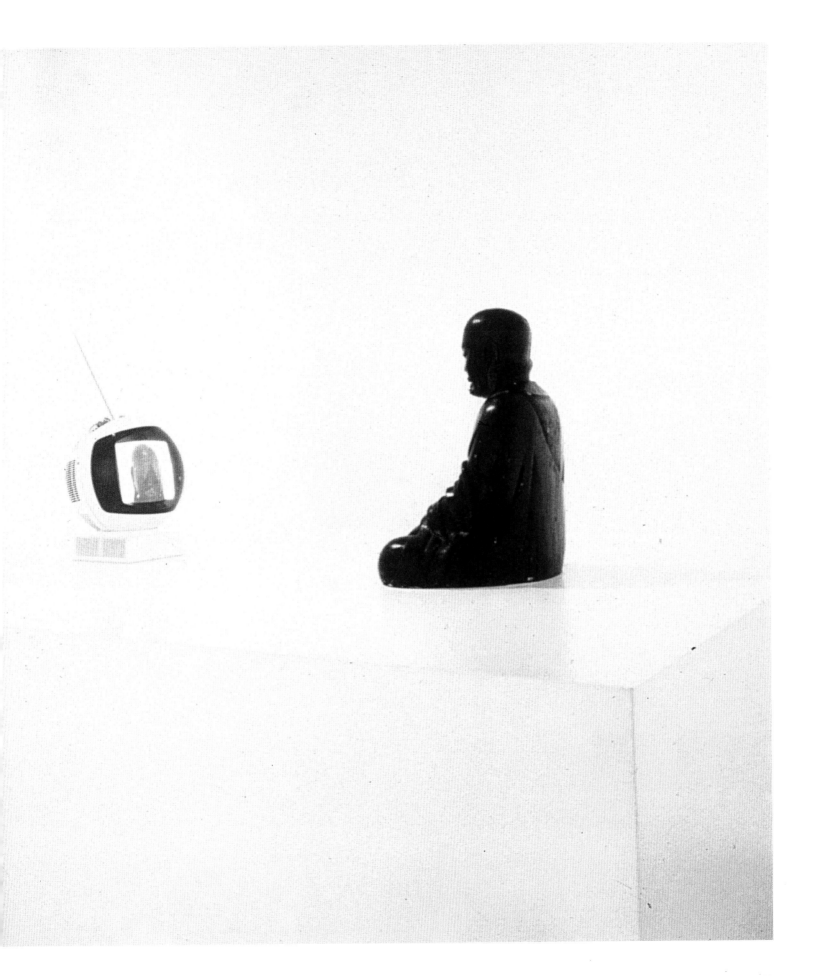

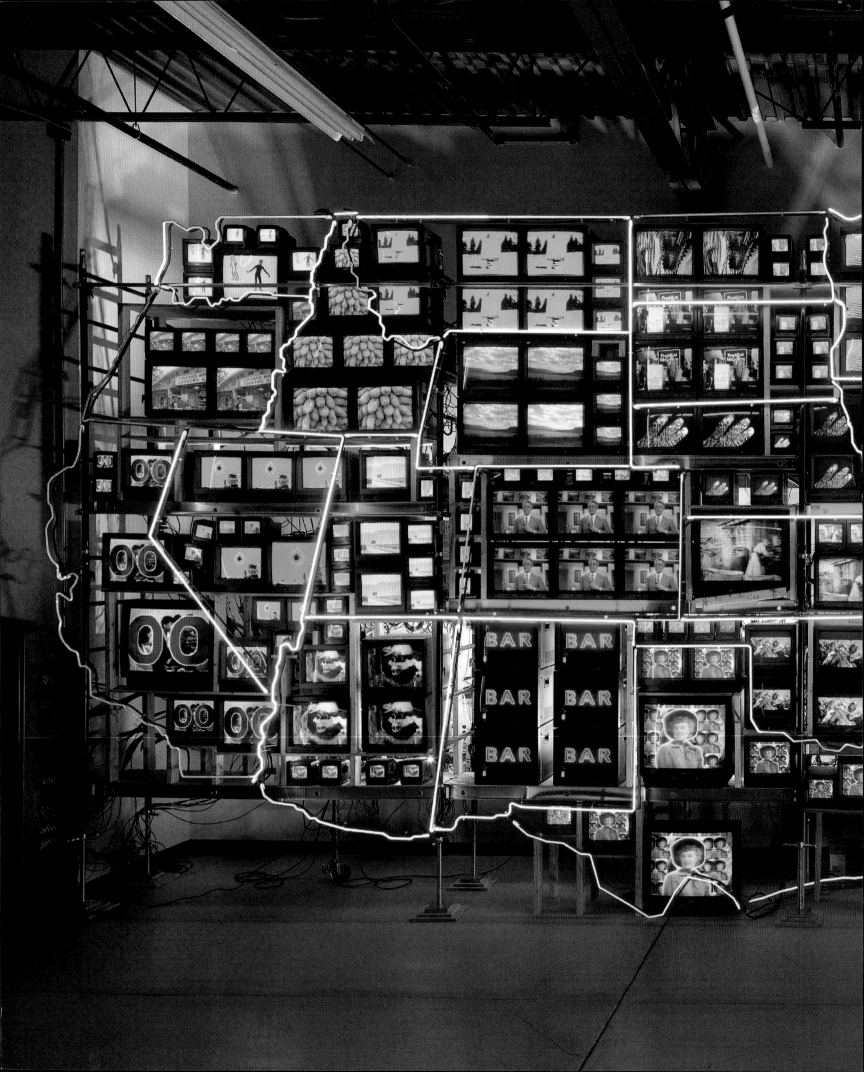

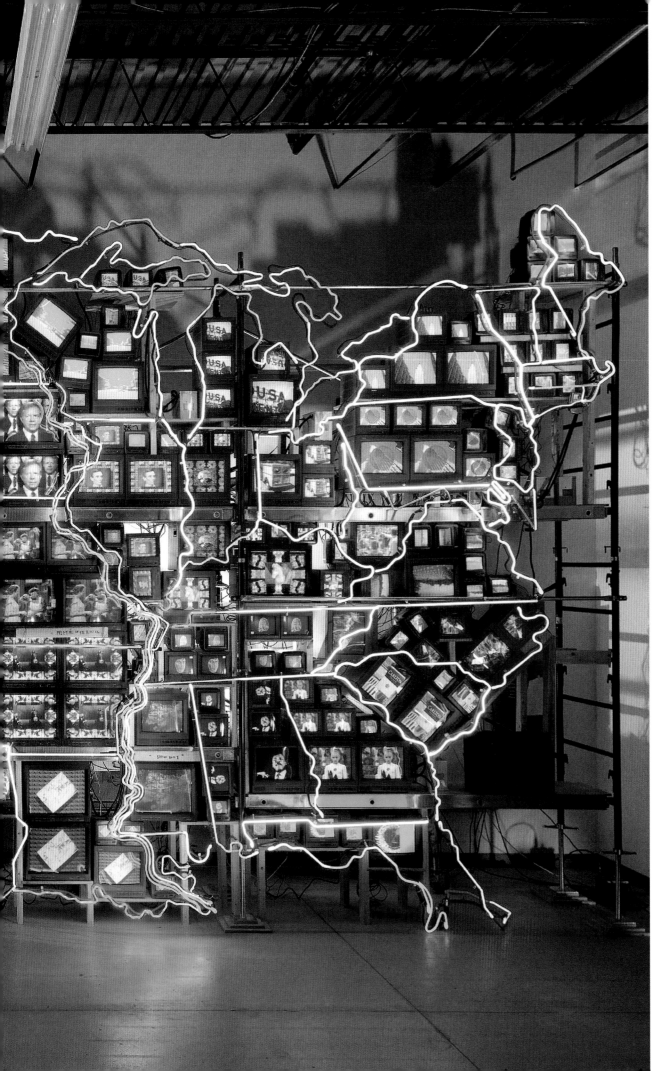

LEFT: Nam June Paik, *Electronic Superhighway: Continental U.S., Alaska, Hawaii*, 1995. Fifty-one channel video installation (including one closed-circuit television feed), custom electronics, neon lighting, steel and wood, sound.

MARIO KLINGEMANN

Mario Klingemann (born 1970) is a code artist working with algorithms, data and artificial neural networks. He investigates the possibilities that machine learning and artificial intelligence offer in understanding how creativity, culture and their perception work. One common denominator in his work is the desire to understand, question and subvert the inner workings of systems of any kind. Art as a system is of particular interest: "What makes an image to be perceived as art and another one not?", "What is an artist?"[1]

He taught himself programming in the early 1980s and has since been trying to create algorithms that are able to surprise and show almost autonomous creative behaviour. With his work involving neural networks, he introduced the concept of the latent space, an internal abstract representation of what a neural network has learned, which is multidimensional. He also coined the term "neurography", which is short for neuro-photography: "Like a photographer goes out into the physical world, selects a motive and frames it, I travel into the latent spaces of the models I trained and bring back the images I find there. The difference to the real world is that with every model I train I can create an entirely new universe with different rules and behaviours."[2]

X Degrees of Separation (2016) is an installation and online experiment that resulted from Klingemann's residency at the Google Arts and Culture Lab in 2016.[3] His installation employed Google's algorithm, which drives its artwork image search, using the visual-feature vectors of those artworks to find other artworks or artefacts so that, step by step, a gradient is created through forms, shades, textures or colours that lead from a painting to a sculpture.

In 2017, Klingemann designed a neural network that uses what he called a "pose-to-image approach" to produce its own artwork. *My Artificial Muse* (2017–20) was an installation where human artist Albert Barqué-Duran performed a live-painting show using oil paint, reproducing an artwork completely designed by an artificial neural network.

One of his video works, *Freeda Beast – Bringing Things to an End* (2017), uses various neural networks. The faces are generated using a Pix2Pix GAN (generative adversarial network)[4] from biometric face markers which are directly controlled by the music itself, including the cuts and effects. The various styles of the faces are either created with style transfer or a technique Klingemann calls GAN2GAN, in which he chains together various GANs that have been trained on transforming faces.

Neural Glitch is a technique Klingemann started exploring in April 2018, in which he manipulates GANs, a class of machine learning system that uses training data sets to create new data. By introducing glitches, he caused the models to misinterpret the input data in interesting ways, which could be interpreted as either glimpses of autonomous creativity or simply the result of the pre-programmed introduction of the glitches.

Klingemann believes that AI and computers have the ability to break us out of the confines of existing tradition and that the art is not just in the images, which disappear, but in the computer code that creates them. He says, "What machines are still missing is the ability to understand what they are making or developing their own motivation to do so. Once machines can make up believable and interesting stories, they will also be able to tell themselves their own stories, which in turn can direct their creativity or give us as an audience explanations as for why they have chosen to generate something."[5]

OPPOSITE: Mario Klingemann, *X Degrees of Separation*, 2016.

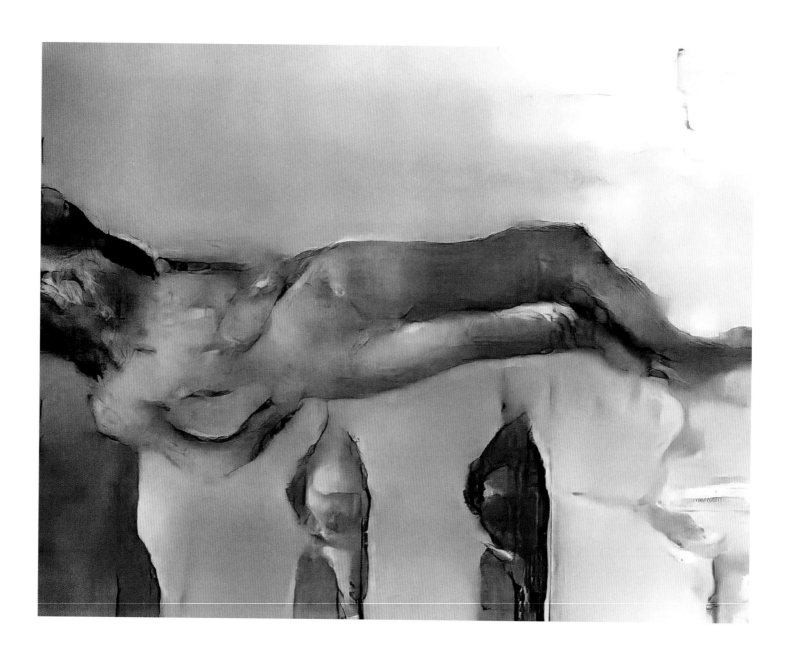

ABOVE: Mario Klingemann, *My Artificial Muse*, June
13, 2017. The first mural/fresco painting designed
by an Artificial Neural Network was created during a
three-day performance at Sónar+D 2017 in Barcelona.

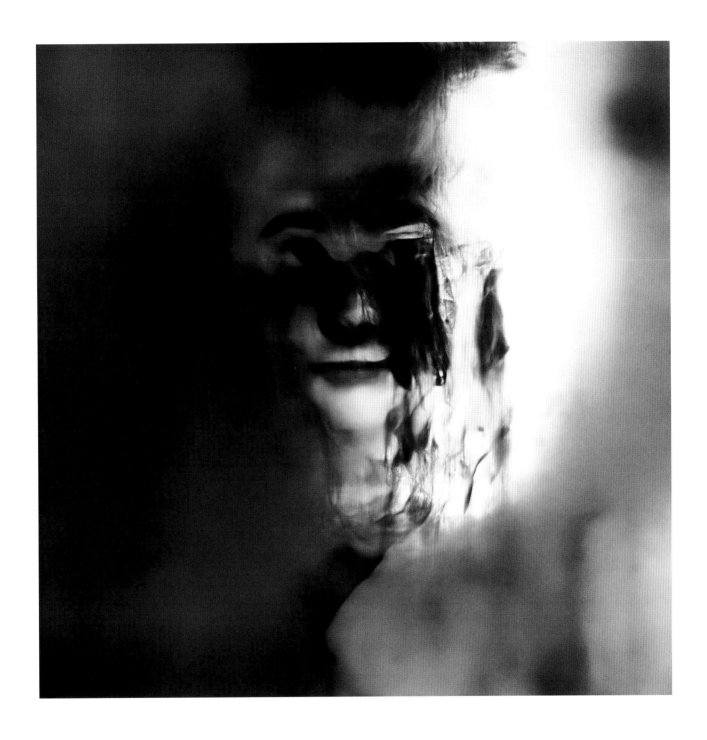

ABOVE: Mario Klingemann, *Neural Glitch/Mistaken Identity*, 2018. GAN, glitch, neural art, neural glitch, neurealism, neurography.

FRED EVERSLEY

"The genesis of energy is central to the mystery of our existence as animate beings in an inanimate universe." – Fred Eversley

Fred Eversley (born 1941) is an American artist whose work is informed by his lifelong studies of light, space, time and gravity. Born and raised in Brooklyn, New York, he studied electrical engineering at the Carnegie Institute of Technology (now Carnegie Mellon University) in Pittsburgh before moving to Los Angeles in 1963 to work for Wyle Laboratories, where he was responsible for supervising the design and construction of high-intensity acoustic and vibration test laboratories at NASA facilities.

Artists have, for centuries, sought to capture the properties of light in their work, both as illumination and a source of inspiration. This has been enhanced by technological inventions, including the lens (telescopes and microscopes) to the invention of photography, light bulbs and the laser. The sun as a source of energy has inspired many cultures and continues to fascinate today as we learn more about its properties and the nature of light, and how this can be harnessed for our practical needs.

In Eversley's work, this is captured in the referencing of lenses and reflectors that concentrate and refract light. Polished surfaces play with reflection, which is also an important element within the construction of the artworks, allowing for dynamic interaction with their environment. There is a sense of kinetic interplay between forms that shift as the light changes, articulating through intensity and shadow a resonance with the space within which they are located.

Colour and transparency are explored, prismatic and fish-eye like in the artworks' formal construction, encapsulating reflections of the space and objects whose embrace they both capture and reside within.

Convex and concave, the forms are conceived to focus light as an expression of energy, at once tangible and metaphysical. The parabolic shapes resonate with forms found in nature and have inspired Eversley's artwork for many years.

There is an exploration of the complimentary properties of translucency and opacity. Capturing the spectrum of electromagnetic energy these artworks act as reflectors, projecting the light into a space that exists between the parabolic surface and the viewer. This is engaging, inviting interaction with the construction that is simultaneously physical and ethereal. It also utilizes the theory of the Savonius Rotor windmill in its design, a type of vertical-axis wind turbine (VAWT) used for converting the force of the wind into torque on a rotating shaft.

The power of another force that is constantly with us and yet remains unseen is also utilized in Eversley's artwork. Wind drives the motion of his parabolic constructions that combine the physicality of their structure with liquid reflections, animating the forms that engage with the natural energy around them.

"The concept of energy transcends mathematical description or its application in classical Newtonian mechanics as well as its currently accepted roles in the twin intellectual revolutions of Einstein's special theory of relativity and Planck's theory of quantum mechanics. The genesis of energy is central to the mystery of our existence as animate beings in an inanimate universe."
– Fred Eversley

OPPOSITE: Fred Eversley, *Untitled (parabolic lens)*, 2018. Cast polyester, 10.2 x 56.5 x 56.5 cm (4 x 22 ¼ x 22 ¼ inches).

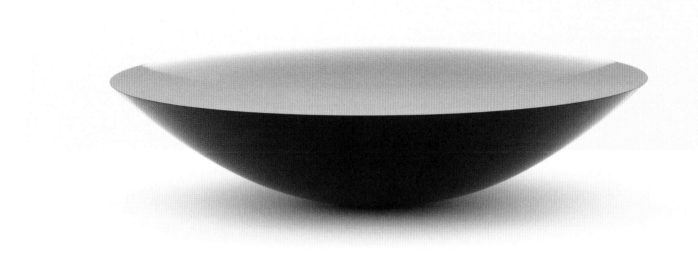

FRED EVERSLEY

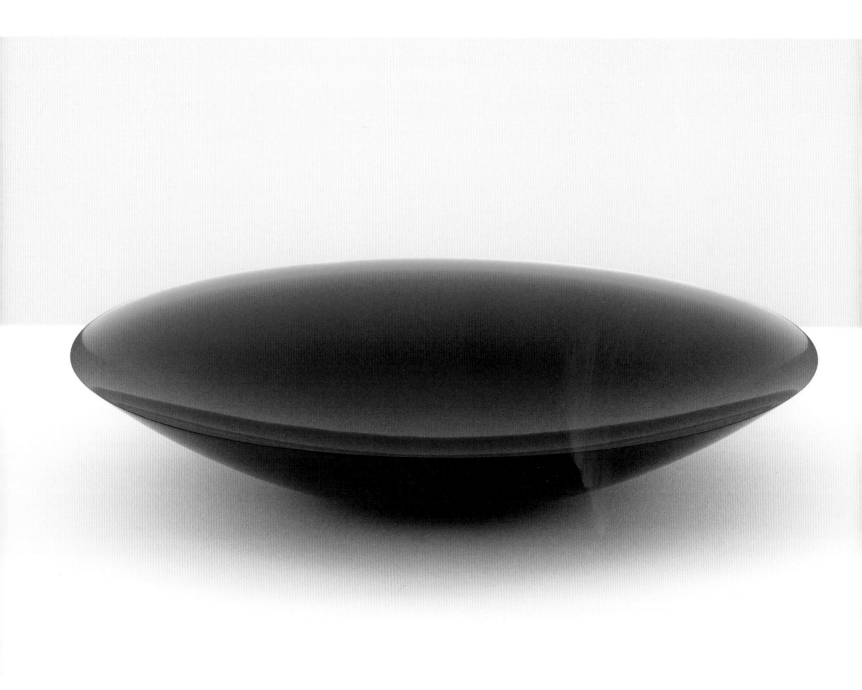

ABOVE: Fred Eversley,
*Untitled (double
parabolic lens)*, 2003.
Cast polyester, 8.9 x 47
x 47 cm (3½ x 18½ x
18½ inches).

OPPOSITE: Fred Eversley, *PARABOLIC FLIGHT*,
1980. Mirror polished stainless steel and neon light,
4.8 x 4.,8 x 10.7 m (15 x 15 x 35 ft).
Miami International Airport, Miami, Florida.

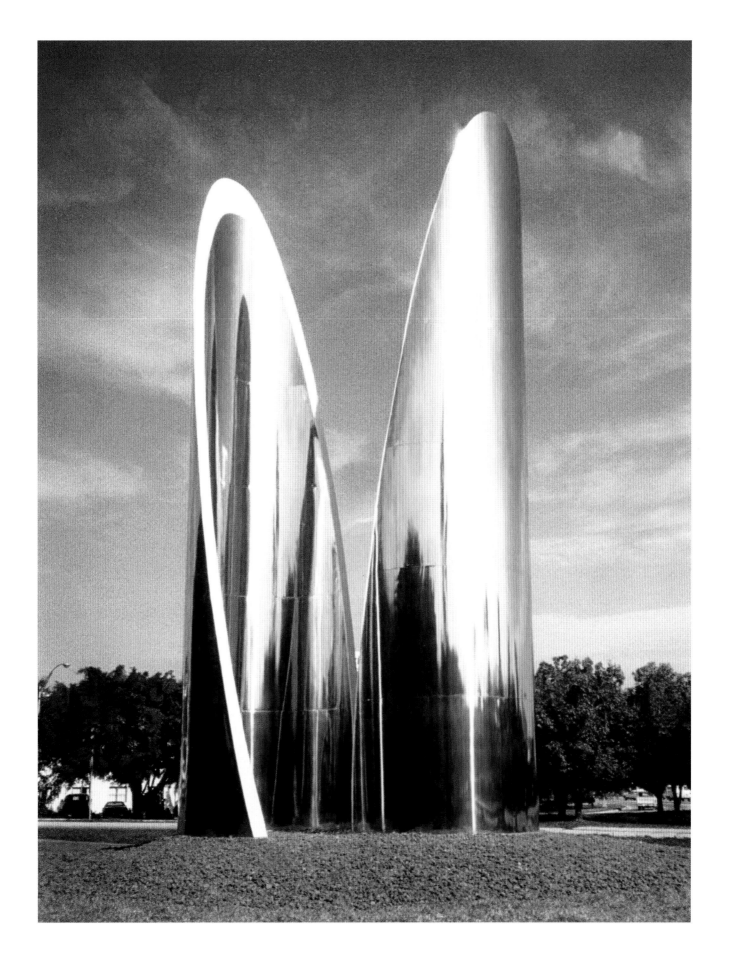

FRED EVERSLEY

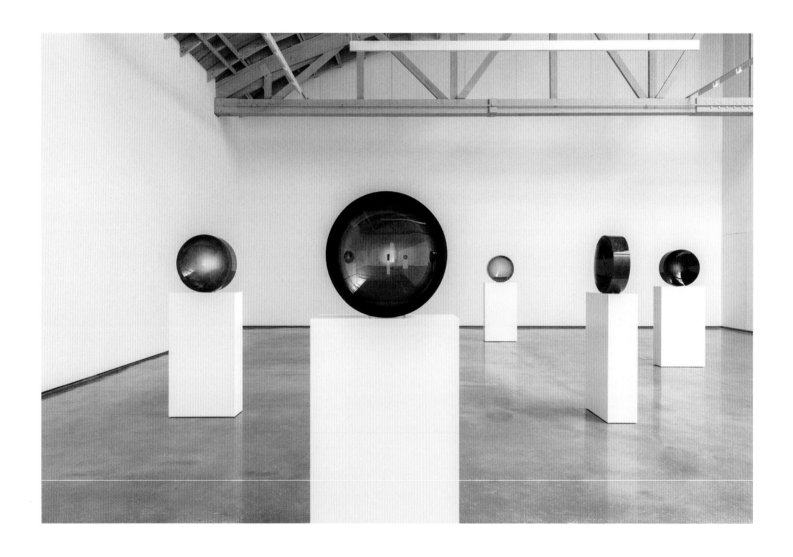

ABOVE: Fred Eversley,
*Untitled (ten parabolic
lenses)*, 2018. Cast
polyester. Exhibited
at David Kordansky
Gallery, Los Angeles.

OPPOSITE: Fred Eversley,
HEX, 1996. Painted aluminium
and clear acrylic, 213 x 183
x 365 cm (7 x 6 x 12 ft). IRS
National Headquarters.

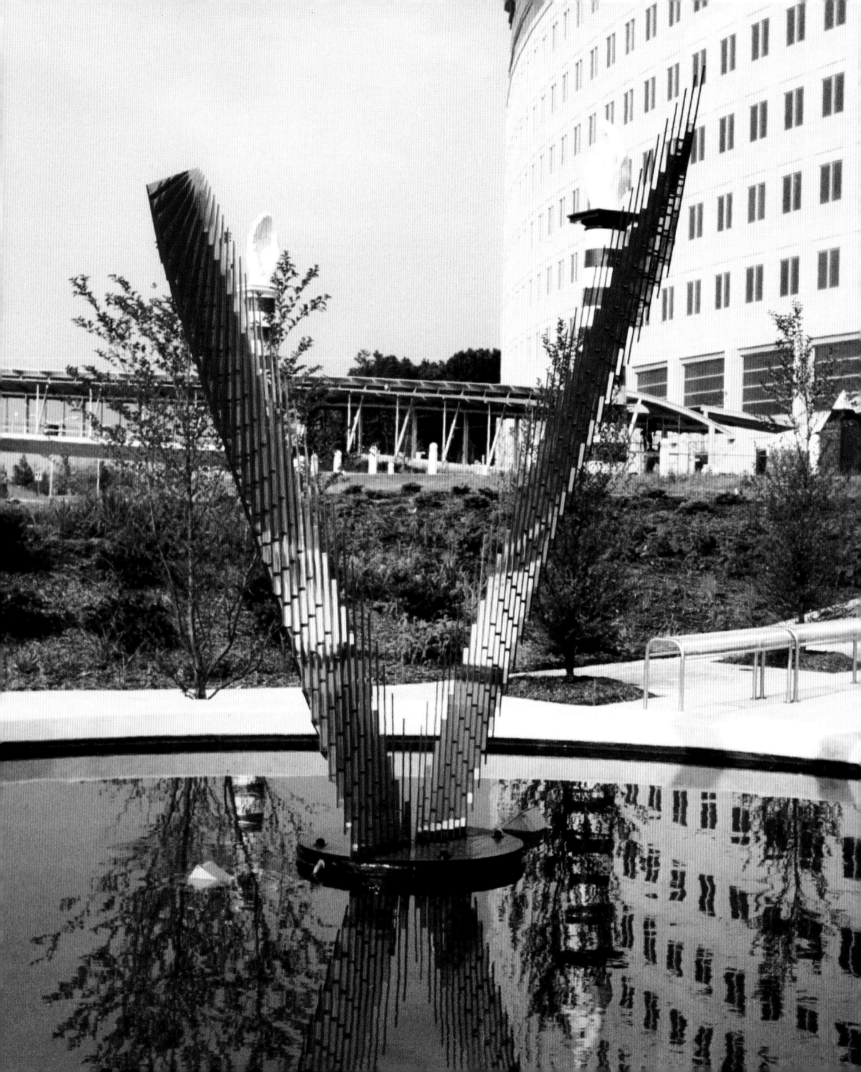

NATURE

&

BEYOND

The English word "nature" is far from easy to define. Derived from the Latin *natura*, itself derived from the past participle for *nascere* and meaning "to be born", it carries the sense of fundamental, inherent character; of that which is, or, more dynamically, of that which makes itself. It has often been personified as a goddess, "Mother Nature", yet, with the rise of modern science, nature has generally come to be distinguished from God and Spirit, and to refer more to the "material world" – although we may note that the word "material", like "matter", is nevertheless derived from the Latin *mater*, meaning mother. Nature today is also distinguished from the human world of culture, and from the made world of human artifice.

Art has often been based upon the observation of nature, and there are similarities, as well as differences, between the concept of art that arose in the Classical world of the Mediterranean and the Middle East, from the 8th century BCE, based upon *mimesis* – the imitation of nature, and the tradition of art that developed in China in the Qin and Han dynasties, 221 BCE–220 CE, based, in part, upon resemblance to what the eye sees. The Chinese artist Huang Quan made paintings based on close observation of nature long before the European Renaissance, and the influence of Chinese painting conventions and techniques upon the European artist Albrecht Dürer and his contemporaries appears evident, even if Dürer's work, unlike Chinese art, embraced the systematic geometric approach of fixed point perspective.

This accurate perspectival representation of nature can be seen over three centuries later in the life-size paintings by James Audubon of *The Birds of America*. Anna Atkins used the new medium of photography to capture delicate direct impressions of nature, eschewing perspective but, like Audubon, utilized a process of collecting, classifying and presenting visual knowledge.

In the twentieth century, the Festival Pattern Group, exploited the patterns of nature revealed by the new instrument of X-ray crystallography, bringing them into public and domestic aesthetic contexts. This interest in revealing hidden patterns of nature is also pursued by designer, artist and educator György Kepes. Finally, both the Tissue Culture and Art Project, and artist Eduardo Kac conduct what are effectively scientific experiments that challenge the very notion of nature – no longer seen from a distance as a counterpart to the human, but a nature that may now be transformed into something new by human actions, with utopian or dystopian consequences.

HUANG QUAN

Although only fragments of his work remain, the tenth century Chinese artist Huang Quan (黃筌) (c.900–65) is credited with innovating a realistic and colourful style of bird-and-flower painting within the long-standing Chinese tradition of natural representation.

A tradition of representing nature in sculptural form has existed in China since ancient times and a related tradition of representing nature in painting, in terms of what the eye sees, is also long established. The famous "Six Principles" of painting were formulated by Xie He at the end of the fifth century, the third principle of which is "Conform with the Objects to Give Likeness".[1] This did not demand a merely technical naturalism, however: "Spirit-resonance" (*qiyun shengdong* 气韵生动) was emphasized as the first principle of painting, and Xie He stressed that a painting should be valued for its spiritual qualities rather than its technical virtuosity.[2] Another critic, Zhang Yanyuan (c.815–77), said that if spirit-resonance were sought for, "the outer likeness will be obtained at the same time".[3] In addition it should be noted that figures from nature were also endowed with symbolic significance and so were not merely objective facts.

Although only one painting reliably attributed to Huang Quan has survived – the scroll in the Beijing Palace Museum – his reputation has endured to the present day. Born around 900, in a turbulent period following the collapse of the Tang Dynasty, Huang Quan lived during the "Five Dynasties" period (907–79). He showed great talent for art from an early age and at around 17 years old, was admitted to the Imperial Academy at Chengdu,[4] then in Shu state. Aged only 23, he became leader of the Academy.[5] He is said to have innovated a new style of the bird-and-flower painting genre, based upon the delicate laying down of colour washes on subtle underdrawing without a strong outline, resulting in a fresh and lifelike appearance.[6] A story is told that Huang Quan and his son Huang Jucai were instructed by the Shu Emperor Meng Chang (919–65) to paint landscapes for the Hall of the Eight Trigrams. As Chang was about to go hunting, he lost control of a falcon and it was released. The falcon flew to attack a pheasant in Huang Quan's painting – demonstrating to the Emperor how wonderfully lifelike was Huang's work.[7]

Not everyone, however, appreciated Huang's style, and his court rival, Xu Xi, the other major innovator of the bird-and-flower genre, was preferred by the literati.[8]

They disdained the obviously pleasing, less cultivated, work of "professionals" such as Huang, and admired Xu Xi's approach of sketching the idea (*xie yi*) impressionistically in ink before applying colour. Nevertheless, Huang's influence endured. One notable painter in the style was the artist Emperor Huizong of Song (1082–1135) (see opposite).

Showing nature as the eye sees

The one surviving work securely attributed to Huang Quan is the scroll painting *Birds, Insects and Turtles* (pages 178–179), held by Beijing Palace Museum. Twenty-four brightly coloured and highly naturalistic birds, insects and turtles are portrayed against a plain background. Despite fairly even spacing, the arrangement does not appear arbitrary. The one bird in flight appears at the top of the picture. The two Eurasian tree sparrows are in communication – one looks to be feeding the other. There is an attention to relative sizes, and the insects might provide food for some of the birds. Overall, there is great accuracy of detail, and Huang Quan's style, using layers of colour wash on delicate underdrawing, accentuates the realistic impact – showing nature as the eye sees it. An inscription attached to the scroll tells us that this is an instructional piece "for my son Jubao to study".

OPPOSITE: Huang Quan
(c.900–965), Eurasian
tree sparrow. Detail from
Birds, Insects and Turtles.
Hand scroll, ink and colour
on silk.

ABOVE: Emperor Huizong (1082–1135), *Peach Blossoms and a Dove*, date unknown. Ink and colour on silk. The Song Emperor Huizong, himself a noted painter and patron of the arts, was one of the artists to follow the naturalistic bird-and-flower painting style of Huang Quan.

LEFT: Huang Quan
(c.900–965), *Birds, Insects
and Turtles*. Hand scroll,
ink and colour on silk. Five
Dynasties period. The only
surviving work reliably
attributed to Huang Quan is
this lively instructional piece
painted for his son Jubao.

ALBRECHT DÜRER

The work of the German artist Albrecht Dürer (1471–1528), spanned oil painting, watercolour, printmaking, illustration and publishing. He was also a writer and naturalist. Like his contemporary Leonardo da Vinci (1452–1519) (see page 48), Dürer worked freely across what we now call the arts and sciences, at a time when no hard distinction existed between those realms.

Born in Nuremberg,[1] Dürer, the son of a master goldsmith, is known for works in various media and in differing styles, including his Christian altarpieces and other large commissioned works painted in oils. On his two visits to Italy, where he met leading artists such as Raphael, he was intent on assimilating what he could of the grace of Italian painting (a contrast to the more hard-edged Northern European style) and to mastering linear perspective, thereby attempting to bring together the best of the Northern and the Southern European Renaissance.[2]

In an age of expanding global exchange, Dürer was also exposed to work from further afield than Southern Europe, including "wonderfully artistic things" brought back from Mexico,[3] and works from Africa and India.[4] His watercolour landscape works such as *The Wire-drawing Mill* (1494) at Nuremberg are in some respects reminiscent of the Chinese landscape watercolour tradition[5] – the elevated viewpoint, aerial perspective receding to the distant blue mountains, the tiny human figures dwarfed by the landscape.

The most clear relationship to what we understand today as "science" is evident both in Dürer's nature studies and in his theoretical writings on human proportion (1528) and measurement (1525) – the latter included a systematic treatment of the theory and techniques of linear perspective. Dürer's theory and practice are integral. And so, in the nature studies, which served as practical studies for his prints and paintings, Dürer meticulously observes and represents nature according to the theories of perspective. The watercolour and gouache *Great Piece of Turf* (1503) presents a world from a humble viewpoint, and the grasses have that disordered accidental quality which today we might associate with a photograph.

Yet despite this seemingly accidental depiction of the flora, Durer's concern for proportion is apparent when we learn that the tallest grass divides the left and right parts of the painting according to the "golden ratio".[6] In its quest for "naturalism", the *Great Piece of Turf* is far away from the symbolic world of the medieval that preceded the Renaissance. Similarly, his exquisitely sensitive watercolour of the *Young Hare* (1502) has an astonishing immediacy. This is no mere specimen or symbolic creature, but a real and unique individual animal that appears, uncannily, to be simply resting in front of our eyes.

It is perhaps characteristic of the man that the malaria he contracted in the Netherlands, and which contributed to his physical decline and death, seems to have resulted from a journey into the marshes to observe the carcass of a stranded whale.

LEFT: Albrecht Dürer, *The Wire-drawing Mill*, 1489–1494. Watercolour on paper.

The self-portrait: an individual in history

"1498. I painted this from my own appearance; I was twenty-six years old," reads Dürer's inscription within the painting. In this self-portrait the young artist depicts himself as an individual in history and in "real" space, according to the conventions of linear perspective. It is a "reality" we still recognize after 500 years. His fine clothes declare the newly elevated status of the artist – to that of the gentleman. This is one of several self-portraits through which Dürer's life is documented.

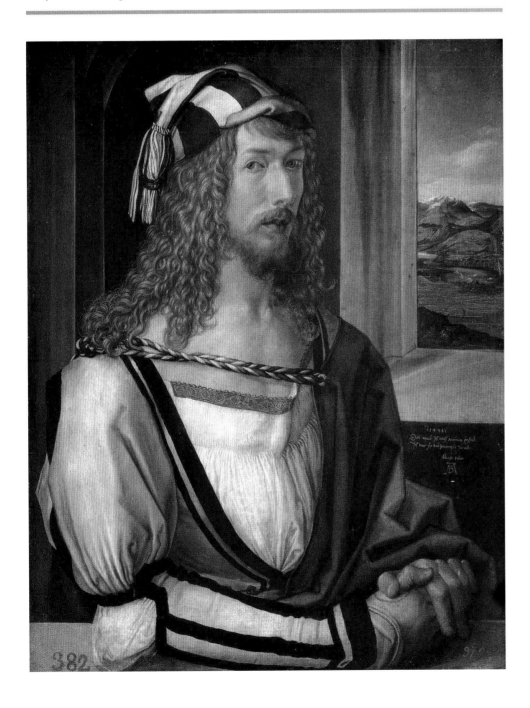

LEFT: Albrecht Dürer, *Self-portrait*, 1498. Oil on limewood.

OPPOSITE: Albrecht Dürer,
Great Piece of Turf, 1503.
Watercolour and gouache
on paper..

ABOVE: Albrecht Dürer, *Young Hare*, 1502.
Watercolour and body colour, heightened with white
body colour on paper.

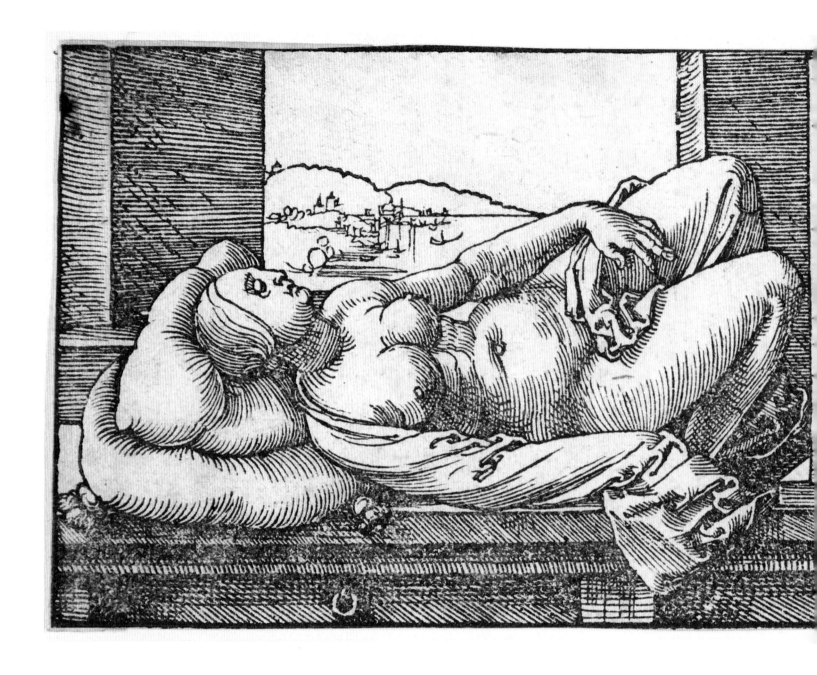

ABOVE: Albrecht Dürer,
*Draughtsman Drawing
a Recumbent Woman,*
1525. Woodcut.

JOHN JAMES AUDUBON

John James Audubon (1785–1851) was an ornithologist and naturalist best known for documenting American birds. His accurate and beautiful watercolour images dramatically represented birds in their natural environments, rather than as specimens.

Audubon was born Jean-Jacques Rabin, on a plantation in Haiti, and emigrated to the United States in 1803. He was always drawn towards birds as a subject matter, and the rural Pennsylvanian location where he initially lived allowed him to develop this interest. He undertook a deep exploration of nature through his realistic, but highly sensitive, paintings and made significant contributions to ornithology as a result.

Working just prior to the 1837 invention of photography, Audubon used the documentary techniques available to him at that time – drawing and painting – to capture the birdlife he saw around him.[1] These images allowed for an aesthetic and highly personalized approach to the documentation of ornithological specimens. Audubon would use wires and pins to fix his birds to boards, in lifelike positions which recontextualized them in their natural environment. In doing so, he was seeking to show nature as it existed, in context. It's this commitment to visually telling the story of how birds lived in the real world, as well as being able to capture the details of their physical attributes from a specimen-based scientific perspective, that distinguished Audubon's work from his contemporaries,

such as Alexander Wilson (1766–1813) and William Bartram (1739–1823).

Embodying the perfect combination of artist and scientist, Audubon demonstrates the best attributes of both: accuracy and imagination, detail and drama. He was able to represent birds in a way that gave great dignity to his specimens, and this is what makes his work so compelling to this day. Audubon is an outstanding artist in his own right and, through his imagery, he also contributes to our scientific understanding of birds. His meticulous artistic and ornithological work led to the discovery of 25 new species.

Alexander Wilson[2] had already published *American Ornithology; or, The Natural History of the Birds of the United States* (1808–14).[3] However, Audubon sought to exceed these efforts and the result is his major contribution to ornithology: *The Birds of America* (1827–38). The book provides an exemplary translation from original paintings by Audubon to printed work. He travelled to London in 1826, seeking support for the publication of a book including more than 250 of his watercolour images, the production of many of which had placed him in dangerous situations as he pursued the specimens he needed. His aim was to paint every bird in North America. After

raising funds through subscriptions (no easy task), he worked initially with William Home Lizars (Edinburgh) and then Robert Havell (London), who engraved, printed and hand-coloured each image, based on the original paintings. Robert Havell worked on the project right through to 1838, when the process had to be scaled up and became more of a production line. The final, copperplate-printed edition is known as a Double Elephant Folio, measuring 1 metre (39.5 inches) tall by 67 centimetres (26.5 inches) wide, printed on handmade paper. At 435 pages, it needed its own furniture to support it. The sheer scale means that, as noted by Audubon, "If bound together, the pages would create a book that rivalled the wingspan of a soaring mountain hawk."[4] This size allowed the illustrations to be reproduced life-size, contributing to the book's dramatic impact. The fact that Audubon took the step of placing birds in their appropriate settings and natural habitats was against the prevailing practice in ornithological illustration. He challenged the ways in which such specimens were presented, and in doing so, arguably led the way for contemporary natural historians such as David Attenborough, who ask us to empathize with, as well as understand, the natural world.

ABOVE: John James Audubon,
Belted Kingfisher, 1808. Hand-
painted watercolour.

Carolina Parrot

PSITTACUS CAROLINENSIS. Linn.
Males 1 Females 2 Young 3
Cockle-bur Xanthium strumarium.

ABOVE: *The Birds of America* (originally titled: *The Birds of America; from original drawings by John James Audubon*), 1827–38. London printer Robert Havell translated Audubon's images into 435 life-size plates that were engraved, printed and then hand-coloured.

OPPOSITE: John James Audubon, *Carolina Parrot*, 1833. From *The Birds of America*, Plate 26, 1827–38. Hand-coloured engraving and aquatint by Robert Havell (London).

PLATE. CLXXI.

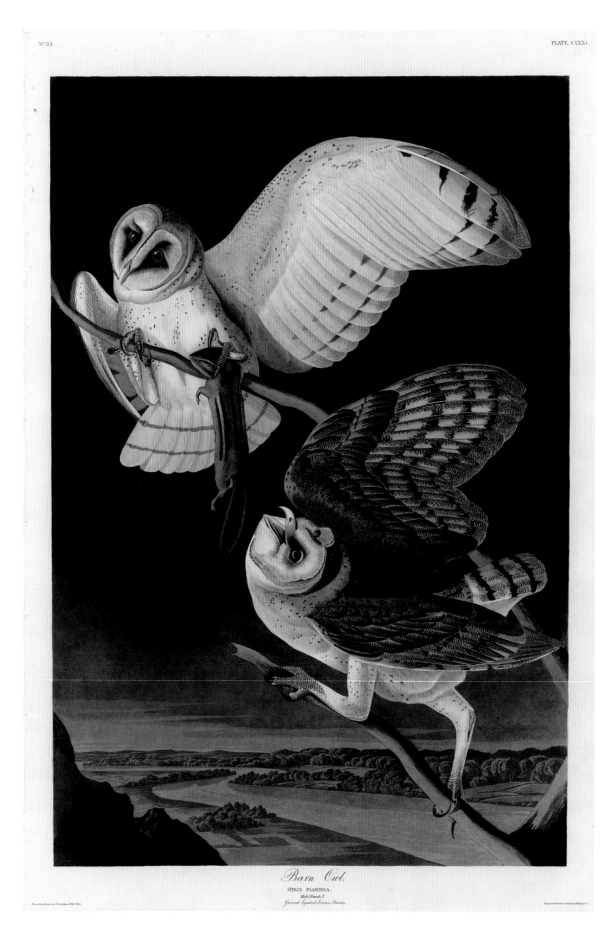

Barn Owl.
STRIX FLAMMEA.
Male 1 Female 2
Given and Signed Section Striatum.

LEFT: John James Audubon, *Barn Owl*, 1833. From *The Birds of America*, Plate 171, 1827–38. Hand-coloured engraving and aquatint by Robert Havell (London).

OPPOSITE: John James Audubon, *Summer Red Bird*, 1828. From *The Birds of America*, Plate 44, 1827–38. Hand-coloured engraving and aquatint by Robert Havell (London).

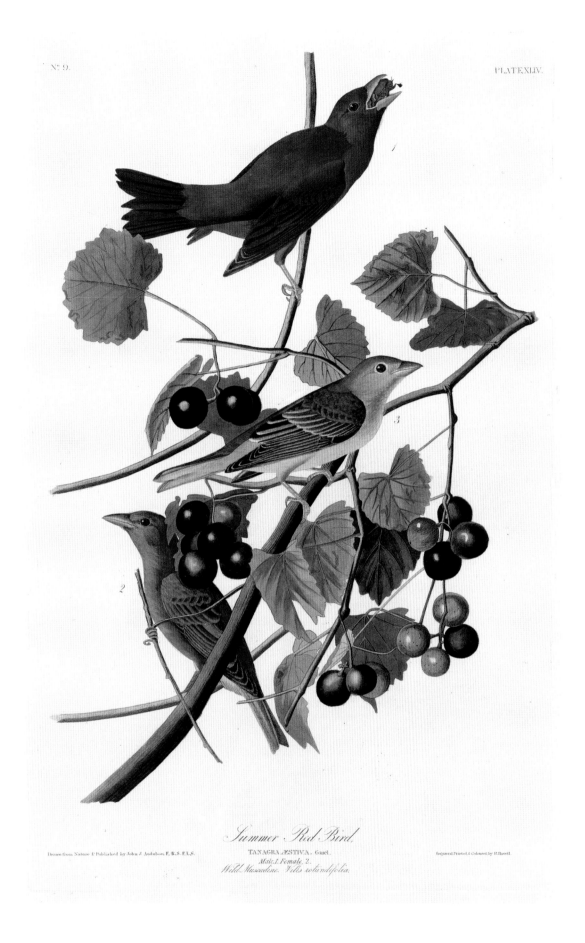

Summer Red Bird.

TANAGRA ÆSTIVA, Gmel.
Male. 1. Female. 2.
Wild Muscadine. Vitis rotundifolia.

Drawn from Nature & Published by John J. Audubon. F. R. S. F. L. S.

Engraved, Printed, & Coloured by R. Havell.

ANNA ATKINS

Anna Atkins (1799–1871) was an English photographer and botanist, noted for her early use of cyanotype photography for scientific purposes.

Originally named Anna Children, she was born in Tonbridge, England and raised by her father John George Children, her mother having died soon after she was born. He was a respected scientist, the first president of the Royal Entomological Society of London, and associated with the British Museum. Atkins became involved from an early age in the scientific activities that occupied her father. Working at her father's side, she became an accomplished illustrator, making drawings in her early 20s for her father's translation of Jean-Baptiste de Monet de Lamarck's *Genera of Shells* (1833). However, her prime interest lay in the study of botany. Women were restricted from professionally practising science for most of the nineteenth century.[1] Botany, however, was a subject that was accessible to all, particularly botanical art and illustration. Before the invention of photography in 1837, scientists relied on detailed descriptions and artistic illustrations or engravings to record the form and colour of botanical specimens.

In 1825, Atkins married John Pelly Atkins, and in the 1830s, began to assemble her own collection of preserved plants, supplying specimens to renowned botanists at Kew Gardens. She became a member of the Botanical Society in London in 1839, one of the few scientific societies that was open to women at that time.

Through her father and her husband, Atkins came to know both William Henry Fox Talbot, a pioneer of early photography who invented a process of creating photographs on paper treated with salt and a solution of silver

nitrate, and Sir John Herschel, the inventor of the cyanotype printing method, a blueprint process that uses paper coated with a light-sensitive solution produced with ferric salts. To make a cyanotype print, a specimen is placed directly onto dry paper and exposed to light, and the image is then fixed by washing in water, appearing as a white negative on a cyan-coloured background. Compared to the then new field of photography, cyanotypes were a much lower-cost method for creating printed impressions, as a wide range of surfaces can be coated with the mixture of chemicals and there is no need for a darkroom or complicated equipment.

Atkins employed the cyanotype process to record all the specimens of algae found in the British Isles. The first part of her work, a self-published book entitled *Photographs of British Algae: Cyanotype Impressions*, appeared in 1843. She made every print herself. The text pages and captions were photographic facsimiles of her own handwriting. With a limited number of copies, it was the first book ever to be printed and illustrated using photography. Two more volumes were produced between 1843 and 1853.

Later, she would collaborate with another female botanist, Anne Dixon (1799–1864), in making two more books featuring cyanotypes: *Cyanotypes of British and Foreign Ferns* (1853) and *Cyanotypes of British and Foreign Flowering Plants and Ferns* (1854).

Despite the simplicity of her means, Atkins created images which demonstrated that the medium of photography could be both scientifically useful and aesthetically pleasing.

OPPOSITE: Anna Atkins and Anne Dixon, *Equisetum sylvaticum*, 1853. Cyanotype.

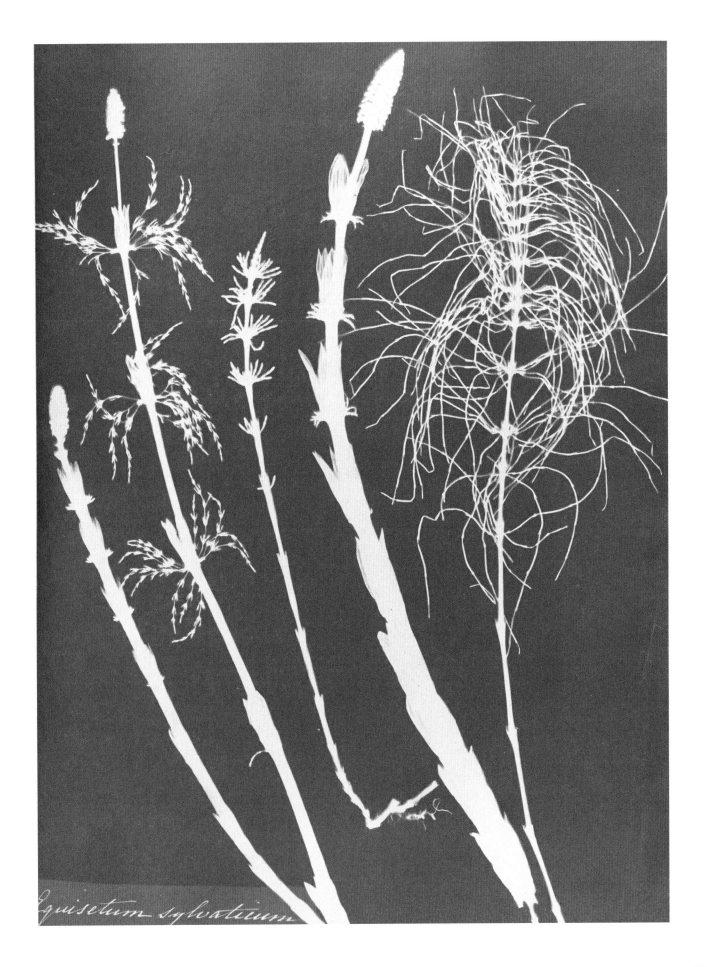

ANNA ATKINS

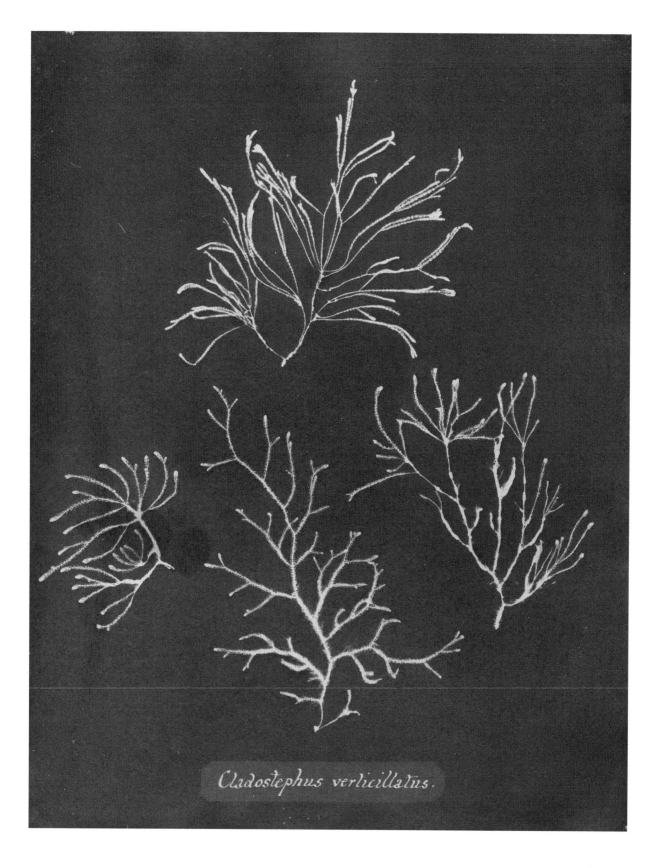

Cladostephus verticillatus.

ABOVE: Anna Atkins,
Cladostephus verticillatus,
1843. Cyanotype.

OPPOSITE: Anna Atkins and
Anne Dixon, *Cyanotypes of
British and Foreign Ferns,*
1853. Cyanotype.

Cyanotypes of British and Foreign Ferns

RIGHT: Anna Atkins
and Anne Dixon,
Lastrea dilatato,
1853. Cyanotype.

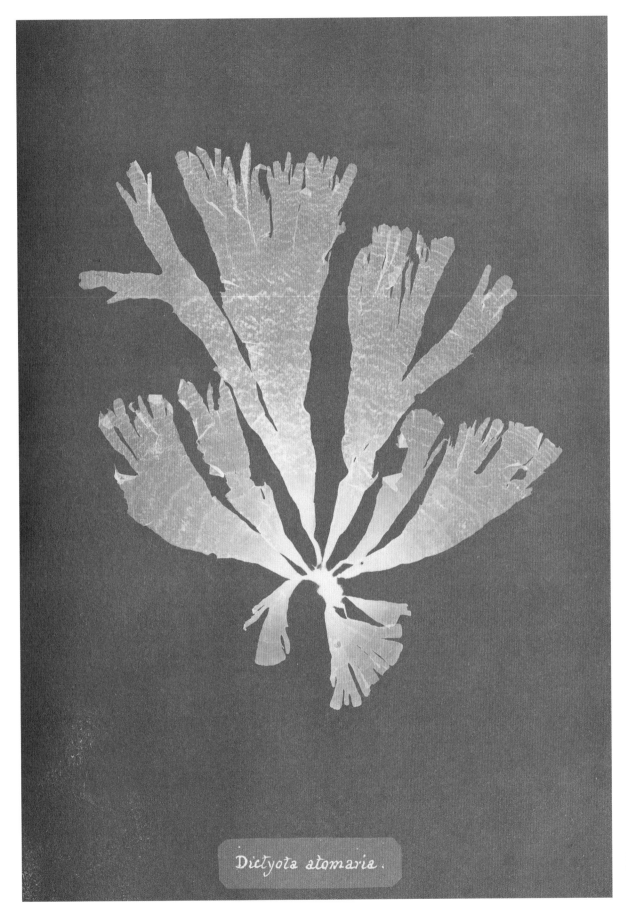

Dictyota atomaria.

LEFT: Anna Atkins
and Anne Dixon,
Dictyota atomaria,
1853. Cyanotype.

GYÖRGY KEPES

György Kepes (1906–2001) was a visionary interdisciplinary artist, designer, author and educator, associated with modernism and the avant-garde and the early twentieth century. His wide-ranging creative works and publications, including *The Language of Vision*, were highly influential in offering a method for bridging the divide between the "two cultures" of art and science.

György Kepes was born in Hungary but moved to Berlin after an invitation to work with Moholy-Nagy (see page 136). He emigrated to the United States after the Bauhaus disbanded in 1937. When the Bauhaus was reinstated in Chicago, Moholy-Nagy invited Kepes to lead the Light and Colour Workshop. Though short-lived, this became an experimental space for innovation in these practices, also leading to publications on the subject.

In his creative practice, Kepes followed Moholy-Nagy's lead in producing abstract experimental images using the process of photograms (objects placed directly onto light-sensitive paper). He had begun this work in Budapest, using nature as the departure point for developing what was termed by Moholy-Nagy, Joseph Albers and others as "the new vision", facilitated by modern technologies and techniques. Kepes was interested in exploring both natural and geometric forms, including inorganic objects like parts of machinery, as raw materials for his imagery. In this way he explored dialectical tensions between nature and the world of man-made objects, and between what may or may not be made visible, and also exploited the potential of the medium of light itself (the medium of photography). The abstract images he produced operated as a bridge between art and science.

Kepes was interested in the limits of consciousness, and was also influenced by theories of perception such as gestalt theory.[1] He was committed to the notion that opposites could be productively approached (but never resolved) through the dialectical tensions which existed between them.[2] Kepes was interested not only in aesthetics but in the ways that such knowledge could be applied to larger world issues such as the Cold War, early concerns about ecology, and the role of technology. Thus, he anticipated the concerns of many contemporary artists, on issues like climate change, social (in)justice and technological shifts such as artificial intelligence. Kepes believed art and design had a civic duty, as well as a private and aesthetic one: a private artistic practice also functioned as a public service.

In 1967, he founded the Center for Advanced Visual Studies at MIT.[3] Kepes was eager to harness the potential of new technologies such as microphotography, which allowed insights previously unavailable to human understanding to emerge. He often spoke about the process of "confronting, combining, and comparing knowledge" as central to his practice, and advocated collaboration between artists and scientists as well as psychologists and other thinkers. He called this thinking across seemingly disparate fields of knowledge "interthinking", also using the term "interseeing".

In 1956, Kepes published *The New Landscape in Art and Science*. Illustrations included microscopic images of minerals, cell structures and electric discharge. Works of art were interconnected and related throughout. Between 1965 and 1966, Kepes edited the Vision + Value series. These volumes contained essays by artists, designers, architects and scientists, whose contributions explored the new "interseeing" and "interthinking" process, crossing numerous fields of study, which Kepes sought to establish as a modern way of thinking.[4] Such publications exemplified his aim of producing the "education of vision", as well as leading to a deeper understanding of the "two cultures" of art and science.

OPPOSITE: György Kepes, *Leaf and Prism*, 1938. Gelatin silver photogram. Kepes was interested in the "micro" and "macro" worlds of seeing, and in the tension between nature and objects and technology.

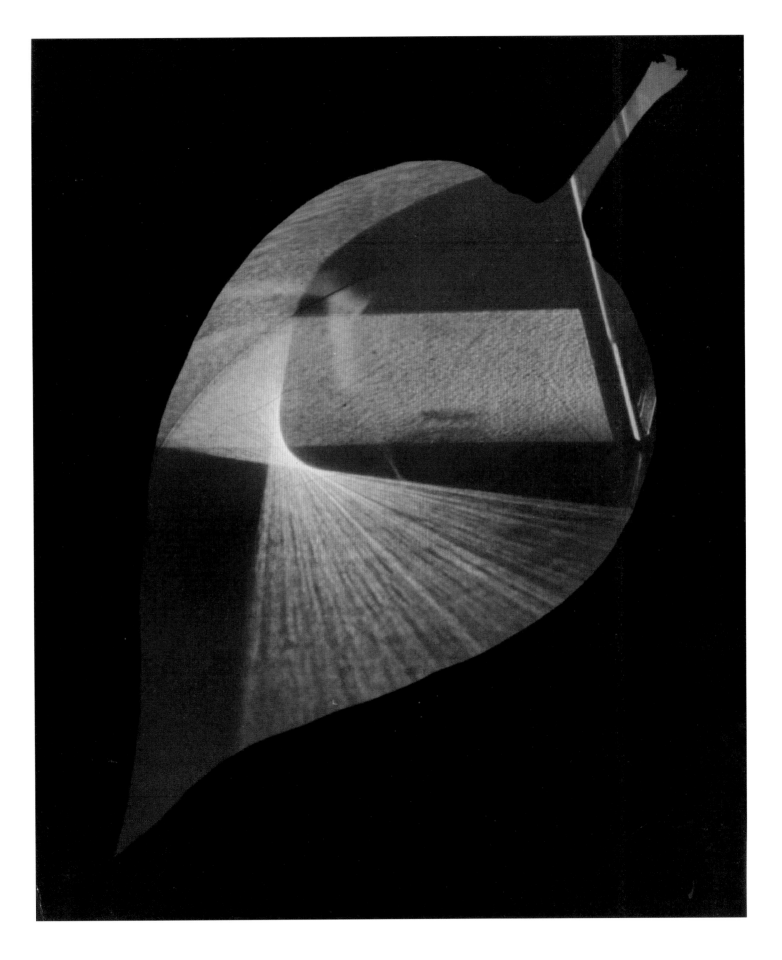

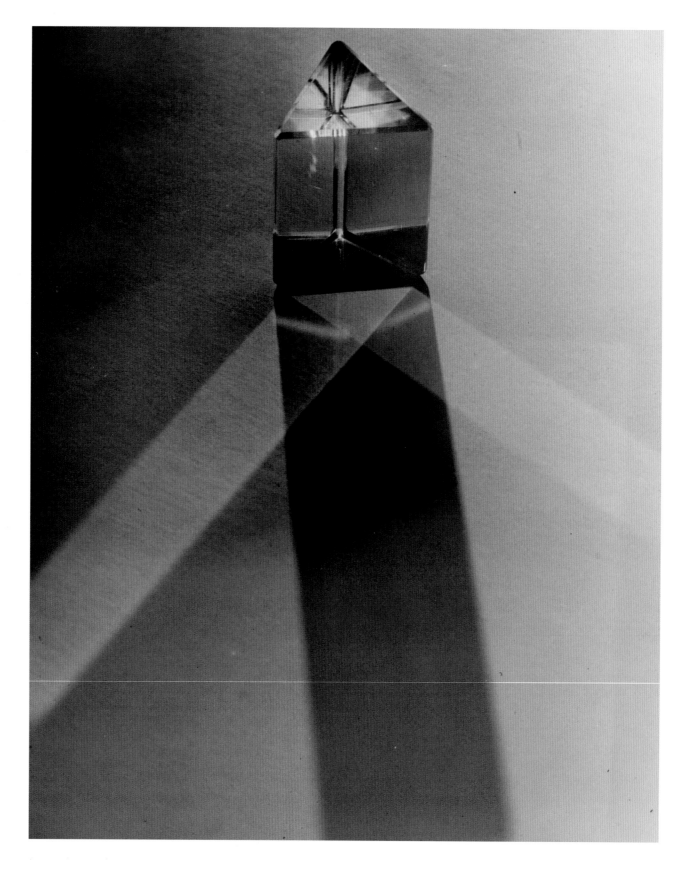

ABOVE: György Kepes,
Untitled, 1939–40.
Gelatin silver print.

ABOVE: György Kepes,
Propeller, c.1939–40.
Gelatin silver photogram.

NATURE & BEYOND

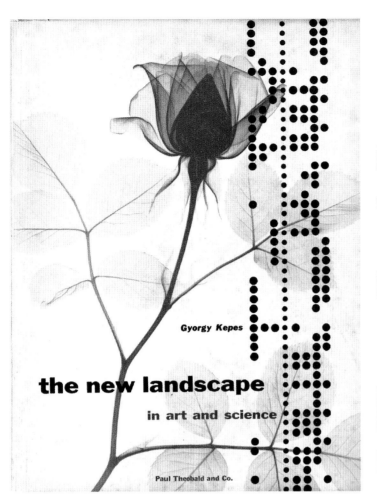

OPPOSITE: György
Kepes, *Untitled #144*,
c.1939–40. Gelatin
silver print.

ABOVE LEFT: György Kepes, *The New Landscape in Art and Science*, 1956. This book attempted to outline a reconfigured, more interlinked relationship between art and science, while introducing themes of nature and cybernetics. Cybernetician Norbert Wiener was one of the contributors.

ABOVE RIGHT: György Kepes, *Language of Vision*, 1944. This book is an exploration of the "new" languages of seeing/vision and their effects on human consciousness.

FESTIVAL
PATTERN GROUP

Festival Pattern Group was formed in 1949 and lasted until 1951. The group explored the interrelationships between design and science, and in particular applied patterns made visible by the new process of X-ray crystallography (XRC) — of which Britain was at the forefront — to fabrics, wallpaper and other forms of two-dimensional design for domestic interiors. This brought such science into the public domain, bringing it to the attention of a broader audience through the process of familiarization.[1]

In 1915, Sir Lawrence Bragg and his father invented XRC.[2] This invention allowed scientists, for the first time, to see deep into the atomic and molecular structure of crystals. In the years following the Second World War, XRC continued to be a vibrant field of scientific inquiry. Many breakthroughs were being made, allowing, for example, the structure of penicillin to be understood for the first time. Several women scientists were at the forefront of XRC, including a pioneer of crystallography, Dr Helen Megaw.[3] Work in XRC continued into the 1950s, and included the discovery of the double helix structure for DNA in 1953, by James Watson and Francis Crick, based on the work of crystallographer Rosalind Franklin.

This new-found submicroscopic view into crystallography prompted Lawrence Bragg and his father to make a comparison with wallpaper patterns, as both are formed of repeated elements.[4] In 1964, Helen Megaw suggested that such images might be applied to design, prompting Mark Hartland Thomas[5] to convene the Festival Pattern Group in 1949 and inviting Megaw to be its scientific consultant. The Group exhibited at the Festival of Britain in 1951.[6] Producing designs based on crystal structures – for fabrics, carpets, tablecloths and even glassware, ceramics and cutlery – meant

that ensuring scientific accuracy was very important. Megaw worked closely not only with other crystallographers, such as Dorothy Hodgkin, Lawrence Bragg and Kathleen Lonsdale, but also in association with designers and manufacturers to ensure that patterns drawn from biological molecules, such as insulin and haemoglobin, and from various minerals, retained their structural accuracy when translated into patterns.

Mark Hartland Thomas brought in companies such as Dunlop, Wedgwood and ICI (Imperial Chemical Industries) to be a part of the Festival Pattern Group. The process of XRC itself was showcased in The Dome of Discovery, while the patterns emerging from these art/science/manufacturing collaborations could be seen in the Regatta Restaurant (not only on furnishings but also in the hydrargillite lace collars of waitresses), as well as in the insulin wallpaper covering the cinema foyer.

The purpose of the group was to collaboratively explore the full potential for novel, nature-derived images, generated by scientists, to be applied to design within contemporary interiors – harnessing the excitement and promoting the success of British scientific discoveries, alongside manufacturing and design excellence. In the playful, aesthetically experimental but

scientifically accurate work they produced, the group brought scientific discoveries and technological innovations to wider public attention, democratizing and popularizing such science, and making it available to non-experts. This non-elitist approach to science made the Festival Pattern Group popular at the Festival of Britain.

While short-lived, and disbanded after only two years – in part due to their inability to find a broader commercial application – the group nonetheless had managed, via the exhibition at the Festival of Britain, to offer insights into the cutting-edge work being undertaken by scientists, through their highly novel means of communicating new scientific knowledge. The group in turn proposed ways in which scientists and designers might collaborate, through similar forms of aesthetic applications of scientific knowledge within contemporary design.

OPPOSITE TOP: Festival Pattern Group, *Boric Acid 8.34*, 1951. Wallpaper.

OPPOSITE BELOW: Festival Pattern Group, *Insulin 8.25*, 1951. Wallpaper.

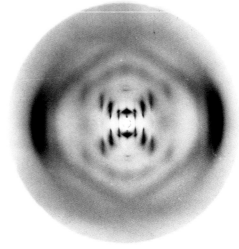

ABOVE: Edward Mills, atoms and molecules in the *Abacus Screen*, Festival of Britain (Southbank Centre), 1951. An interest in science permeated exhibits at the Festival of Britain.

RIGHT: Rosalind Franklin, *Photograph 51*, 1952. X-ray diffraction photograph. The image was taken by chemist and X-ray crystallographer Franklin, with Raymond Gosling's assistance. Its significance lies in identifying the structure of deoxyribonucleic acid, or DNA.

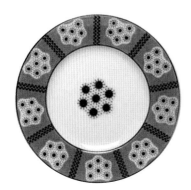

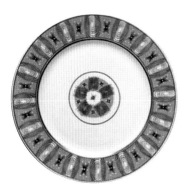

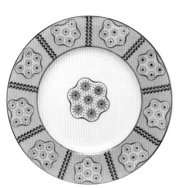

Insulin

There is no general formula for Insulin, it being a hormone from which at least sixteen amino-acids can be isolated.

Pentaerythritol

$$HO \cdot CH_2 - \overset{\displaystyle CH_2OH}{\underset{\displaystyle CH_2OH}{\overset{|}{\underset{|}{C}}}} - CH_2OH$$

ABOVE: Wedgwood, plate designs based on the structure of the crystal beryl, 1951. These highly stylized designs exemplify the Festival Pattern Group's aim to integrate imagery from scientific observation into everyday domestic interiors. By doing so, they popularized science and gave non-scientific audiences a window into the deep structures of crystals.

ABOVE RIGHT: The Regatta Restaurant, Royal Festival Hall, 1951. Festival Pattern Group designs in context.

RIGHT: Robert Sevant for John Line & Sons, 1951. Wallpaper. Insulin (left) and pentaerythritol (right). The crystallographer Dorothy Hodgkin's diagrams, which formed the basis of these screen-printed wallpapers, were originally published in an article in *Proceedings of the Royal Society* (1938). The simplified Insulin pattern extracted the hexagonal motifs and eliminated the rounded triangular forms, and was used in the cinema foyer at the Exhibition of Science, Festival of Britain, 1951.

EDUARDO KAC

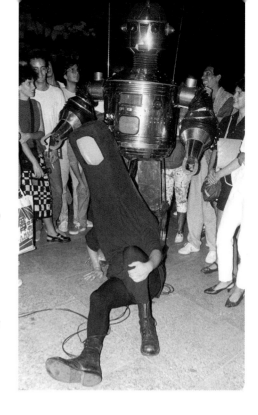

A Brazilian-American artist whose work encompasses many genres, Eduardo Kac (born 1962) is internationally recognized for his media poetry, telepresence, transgenic and bio artworks. A pioneer of telecommunications art in the pre-internet 1980s, he emerged in the early 1990s with radical works combining telerobotics and living organisms, followed by groundbreaking bio art and transgenic art works from the late 90s onwards.

Kac began his artistic career working in poetry, combining it with video, digital technologies and performance. In 1982, he created his first digital poem, followed by his first holographic poem in 1983 and his first online poem in 1985. It was at this time that he realized he could pursue media-art as an independent exploration: "I've always been interested in the question of communication processes. I gained an insight early on that communication processes lie at the heart of everything there is."[1]

In 1986, Kac made his first telepresence robot, *Ornitorrinco*. An anthropomorphic robot 2 metres (7 foot) tall acted as a host who conversed with exhibition visitors in real time. The robot's voice was that of a human telerobot operator transmitted via radio, who was telepresent on the radio-controlled robot's body.

The interactive telepresence work *Uirapuru* (1996/99) is based on the name of both an actual Amazonian bird and a mythical creature. A flying fish hovers above a forest in the gallery, responding to local as well as web-based commands. Audio and video from its point of view are streamed on the web, where local and remote participants interact with the avatar of the flying fish in a virtual world. When this happens, the flying fish sings in the gallery.

At the dawn of the twenty-first century, Kac opened a new direction for contemporary art

with his transgenic art and a ground-breaking work entitled *Genesis* (1998/99). Kac defines transgenic art as "a new art form based on the use of genetic engineering techniques to transfer synthetic genes to an organism or to transfer natural genetic material from one species into another, to create unique living beings".[2]

Genesis explores the intricate relationship between biology, belief systems, information technology, dialogical interaction, ethics and the internet, the latter allowing an interactive platform for the public to participate in altering the DNA of an organism. The key element of the work is an "artist's gene", a synthetic gene that was created by Kac by translating a sentence from the biblical book of Genesis into Morse code, then converting the Morse code into DNA base pairs. The sentence reads: "Let man have dominion over the fish of the sea, and over the fowl of the air, and over every living thing that moves upon the earth."

GFP Bunny (2000) is a transgenic artwork that comprises the creation of a green fluorescent rabbit called *Alba*, which Kac describes as a "complex social event", creating public dialogue generated by the project and the social integration of the rabbit. Employing molecular biology, Kac combined jellyfish and rabbit DNA to produce a bunny that glows green under blue light. Alba attracted much media attention and subsequent controversy,

which gave Kac "the platform to make everyone aware of the fact that she's not an object, she's a subject."[3]

The central work in the Natural History of the Enigma series is a "plantimal", a new life form Kac created that he calls "Edunia", a genetically engineered flower that is a hybrid of a gene sequenced from Kac's blood and a petunia. The resulting bloom creates the living image of human blood rushing through the veins of a flower, which acts as a reflection on the contiguity of life between different species.

ABOVE: Eduardo Kac, *Ornitorrinco*, 1986. Radio-controlled robot employed by Kac as an exhibition host and as a performer. The robot was built by Cristovão Batista da Silva.

OPPOSITE: Eduardo Kac, *Uirapuru*, 1996/99. Shown 15 October–28 November 1999, at the InterCommunication Center (ICC), Tokyo.

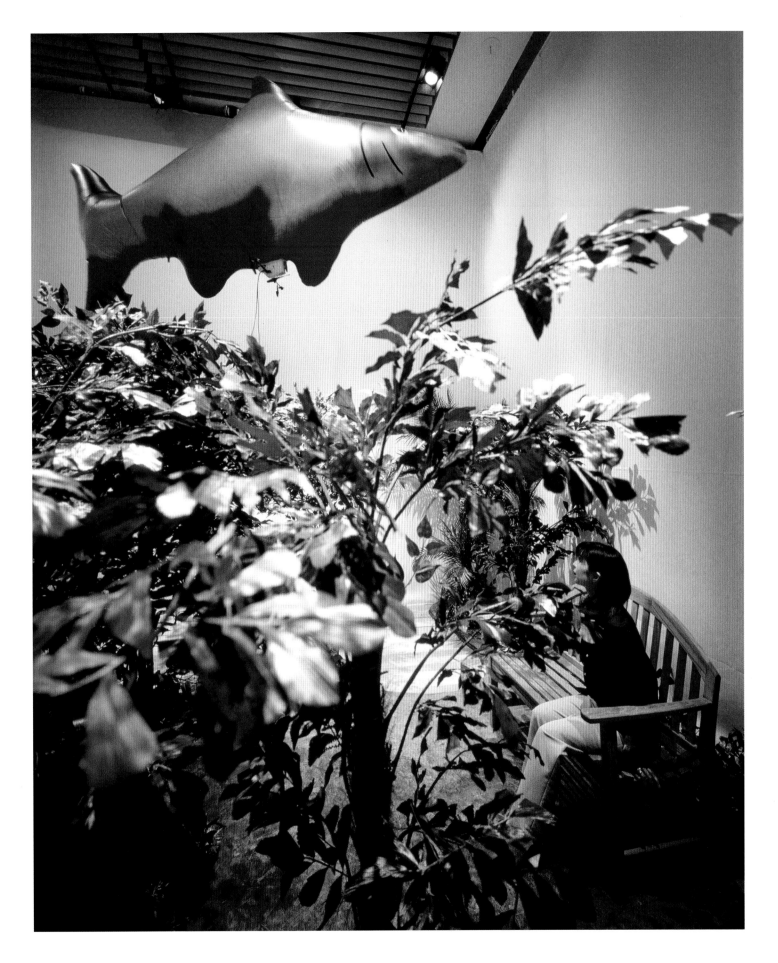

BELOW: Eduardo
Kac, *Genesis*, 1999.
Commissioned by Ars
Electronica 99 and
presented online and
at the OK Center for
Contemporary Art, Linz,
4–19 September 1999.

OPPOSITE: Eduardo
Kac, *GFP Bunny*, 2000.

EDUARDO KAC

THE TISSUE, CULTURE & ART (TC&A) PROJECT

Calling into question definitions of life and our duty of care towards it, the Tissue, Culture & Art (TC&A) Project connects biotechnological and artistic research as provocation for debate.

The Tissue, Culture & Art (TC&A) Project is Oron Catts (born 1967, Finland) and Ionat Zurr (born 1970, UK) who, since 1996, have collaboratively explored the social implications of tissue engineering through artistic laboratory practice, curatorial projects and participatory actions. Their works problematize how we define what is living or "semi-living",[1] and how we build ethical life-support systems. Recurring themes include critiques of cell lines used in scientific experimentation, the commercial developments of laboratory-grown meat and our interrelationships with other life forms.

Early tissue engineered works include *Pig Wings* (2000), three tiny sets of wings grown on polymer from pig bone-marrow cells,[2] and *Semi-Living Worry Dolls* (2001), talismans of cultured cells bound by surgical suture.[3] Here the laboratory-created artworks – imbued with myth, fiction and fantasy – question the rhetoric used to present the promise of biotechnologies to the public.

In recent years, many laboratories have made claims to be the first to produce lab-grown meat. In fact, back in 2000, it was TC&A who developed a proof-of-concept *Semi-Living Steak*.[4] Cells taken from pre-natal sheep muscle were incubated in a bioreactor and fed with fetal calf serum, the cells forming tiny "steaks" measuring just 1 centimetre (3/8 inch) diameter. These culinary offerings were presented to invited guests at a staged gallery dinner, where the production processes were screened and the social, cultural and ethical implications of the work discussed. Other explorations related to biosynthetic meat production include a live cooking show, *Art Meat Flesh* (2012–14), with artists and scientists competing against each other, and *Vapour Meat* (2018), a speculative sculpture emanating the scent of flesh to "satirize the bombastic promises of lab-grown meat companies".[5]

Another work to evolve over time, growing in scale and ambition with each iteration, is *Compostcubator* (2016–2019). With four versions to date, the works consist of a pyramidical compost heap which, utilizing the heat generated through microbial processes, powers an incubator containing a flask of cells (usually mouse cells). Part artwork, part experiment, the Compostcubators harness energy from one living process in order to sustain life in another.

Catts and Zurr are also pioneers of biological arts education. In 2000, they established SymbioticA, a laboratory for artistic research situated within the School of Human Sciences at The University of Western Australia in Perth. The first of its kind, the laboratory supports masters and PhD students working with biological materials, processes and concepts and hosts many prominent research residencies.

Across the board, Catts and Zurr aim to merge scientific laboratory techniques with performative, provocative and often participatory processes as a way to challenge technoscientific progress and question its moral, social and cultural implications.

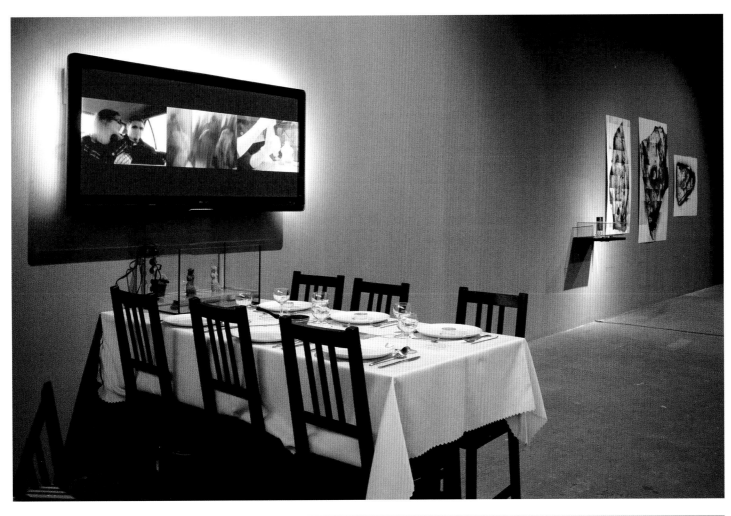

ABOVE: Ionat Zurr and Oron Catts, *Semi-Living Steak*, 2003. Presented as part of the *Disembodied Cuisine* installation performance.

RIGHT: Ionat Zurr and Oron Catts, *Semi-Living Steak*, 2003. Detail of place setting presented as part of the *Disembodied Cuisine* installation.

Victimless Leather

Suspended within a profusion chamber surrounded by life-sustaining apparatus, cell-inoculated polymers are drip-fed with nutrients, nurturing the growth of a laboratory-grown jacket. *Victimless Leather* (2004) presents a mini-prototype for stitch-less leather, a possible antidote to the animal suffering within the clothing industry.

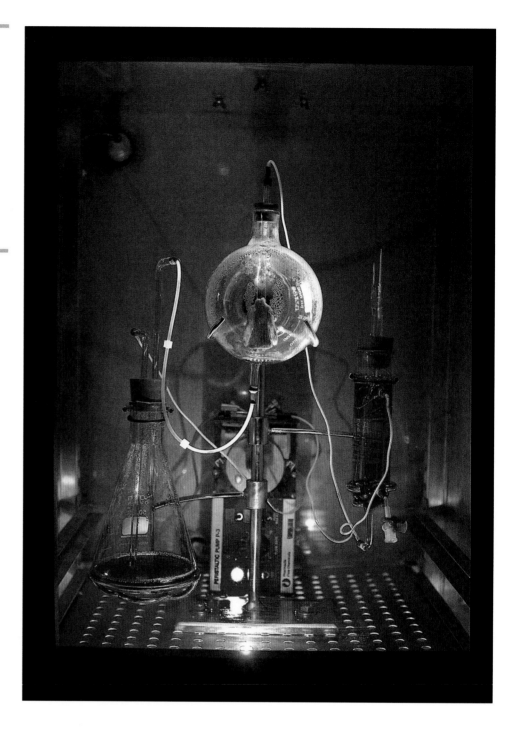

ABOVE: Ionat Zurr and Oron Catts, *Victimless Leather*, 2004. Jacket – biodegradable polymer, connective and bone cells, custom-made bioreactor, incubator.

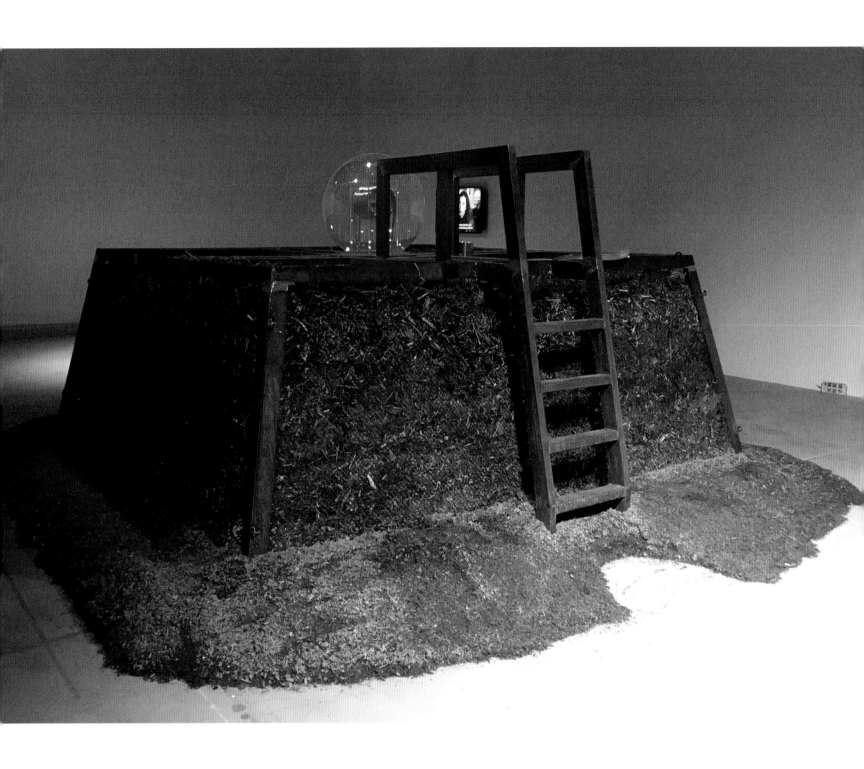

ABOVE: Ionat Zurr, Oron
Catts and Devon Ward,
Compostcubator 0.4,
2019. Composted hay,
incubator, flask, cells.

ENDNOTES

Robert Fludd

1. Alchemy was an integrated system of magic, spiritual development and material experimentation, purification and transmutation that eventually gave rise to modern science. Forms of alchemy were practised across Asia, Europe and Africa.
2. Frances Yates describes Rosicrucianism as an intermediate phase between the European Renaissance and the scientific revolution of the seventeenth century – combining hermetic and cabalist texts with alchemical experimentation. See Yates, Frances, *The Rosicrucian Enlightenment*, London: Routledge, 1972.
3. Huffman, William H. (Ed). *Robert Fludd: Essential Readings*. London: Harper Collins, 1992.
4. *Apologia Compendiaria*, 1616; and *Tractatus Apologeticus Integritatem Societatis de Rosea Cruce defendens*. Leiden: Basson, 1617
5. Yates, Frances. *The Rosicrucian Enlightenment*. London: Routledge, 1972
6. Fludd, cited by Pauli, in Huffman, William H. (Ed). *Robert Fludd: Essential Readings*. London: Harper Collins, 1992, p. 123.
7. For further details see Roob, A. *Alchemy and Mysticism*. Cologne: Taschen, 1997, Pp. 104-112.

Joseph Wright of Derby

1. Holme, Adrian. "Landscape and light: alchemical interpretations of light in the works of Joseph Wright of Derby". Paper read at Shaping the View: Understanding Landscape Through Illustration, 5 September 2016, at Edinburgh College of Art.

Georges Seurat

1. Rood's book, *Students' Text-book of Color; Or, Modern Chromatics, with Applications to Art and Industry* (New York: D. Appleton and Co, 1879), provided calculations on light values, suggesting that small dots or lines of different colours, when viewed from a distance, would blend into a new colour. Chevreul's book, *De la loi du contraste simultané des couleurs* (1839), translated into English as *The Principles of Harmony and Contrast of Colours* (1854), described the law of simultaneous contrast of colours, which Seurat would deliberately and systematically apply in his paintings. Simultaneous contrast is most intense when the two colours are complementary colours.

Berenice Abbott

1. Between 1933 and 1939, Abbott took more than 300 large-format negatives of New York City undergoing change, initially working independently and then, from 1935, supported by the Federal Art Project. The work was exhibited first in 1937, published in 1939 and later reprinted as *New York in the Thirties* in 1973.
2. Whitehead wrote several influential books, in particular *Science and the Modern World* (New York: Macmillan, 1925) and *Process and Reality* (New York: Macmillan, 1929).
3. Kemp, Martin. *Visualizations: The Nature Book of Art and Science*. Oxford University Press, 2000, p. 107.
4. Abbott devised many tools and techniques to capture the behaviour of physical phenomena, involving projection, macro photography and motion capture. She was also heavily influenced by other contemporary technical developments such as the strobe lighting techniques developed by Harold Edgerton, motion capture of Étienne-Jules Marey and camera-less photographic techniques developed by Man Ray.
5. Notable exhibitions include: *Berenice Abbott: Photography and Science: An Essential Unity*, a major retrospective at MIT Museum in Cambridge, Massachusetts, 2012; and contribution to *Revelations: Experiments in Photography* at the Science Museum in London, 2016.

Yves Klein

1. Yves Klein died of a heart attack on 6 June 1962, aged 34.
2. Alchemy – from the Arabic, *al-kimiya*, the art of transmuting metals – refers to the theories and practices for the transformation and purification of matter and spirit, from the ancient world to the dawn of modern science. Alchemy was practised across the globe, from Ancient Egypt to Europe, India and China.
3. Quoted in Pierre Restany, Foreword to Jean-Paul Ledeur. *Yves Klein: Matter and the Immaterial*. Guy Pieters, 1999, p. 16.
4. Echoing the use of fire in the "burn paintings" by Gutai artist Toshio Yoshida (1928–97).
5. Restany, quoted by Nyzam.
6. Seymour, Anne. *Transformation and prophecy*. (Catalogue essay). In: Anthony d'Offay Gallery. Beuys, Klein, Rothko. London: Anthony d'Offay Gallery, 1987, pp. 9-28.

Susan Derges

1. A photogram is a photographic image made without a camera by placing objects directly onto the surface of a light-sensitive material such as photographic paper and then exposing it to light. An early exponent of the photogram was the English photographer and botanist Anna Atkins.
2. Susan Derges studied painting at Chelsea School of Art from 1973 to 1976. She was awarded a DAAD/British Council scholarship to Berlin in 1976/77 and returned to complete two years of postgraduate study at the Slade School of Fine Art, London. In 1981, she was awarded a travel scholarship to Japan for audiovisual research at Tsukuba University and ended up staying in Tokyo for a further five years.
3. Inspired by the experimental work on acoustics and vibrations by German physicist Ernst Chladni (1756–1827), Derges's 1985 work *Chladni Figures* was produced by sprinkling carborundum powder directly onto photographic emulsion, where it was exposed to sound waves at different frequencies, creating ghostly black-and-white images of natural order and chaos.
4. Sir Charles Vernon Boys (1855–1944) was a British physicist known for his careful and innovative experimental work. His *Experiment to demonstrate drops in a fountain* consisted of a beam of light projected onto a screen through a small hole in a card, behind which is a spinning disk with six holes round its rim. The pulsing beam casts the shadow of a fountain, which is vibrated by a tuning-fork. The apparently continuous jet is revealed as an arc of beads.

Semiconductor

1. *Black Rain* was made by Semiconductor in collaboration with the STFC Rutherford Appleton Laboratory, UK, and the Space Sciences Lab UC Berkeley, USA. The piece visualizes raw tracking data from the Heliospheric Imager, collected by the twin satellite STEREO solar observation mission.
2. *365 Days of Data* was made using data collected from the Flux Tower at the Alice Holt Research Forest, UK. The instruments collected data on CO2, wind, temperature and water vapour.
3. Analogue modelling places physical particles in layers and applies pressure to simulate the geological forces that sculpt the evolution of landscapes over thousands of years. The piece combined this dynamic process with seismic data acquired from different sites across the globe to translate geological time to human time.
4. Description of *Earthworks*. 2016. Available at: *https://semiconductorfilms.com/art/earthworks/* (Accessed September 2020.)

5. Description of Semiconductor's work, Available at: *https://semiconductorfilms.com/data/about/* (Accessed September 2020.)

Leonardo da Vinci

1. *De pictura* (*On Painting*) was composed in Latin 1435 and published 1450; *De scultura* (*On Sculpture*), composed 1462 and published 1464; *De re aedificaturia* (*On the Art of Building*), composed c.1443–52 and published 1485. The painter Piero Della Francesca also produced the first published treatise devoted to the subject of perspective, *De Prospectiva pingendi* (*On the Perspective of Painting*) c.1470–80.
2. Leonardo's codices are found in libraries and collections, including the Codex Arundel (British Library), Codex Ashburnham (Institute de France), Codex Atlanticus (Biblioteca Ambrosiana, Milan), Codex Forster (V&A Museum), Codex Leicester (private collection), and drawings in the Royal Collection belonging to HM Queen Elizabeth II.
3. Published 1654 in France as *A Treatise on Painting*, assembled as a collection of Leonardo's writings by Francesco Melzi.
4. Leonardo described this as *Prospettiva aerea* (aerial perspective) in writings related to his theory of colour.

Johannes Vermeer

1. Anton van Leeuwenhoek refined a technique for grinding small lenses that, when mounted together, increased the magnification of what was being observed beyond what was visible to the naked eye. The two men were born and baptized within days of each other in the same town of Delft, and van Leeuwenhoek was an executor of Vermeer's will on the painter's death in 1675.
2. Steadman, Philip. *Vermeer's Camera: Uncovering the Truth Behind the Masterpieces.* Oxford: Oxford University Press, 2001.

Stelarc

1. Garner is similarly concerned with how the body can be a site of intense critical investigation, and she also undertakes performances that use her own body as a medium, such as *The Observatory* (2014). Available at: *http://www.doreengarner.com/objectify* (Accessed November, 2020.)
2. Stelarc's work shares common themes with the performance artist Orlan, who uses her body as a site of self-modification, focusing on radical plastic surgery, and including implantation.
3. Stelarc, in his own words, from: *http://stelarc.org/?catID=20316* (Accessed November 2020.)
4. See the work of The Tissue Culture & Art Project. (Oron Catts and Ionat Zurr, p. 212), who created *Extra Ear: ¼ Scale*, a replica of Stelarc's own ear. Further information about the collaboration is available at: *http://stelarc.org/?catID=20240* (Accessed November 2020.)

Helen Chadwick

1. Beck Road was a semi-derelict row of Victorian terraced houses in Hackney, East London, which was destined for demolition. Chadwick and other artists occupied the street, transforming it into a vibrant community full of impromptu exhibitions and happenings. The community was so successful they persuaded the local authority to allow them to stay, establishing many artist studios and galleries such as Interim Art, later renamed Maureen Paley after the owner, a close friend and collaborator of Chadwick.
2. From 1985 until the mid-1990s, Chadwick was an active teacher with several visiting lecturer positions across London art schools. She taught at Goldsmiths (1985–90), Chelsea College of Arts (1985–95), Central Saint Martins (1987–95) and the Royal College of Art (1990–94).

Susan Aldworth

1. Aldworth, Susan. "Passing Thoughts". *Interalia Magazine*, May 2015. Available at: *https://www.interaliamag.org/interviews/susan-aldworth/* (Accessed September 2020.)
2. Aldworth, Susan, Broks, Paul (contributor), Mason, Robert (contributor) and Saunders, Gill (Contributor). *Scribing The Soul*. Susan Aldworth, 2008.
3. Aldworth, Susan. "Passing Thoughts". *Interalia Magazine*. Available at: *https://www.interaliamag.org/interviews/susan-aldworth/* (Accessed September 2020.)
4. Aldworth, Susan, *op. cit.*

Helen Pynor

1. Helen Pynor completed a Bachelor of Science at Macquarie University, Sydney, majoring in cell and molecular biology before going to Sydney College of the Arts, the University of Sydney, to major in photography, sculpture and installation. In 2009, she completed a PhD that combined her disciplinary backgrounds, undertaken as a practice-based doctorate at Sydney College of the Arts.
2. First shown at *Brainstorm: Investigating the Brain through Art and Science* in 2011 at GV Art Gallery, London, the work became an iconic representative for the exhibition *Brains: The Mind as Matter* at Wellcome Collection in London in 2012.
3. *The Body is a Big Place* was part of the Science Gallery at BLOOD: Life Uncut, an exhibition and interview with Helen Paynor at King's College London in 2017.
4. Pynor, Helen. "The Body is a Big Place". *Interalia Magazine*. Available at: *https://www.interaliamag.org/interviews/helen-pynor-the-body-is-a-big-place/* (accessed September 2020.)
5. The work was developed at The Max Planck Institute of Molecular Cell Biology and Genetics, Dresden, in the laboratory of regeneration biologist Dr Jochen Rink.

Anicka Yi

1. Yi was born in Seoul, South Korea and moved with her family to America when she was two years old. She spent her early twenties freelancing in London, writing advertising copy and styling fashion shoots, before moving back to New York City in 1996. Here she became friends with a group of downtown fashion designers and artists, many of them members of the collective The Bernadette Corporation, known for its performance, fashion and art, which, in varying ways, aimed to emulate and disturb corporations. Yi was included in her first group exhibition in 2008. In 2009, she began showing at 179 Canal, now 47 Canal, which gave Yi her first solo show in New York in 2011.
2. Cannon, Kelly and Custodio, Isabel, "Studio Visit: Anicka Yi". Available at: *https://www.moma.org/magazine/articles/49* (Accessed September 2020.)

Maria Sibylla Merian

1. Aristotle explains that this process comes about as the result of the presence of "vital heat", or "pneuma". In *History of Animals* (539a18–26), he explains: "Some spring from parent animals according to their kind, whilst others grow spontaneously and not from kindred stock; and of these instances of spontaneous generation some come from putrefying earth or vegetable matter, as is the case with a number of insects, while others are spontaneously generated in the inside of animals out of the secretions of their several organs."
2. During the intellectual movement of the seventeenth and eighteenth centuries known as the Enlightenment, rationality and reason started to take over from such creationist myths, forming the basis of knowledge. Humans were now to understand the universe through reason, and by doing so, would gain power over it.
3. At that time, Suriname was a plantation-based slave colony.

J.M.W. Turner

1. Hamilton notes that two years after Sir William Hershel lectured to scientists in 1801 on the "ridges, nodules and corrugations" he had observed in the surface of the sun, Turner was also creating the effect within the painting *The Festival of the Opening of the Vintage at Mâcon* (1803). See Hamilton, James. *Turner and the Scientists*. London: Tate Gallery Publications, 1998.

Ernst Haeckel

1. Breidbach, Olaf. *Visions of Nature: The Art and Science of Ernst Haeckel*. Munich: Prestel, 2006.
2. The concept that Darwinian evolution is applicable in the social realm, and reflected

in the social realm. It underpinned racial pseudoscience. Social Darwinism is thoroughly discredited today and seen as a perversion of the work of Charles Darwin.

3. Stephen Jay Gould (*Ever Since Darwin*, London: Penguin, 1991) was one of many scholars to highlight Haeckel's racism, but specific influences on National Socialism (Nazism) are dubious. See Richards, Robert J. *The Tragic Sense of Life: Ernst Haeckel and the Struggle over Evolutionary Thought*, Chicago: University of Chicago Press, 2008.

4. See, for example, American Association of Physical Anthropologists (AAPA). "AAPA Statement on Race and Racism", 2019. Available at: *https://physanth.org/about/position-statements/aapa-statement-race-and-racism-2019/* (Accessed October 2020.)

5. Ornament, in architecture and design, refers to elements of decoration adapted or developed from natural foliage.

6. Breidbach, Olaf. *Visions of Nature: The Art and Science of Ernst Haeckel*. Munich: Prestel, 2006; Breidbach, Olaf. "Brief introduction to viewing Haeckel's pictures" in *Ernst Haeckel: Art Forms in Nature*. Munich: Prestel, 2014.

Agnes Denes

1. Denes, Agnes *A Forest For New York – A Peace Park for Mind and Soul*. A Project for the Edgemere Landfill, Queens, New York © 2014 Agnes Denes. Available at: *http://agnesdenesstudio.com/works1.html*

Annie Cattrell

1. Annie Cattrell later studied Fine Art at Glasgow School of Art and the University of Ulster, before going on to study ceramics and glass at the Royal College of Art, London.

2. Cattrell, Annie. "Transformations". *Interalia Magazine. https://www.interaliamag.org/interviews/annie-cattrell/* (Accessed September 2020.)

3. Cattrell, Annie, *op. cit.*

4. Magnetic resonance imaging (MRI) is a medical imaging technique used in radiology to form pictures of the anatomy and the physiological processes of the body. Functional magnetic resonance imaging (fMRI) measures brain activity by detecting changes associated with blood flow. A positron emission tomography (PET) scan is an imaging test that helps reveal how your tissues and organs are functioning. This scan can sometimes detect disease before it shows up on other imaging tests.

Olafur Eliasson

1. Olafur Eliasson. "Why Art Has the Power to Change the World". Blog post from 23 January, 2016. Part of a series produced by *The Huffington Post* and The World Economic Forum to mark the Forum's Annual Meeting 2016 (Davos-Klosters, Switzerland, 20–23 January). Available at: *https://s3-eu-west-1.amazonaws.com/olafureliasson.net/texts/Why_Art_Has_The_Power_to_Change_the_World_117961.pdf* (Accessed October 2020.)

2. Phaidon.com. "'Street dance is crucial' – Olafur Eliasson on Harlem Gun Crew, his teenage years and the Experience of space". Available at: *https://uk.phaidon.com/agenda/art/articles/2018/september/17/street-dance-is-crucial-olafur-eliasson-on-harlem-gun-crew-his-teenage-years-and-the-experience-of-space/* (Accessed October 2020.)

3. The title presents a pun on the English word "watch" – a timepiece on the wrist, and the idea of "keeping watch" i.e. alert to danger.

4. Sublime has the meaning of "lofty" or "elevated". In the eighteenth century, the sublime became a key element in the aesthetic theory of Immanuel Kant and Edmund Burke. Contrasted with "beauty", the sublime was associated with awe (Kant) and terror (Burke), and generally with the enormous, the vast and the dark. Adrian Searle remarks that Eliasson finds the sublime "deeply troubling": Searle, Adrian. "Reflecting on sublime smoke and mirrors". London: *The Guardian*, 16 October 2003. Available at: *https://www.theguardian.com/uk/2003/oct/16/arts.artsnews* (Accessed October 2020.)

Critical Art Ensemble

1. The conceptual art movement developed in the 1960s, and laid stress on ideas, often philosophical, over other traditional aesthetic considerations in the making of works of art. The "do it yourself" or "DIY" art and culture movement stemmed from the 1950s and 1960s and was particularly associated with the 1970s punk movement. It challenged the tenets of mass production and standardization of commodities along with the "alienation" thought to accompany them.

2. A European anti-authoritarian Marxist movement of social revolutionaries, comprising artists and theorists, founded in 1957 by Guy Debord and others.

3. Books by Critical Art Ensemble: *Aesthetics, Necropolitics, and Environmental Struggle*. New York: Autonomedia, 2018; *Digital Resistance: Explorations in Tactical Media*. New York: Autonomedia, 2001; *Electronic Civil Disobedience and Other Unpopular Ideas*. New York: Autonomedia, 1996; *The Electronic Disturbance*. New York: Autonomedia, 1994; *Flesh Machine: Cyborgs, Designer Babies, and New Eugenic Consciousness*. New York: Autonomedia, 1998; *Marching Plague: Germ Warfare and Global Public Health*. New York: Autonomedia, 2006; *The Molecular Invasion*. New York: Autonomedia, 2002. For further publications see: *http://critical-art.net/category/printed-material/* (Accessed November 2020.)

4. The word *détournement*, meaning "rerouting" or "hijacking", is associated particularly with the Situationist International.

5. Buffalo is the second largest city in New York State, USA.

6. "On with the show: why scientists should support an artist in trouble", *Nature*, 429 (6993) (17 June, 2004): p. 685. Available at: *https://www.nature.com/articles/429685b.pdf* (Accessed November 2020.)

Paul Klee

1. Albert Einstein published a number of seminal papers relating to special relativity, thermodynamics and matter-energy equivalence, among many others. In the field of quantum chemistry, a key paper was published linking quantum mechanics to the hydrogen atom: Heitler, Walter and London, Fritz "Wechselwirkung neutraler atome und homöopolare binding nach der Quantenmechanik". *Z. Physik*, 44, 455, 1927.

2. Klee, Paul. *The Notebooks of Paul Klee*. Volume 1. *The Thinking Eye* and Volume 2. *The Nature of Nature* London: Lund Humphries, 1961.

3. Cited in Klee, Paul. *The Paul Klee Notebooks*. Volume 1. *The Thinking Eye*. London: Lund Humphries, 1961. Entry dated September 1914.

4. See Verdi, Richard. "Paul Klee's 'Fish Magic': An Interpretation". *The Burlington Magazine*, CXVI (1974), pp. 147–54.

László Moholy-Nagy

1. Moholy-Nagy was interested in the directness offered by the process of making photograms: "When you expose photo paper or film to light, light effects of different intensities are recorded directly on the light-sensitive paper in shades of black, white and grey." — *Vision in Motion*, 1947.

2. The work Moholy-Nagy produced was not only an exercise in formal abstraction. He also engaged in the political concerns of the time and sought to critique the prevailing politics and conservatism of Weimar Germany, which was a direct legacy of the Dada movement. Dada was an avant-garde art movement that emerged during the First World War as a response to the horrors and pointlessness of conflict. Its participants employed satire, irony, nonsense and performance art to attack the society that had allowed the war to take place.

Alexander Calder

1. Calder's mother, Nanette Calder (née Lederer), was a painter and his father, Alexander Stirling Calder, a sculptor. His paternal grandfather, Alexander Milne Calder, was also a sculptor.

New Abstractions

1. Dalrymple Henderson, Linda. *The Fourth Dimension and Non-Euclidean Geometry in Modern Art*. Princeton: Princeton University Press, 1983.

2. In his 1945 essay "Cubism and the Theory of Relativity", Paul Laporte states, "In both, the old mode of paying attention to body or mass while taking the manner of observation for granted, was abandoned. Instead, attention

was paid to relationships, and allowance was made for the simultaneity of several views." In *Art Journal* 25(3), pp. 246–248. *https://www.varsity.co.uk/science/19352* (Accessed September 2020.)

3. Arthur I. Miller and Christophe Schinkus argue that this finds resonance in the research of physicist Niels Bohr, whose *Complementarity Principle* (published 1928) describes particle-wave duality as a way of understanding the properties of atomic particles that, depending on how they are observed, can assume different forms.

4. Artists associated with the Russian avant-garde were aware of these developments in Paris, including Alexandre Exter and Lyubov Popova, the latter having a direct connection with Jean Metzinger who published, with Albert Gleizes, *Du Cubisme* (1912), connecting the space of Cubism to "the non-Euclidean scholars".

5. Written by the poet Filippo Tommaso Marinetti, and first published in the preface to a volume of his poems. It was then published as *Manifeste du Futurisme* in *Le Figaro*, 20 February 1909.

6. The theoretical underpinnings of the Futurist painters is set out by Boccioni, Umberto. "Futurist Painting: Technical Manifesto" in *Poesia*, Milan: 1910.

7. Boccioni, Umberto. "Technical manifesto of Futurist Sculpture." 1912.

8. Boccioni, Umberto. *Pittura scultura futuriste (Dinamismo plastico).* Milan: Poesia, 1914. Boccioni wrote that "dynamic form is a species of the fourth dimension in painting and sculpture … We Futurists give the method for creating a conception more abstract and symbolic of reality, but we do not define the fixed and absolute measure that creates dynamism."

9. Malevich, Kazimir. "From Cubism and Futurism to Suprematism". 1915. Translated in Douglas, Charlotte. *Swans of Other Worlds, Kazimir Malevich and the Origins of Abstraction in Russia.* Ann Arbor: UMI Research Press, 1980.

10. Malevich, Kasimir. "Non-Objectivity c.1923–1925" in *The Non-Objective World: The Manifesto of Suprematism.* 1927.

11. See also László Moholy-Nagy, p.136.

12. De Stijl was founded in Leiden, Netherlands, in 1917 including the painters Bart van der Leck, Wilmos Huszar, Theo van Doesburg and Piet Mondrian among others. The publication produced by the group was edited by Theo van Doesburg.

13. Theosophy, in the context of the twentieth century, describes a philosophical-religious system based in part on Neoplatonism and Asian religious beliefs. M. H. J. Schoenmaekers was a mathematician whose views were influential in the De Stijl movement.

Kenneth and Mary Martin

1. In the UK: Systems Group (c.1960s to 1970s); Constructivist Forum (1985–1990), Exhibiting Space (1984–1989), Archive 90 (1990–2010) and Saturation Point (2011–present).

2. The Tate Gallery, London, offers this definition: "Modernism refers to a global movement in society and culture that from the early decades of the twentieth century sought a new alignment with the experience and values of modern industrial life. Building on late nineteenth-century precedents, artists around the world used new imagery, materials and techniques to create artworks that they felt better reflected the realities and hopes of modern societies."

3. See also Paul Klee, p. 132.

4. For an analysis of the sequence ordering used by Kenneth Martin, see: Forge, Andrew and Lane, Hilary. *Chance and Order: Drawings by Kenneth Martin* (exhibition catalogue), London: Waddington Galleries, 1973; Forge, Andrew et al., *Kenneth Martin.* London: Tate Gallery, 1975.

5. The Fibonacci sequence is an additive process where the sum of the previous 2 numbers in the sequence determine the next, and so on: 0, 1, 1, 2, 3, 5, 8, 13, 21, 34 …

6. For more information about Mary Martin's methods of composition, see: Bowness, Alan. *Mary Martin* (exhibition catalogue). London: Tate Gallery, 1984.

Nam June Paik

1. In West Germany, Nam June Paik met with the composers Karlheinz Stockhausen and John Cage, and Joseph Beuys and Wolf Vostell, leading to his association with the Neo-Dadaist Fluxus group.

2. Cited in Hölling, Hanna B. *Paik's Virtual Archive: Time, Change, and Materiality in Media Art.* Berkeley: University of California Press, 2017.

3. A criticism noted by Edward R. Murrow in his prescient speech to the Radio-Television News Directors Association convention, 25 October 1958.

Mario Klingemann

1. Klingemann, Mario. "AI and Neurography". *Interalia Magazine.* Available at: *https://www.interaliamag.org/interviews/mario-klingemann* (Accessed August 2020.)

2. Klingemann, Mario, *op. cit.*

3. The Lab helps museums and collections to digitize their cultural artefacts, making them available for free to everyone around the world.

4. A generative adversarial network (GAN) is a class of machine deep-learning framework where two neural networks contest with each other in a game. For example, a GAN trained on photographs can generate new photographs that look at least superficially authentic to human observers.

5. Klingemann, Mario, *op. cit.*

Huang Quan

1. See Sirén, Osvald. *The Chinese on the Art of Painting: Texts by the Painter-Critics, from the Han through the Ch'ing Dynasties.* Mineola, New York: Dover, 2005 (first published 1936). The Six Principles are translated as 1) "Spirit Resonance"; 2) "Bone Manner" or structural use of the brush; 3) "Conform with the Objects to Give Likeness"; 4) "Apply the Colours according to the Characteristics"; 5) "Plan and Design, Place and Position"; and 6) "To Transmit Models by Drawing". (See Sirén p. 19)

2. Fong, Wen C. B*eyond Representation: Chinese Painting and Calligraphy, 8th-14th Century.* New York: Metropolitan Museum of Art/New Haven: Yale University Press, 1992.

3. Zhang Yangyuan (Chang Yen-yüan), quoted in Sirén 2005, *op. cit.* p. 22

4. China has a long history of official and private education that gave rise to the concept of a meritocratic society.

5. Zettl, Friedrich. "Huang Quan [Huang Ch'üan]". Grove Art Online. Oxford University Press, 2003. Available at: *https://doi-org.arts.idm.oclc.org/10.1093/gao/9781884446054.article.T039225* (Accessed 7 November 2020.)

6. The absence of obvious outline in Huang's work has sometimes been associated with the so-called "boneless" style *(mogu hua)*, but this is controversial since underdrawing is clearly visible.

7. Liu, Tao-ch'un. *Evaluations of Sung Dynasty Painters of Renown.* Leiden: E.J. Brill, 1989. This account has some striking similarities to the classical story, told by Pliny the Elder, of Zeuxis and Parrhasius, who staged a contest to determine who was the better painter. A bird came to peck at grapes painted by Zeuxis, yet Parrhasius deceived Zeuxis into believing that his own painting was covered by a curtain – actually a painted curtain – and in deceiving another artist, was shown to be the better of the two.

8. The literati were scholars who studied the range of arts and cultivated a more personal response than that of the "professionals". The literati style of painting is connected to the other arts, especially calligraphy.

Albrecht Dürer

1. Nuremberg, formerly an important city of the Holy Roman Empire, is in today's Germany.

2. This synthesis is seen generally in Dürer's paintings – see, for example, the oil painting of Adam and Eve and also the engraving.

3. Dürer wrote, "all the days of my life I have seen nothing that reaches my heart so much as these, for among them I have seen wonderfully artistic things and have admired the subtle

ingenuity of men in foreign lands; indeed, I don't know how to express what I there found". Dürer, Albrecht. *Memoirs of Journeys to Venice and the Low Countries*, Project Gutenberg, 1471–1528. Available at: *http://www.gutenberg.org/cache/epub/3226/pg3226.html*. (Accessed 27 July 2020.)

4. Chipps Smith, Jeffrey. "The 2010 Josephine Waters Bennett Lecture: Albrecht Dürer as Collector". *Renaissance Quarterly*, 64, 1 (Spring 2011) pp. 1–49. *https://www.jstor.org/stable/pdf/10.1086/660367.pdf* (Accessed 3 August 2020.)

5. Dürer's drawing of Chinese porcelain provides direct evidence of his exposure to Chinese art.

6. Two quantities *a* and *b* are said to be in the *golden ratio*, φ, if the proportion of *a:b*, is such that *a+b* is to *a*, as *a* is to *b*. The golden ratio is discussed in the works of the Greek geometer Euclid.

John James Audubon

1. We might speculate that, had photography been available to Audubon as he began his endeavour, these documentations of birds would have been easier and less time-consuming to produce. Arguably, however, photographs would have lacked the narrative qualities and ability to "animate", contextualize and dramatize the birds in their natural environment, through the lens of the artist's eye.

2. Wilson, Alexander. *American Ornithology; or, the Natural History of the Birds of the United States: Illustrated with Plates Engraved and Colored from Original drawings taken from Nature*. Philadelphia: published by Bradford and Inskeep, printed by Robert Carr, 1808–14.

3. The plates were published in serial form between 1827 and 1838, before coming together in a final, bound volume.

4. McCarthy, Erin. "The Book So Big It Needed Its Own Furniture", *Mental Floss*, 15 December 2017. Available at: *https://www.mentalfloss.com/article/520325/audubons-birds-america-book-so-big-it-needed-its-own-furniture* (Accessed 10 September 2020.)

Anna Atkins

1. This was also the case for women working in other centuries, such as the German-born naturalist and scientific illustrator Maris Sibylla Merian (1647–1717), one of the early European naturalists to observe insects directly. She received her artistic training from her stepfather, Jacob Marrel, a student of the still life painter Georg Flegel. Her first book of nature illustrations was published in 1675.

György Kepes

1. Gestalt theory emerged in Austria and Germany at the start of the twentieth century. Gestalt means form, pattern, configuration. As a psychological theory, it held that organisms (human/animal) do not view things in isolation ("atomically") but naturally configure individual elements into patterns or "wholes". The theory can be attributed to Max Wertheimer, Wolfgang Köhler and Kurt Koffka. The various "laws" which emerged from gestalt theory – such as the laws of symmetry, proximity, closure and figure-ground – have been highly influential in creative areas, from composition within artworks to computer interface design. The theory has been attributed a scientific basis within such areas of study as neurology and cybernetics.

2. Dialectics is the process by which two opposites – posed as thesis and antithesis – are placed in a relationship such that they can be resolved. Through this process, the aim is a synthesis of both. However, this process is not always neat and tidy, and Kepes recognized this, preferring to stay with the tension created by two things that don't fit neatly together or resolve themselves in a higher level of understanding. This method of allowing for irreconcilable dialectical tension was at the core of his method of approaching art and science.

3. Kepes set up the CAVS programme at Massachussets Institute of Technology in 1967. The Center for Advanced Visual Studies was intended as an artists' fellowship programme, where artists could work both collaboratively and individually on large- and small-scale projects. The social role of the artist was foregrounded and studies in the environment were particularly emphasized, supported and enabled by available new technologies. Fellows included Muriel Cooper, who went on to work at MIT, and Yvonne Rainer, the dancer, choreographer and filmmaker. Krzysztof Wodiczko took over the directorship of CAVS in 1994, and it continues to this day.

4. The titles of these volumes express their breadth. Volumes 1–6 covered: *The Education of Vision; Structure in Art and Science; The Nature and Art of Motion; Module, Symmetry, Proportion, Rhythm; Sign, Image, Symbol;* and *The Man-Made Object*.

Festival Pattern Group

1. In the Festival Pattern Group, "patterns [were to be] derived from crystallographic structure as the basis for repetitive patterns in mass-produced consumer products such as carpets, textiles, glassware or lighting" – Sophie Forgan (1998), "Festivals of science and the two cultures: science, design and display in the Festival of Britain, 1951", *British Journal for the History of Science 31* (1998), pp. 217–40.

2. X-ray crystallography involves illuminating and exposing a crystal's atomic and molecular structure, as well as chemical bonds, using fine X-ray beams. This, in turn, sends light into different directions (called diffraction), which produces what are called "reflections". Once mapped from 2-D into 3-D, these data points can be used to make a crystal's unique structure visible.

3. At the time of the Festival of Britain, Helen Megaw (1907–2002), was Assistant Director of Research at the Cavendish Laboratory in Cambridge.

4. Anticipating Megaw's later work, the Braggs themselves had observed: "A crystal structure, like wallpaper, consists of a unit of pattern which repeats itself indefinitely". Cited in Jackson, Lesley *From Atoms to Patterns: Crystal structure designs from the 1951 Festival of Britain*. Somerset: Richard Dennis Publications, 2008, p. 7.

5. Hartland Thomas was an architect and the Chief Industrial Officer for the Council of Industrial Design. He was on the Festival of Britain Presentations Panel at Southbank Centre, and was instrumental in bringing Helen Megaw's idea about application of patterns drawn from science, into that context.

6. The 1951 Festival of Britain was held at Southbank Centre in London, a successor to The Great Exhibition held in London in 1851. Both aimed to showcase and celebrate Britain's industrial, manufacturing and scientific achievements, alongside its contributions to arts, culture, and civilization more broadly. The 1951 Festival was hugely popular and offered a bright new vision of a modern, progressive, technologically advanced future from Britain, with recent scientific achievements at its core.

Eduardo Kac

1. Bright, Richard. "Transgenic Art and Beyond". *Interalia Magazine*. Available at: *https://www.interaliamag.org/interviews/eduardo-kac/* (Accessed August 2020.)

2. Kac, Eduardo. "Transgenic Art". Originally published in *Leonardo Electronic Almanac*, 1998. Available at: *https://www.ekac.org/transgenic.html* (Accessed August 2020.)

3. Bright, Richard, *op. cit.*

The Tissue, Culture & Art (TC&A) Project

1. TC&A established the term "semi-living" to describe the life forms they were working with, the living cells and tissues derived from organisms and cultured in artificial environments.

2. Grown in a bioreactor over a period of nine months, the wings reached a size of $4 \times 2 \times 0.5$ centimetres.

3. Intended as a means to capture public fears about the future implications of its means of production.

4. The *Semi-living Steak* (2001) was produced following a residency with the Tissue Engineering & Organ Fabrication Laboratory at Harvard Medical School.

5. See: *https://tcaproject.net/portfolio/vapour-meat/* (Accessed September 2020.)

INDEX

CREDITS

The publishers would like to thank the following sources for their kind permission to reproduce the pictures in this book.

10 Universal History Archive/Universal Images Group via Getty Images, 11 Public Domain, 12 left Wellcome Collection. Attribution 4.0 International (4.0), 12 right to 13 akg-images/© Getty Research Institute/Science Source, 14-17 Public Domain, 18 © 2020. Image Copyright The Metropolitan Museum of Art/Art Resource/Scala, Florence, 19 Georges Seurat 1859-1891, Le Bec du Hoc, Grandcamp, 1885, Oil paint on canvas, Photo © Tate 2021, 20-21 Leemage/UIG via Getty Images, 22 Keystone-France/Gamma-Rapho via Getty Images, 22 Berenice Abbott/Getty Images, 23-27 Berenice Abbott/Getty Images, 29 Copyright J. Paul Getty Trust. Shunk-Kender 2014.R.20, 30-33 © Succession Yves Klein c/o ADAGP, Paris and DACS, London 2021, 35-37 © Susan Derges, courtesy of the artist, 38 Claudia Marcelloni/CERN via Semiconductor, 39 Photograph by Bernard G Mills via Semiconductor, 40 Semiconductor, 41 Francis Ware/Royal Academy of Arts via Semiconductor, 43 Image courtesy the Artist/ Turner Contemporary, Margate/ Ingleby, Edinburgh, Photograph by Marcus J Leith Hayward, 44-45 Image courtesy the Artist/ Turner Contemporary, Margate/ Ingleby, Edinburgh, Photograph by Stephen White, 48 Royal Collection Trust © Her Majesty Queen Elizabeth II, 2021 / Bridgeman Images, 49 Bridgeman Images, 50 Painting/Alamy Stock Photo, 51 Public Domain, 53 Bridgeman Images, 54 Painting/Alamy Stock Photo, 55 Bridgeman Images, 56 SSPL/Getty Images, 57 left Fine Art Images/Heritage Images/Getty Images, 57 right Public Domain, 59 Copyright Stelarc/Photography by Nina Sellars, 60 Copyright Stelarc/Photography by Polixeni Papapetrou, 61 left Copyright Stelarc/Photograph by T.Ike, 61 right Copyright Stelarc, 62 © The Estate of the Artist; Courtesy of Richard Saltoun Gallery, London, 63 The Estate of the Artist; Courtesy of Richard Saltoun Gallery, London , photography by Karen Bengall, 64-67 © The Estate of the Artist; Courtesy of Richard Saltoun Gallery, London, 68-71 © Susan Aldworth, image courtesy of the artist, 73 © Helen Pynor/Copyright Agency. Licensed by DACS 2021, GV Art gallery, London, and Dominik Mersch Gallery,

Sydney, 73-76 © Helen Pynor/Copyright Agency. Licensed by DACS 2021, 79 Image courtesy of the artist; 47 Canal, New York; and La Biennale di Venezia., Photo: Renato Ghiazza, 80 Image courtesy of the artist, 47 Canal, New York, and Kunsthalle Basel, Basel. Photo: Phillip Hänger, 81 Image courtesy of the artist, 47 Canal, New York, and The Kitchen, New York. Photo: Jason Mandella, 84 World History Archive/Alamy Stock Photo, 85-86 Bridgeman Images, 87 Art Heritage/Alamy, 91 Photosublime/Alamy, 92 World History Archive/Alamy Stock Photo, 93 Art Collection 3/Alamy Stock Photo, 94 Photo © Tate Images, 95 Archivart/Alamy Stock Photo, 97 GFDL, CC-BY, Public Domain, 98-101 Public Domain, 102 John McGrail/The LIFE Images Collection via Getty Images, 103 Copyright Agnes Denes, Courtesy Leslie Tonkonow Artworks + Projects, New York, 106 2009 © Ackroyd & Harvey (burning bone), 107 left 2009 © Ackroyd & Harvey, 107 right 2009 © Ackroyd & Harvey (before framing), 108 © Ackroyd & Harvey (comparative study, the artists' studio, Dorking 2001), 109 2009 © Ackroyd & Harvey, 111-113 © Annie Cattrell, courtesy of the artist, 115 © Richard Haughton/Bridgeman Images, 116 top Photo by Christopher Burke via Studio Olafur Eliasson, 116 bottom Photo by Studio Olafur Eliasson, 116 top Photo by Christopher Burke, 116 bottom Photo by Studio Olafur Eliasson, 117 Martin Brink/Alamy Stock Photo, 118-119 118-119 Eric Feferberg/AFP via Getty Images, 120-123 Courtesy of critical-art. net, 127 SSPL/Getty Images, 128 top Sepia Times/Universal Images Group, 128 bottom SSPL/Getty Images, 129 top Prismatic Pictures/Bridgeman Images, 129 bottom Look and Learn/Bridgeman Images, 130-131 gift of the Edwin J. Beinecke Trust/Bridgeman Images, 133 akg-images/Erich Lessing, 134 Everett Collection/Shutterstock, 135 top Heritage Image Partnership/Alamy Stock Photo, 135 bottom Everett Collection/Shutterstock, 137 The Spoiler/Alamy Stock Photo, 138 top Museum purchase funded by the S. I. Morris Photography Endowment/Bridgeman Images, 138 bottom akg-images, 139 akg-images, 140 akg-images/Ullstein Bild, 141 akg-images/Keystone/STR, 142-145 © 2021 Calder Foundation, New York/DACS, London/Art Resource, NY, 147 © ADAGP, Paris and DACS, London 2020/Photo © Tate 2021, 148 Mondadori Portfolio/Electa/Luca

Carrà /Bridgeman Images, 149 Private Collection, 150 Bridgeman Images, 151 Piet Mondrian 1872-1944, No. VI/Composition No.11, 1920, Oil paint on canvas, Photo © Tate 2021, 153-154 © The estate of Kenneth Martin, 155-156 © Estate of Mary Martin/DACS 2020, 157 © The estate of Kenneth Martin, 158 Digital image Whitney Museum of American Art/Licensed by Scala, 159 Digital image, The Museum of Modern Art, New York/Scala, Florence, 160-161 Digital image, The Museum of Modern Art, New York/Scala, Florence,162-163 Photo Smithsonian American Art Museum/Art Resource/Scala, Florence, 165-167 Courtesy of Mario Klingemann, 169-173 Courtesy of Fred Eversley, 176 Public Domain, 177 Chronicle of World History/Alamy, 178-179 Public Domain, 180 Artokoloro/Alamy Stock Photo, 181 Photo © Photo Josse/Bridgeman Images, 182 Archivart/Alamy Stock Photo, 183 Classic Paintings/Alamy Stock Photo, 184-185 Artokoloro/Alamy Stock Photo, 187 Harvard University, Houghton Library, 188 Public Domain, 189 Ben Stansall/AFP via Getty Images, 190-191 Public Domain, 193 Sepia Times/Universal Images Group/Getty Images, 195 Artokoloro/Alamy Stock Photo, 196 Sepia Times/Universal Images Group/Getty Images, 197 Heritage Art/Heritage Images/Getty Images, 199-202 © estate of György Kepes (Imre Kepes and Juliet Kepes Stone), Photo © Tate Images, 203 © estate of György Kepes (Imre Kepes and Juliet Kepes Stone), Private Collection, 205 © Victoria and Albert Museum, London, 206 top Architectural Press Archive/RIBA Collections, 206 bottom Courtesy of the Norman Collection on the History of Molecular Biology in Novato, California, 207 Private Collection, 208-211 Courtesy of KAC Studio, 212-215 All images are courtesy of The Tissue Culture & Art Project (Oron Catts & Ionat Zurr).TC&A is hosted at Symbiotic A, School of Anatomy, Physiology and Human Biology, The University of Western Australia

Every effort has been made to acknowledge correctly and contact the source and/or copyright holder of each picture and Welbeck Publishing apologises for any unintentional errors or omissions, which will be corrected in future editions of this book.